Study Guide to accompany

GARDNER'S

ART

THROUGH
THE
AGES

TENTH EDITION

KATHLEEN COHEN

San Jose State University

Harcourt Brace College Publishers
Fort Worth Philadelphia San Diego
New York Orlando Austin San Antonio
Toronto Montreal London Sydney Tokyo

ISBN: 0-15-503152-X

Cover image: Correggio, *Jupiter and Io,* (detail) c. 1532. Oil on canvas, approx. 64 1/2 " x 29 3/4". Kunsthistorisches Museum, Vienna.

Address for Editorial Correspondence: Harcourt Brace College Publishers, 301 Commerce Street, Suite 3700, Fort Worth, TX 76102.

Address for Orders:
Harcourt Brace & Company, 6277 Sea Harbor Drive, Orlando, Florida 32887-6777, 1-800-782-4479 or 1-800-435-0001 (in Florida).

Printed in the United States of America

5 6 7 8 9 0 1 2 3 4 095 0 9 8 7 6 5 4 3 2 1

PREFACE

This Study Guide to accompany Gardner's *Art through the Ages,* Tenth Edition, is intended to help students approach the vast amount of material encountered in a survey of art history. The guide provides them with a structure for their learning that both reinforces and supplements the structure implicit in the text.

The guide has been designed to ensure that upon completion of this course, students will be able to meet the following objectives:

1. Identify the time periods, geographical centers, and stylistic characteristics of major art movements from the prehistoric period to the present and name artists working in each movement.

2. Discuss the work of major artists in terms of their artistic concerns and stylistic characteristics, the media they used, and the principal influences on them.

3. Define and use common terms of art history.

4. Recognize and discuss the iconography of specified works of art, as well as the iconography popular during various historical periods.

5. Identify significant philosophical movements, religious concepts, and historical figures, events, and places and discuss their relation to works of art.

6. Attribute unfamiliar works of art to an artist, a country and/or style, and a period.

The questions in the first part of each unit call for short answers to be written in the guide. These questions emphasize recognition of the stylistic characteristics of both artists and periods and the basic terminology of art history. Studies have shown that the act of writing down an answer rather than merely reading it serves to imprint it more securely in the mind. Furthermore, reading through the text for specific answers helps students to concentrate effectively. The Glossary in the back of the text, as well as the text itself, can be used in completing many of these questions.

Each unit ends with a variety of discussion questions designed to engage students actively in assessing the significance of what they have learned. Some questions are of a general, philosophical nature, requiring reference to specific artists and styles. Some ask for interpretation of theories. Others involve the comparison of works, artists, and styles from different times and places, sometimes with reference to the students' daily experience. All are calculated to broaden the students' perspective by making them see familiar styles in unfamiliar contexts.

Summary charts throughout the guide cover one or more chapters in the text. These are organized chronologically and contain sections for students to write in major artists, representative works, stylistic characteristics, and other relevant facts. Students should be urged to fill in these charts as much as possible from memory, using the text to complete any unanswered sections. The process will integrate the material into a coherent, condensed form that will help students understand important developments; the completed summary charts will be invaluable in reviewing for examinations.

Self-quizzes appear at the end of each of the five major divisions of the guide. Answers are given at the back, so that students can determine for themselves how well they are progressing.

The overall emphasis on stylistic characteristics is intended to give students the visual and intellectual tools to approach works of art they have never seen before with some degree of confidence. A feature of each of the five self-quizzes is a group of illustrations of works or details not shown in the main textbook, which students are asked to attribute to particular artists or periods, giving reasons for their answers. These exercises may be done as either closed- or open-book tests, at the discretion of the instructor.

Many of the questions in the guide will serve as excellent preparation for examinations. Instructors may wish to base some of their examination questions on the materials covered in the guide; they may even wish to establish with students at the beginning of the course that a specified percentage of the examination questions will be taken from the guide.

KATHLEEN COHEN

CONTENTS

INTRODUCTION

TEXT PAGES 3–19

1. List three features that are used to physically categorize art objects.

 a. *Kind or type of object (building, statue, picture)*

 b. *medium or material (brick, bronze, oil on canvas)*

 c. *dimensions*

 ·d. *physical condition*

2. List six visual and tactile features that are used in categorizing art objects esthetically:

 a. *form* d. *color*

 b. *shape* e. *mass*

 c. *line* f. *volume*

3. Define the following terms as used by art historians, using the text and glossary as necessary:

 area

 axis

 canon of proportion

 form

 hue

 line

 mass

 module

 perspective

 plane

 provenance *the place of origin of a style of art*

 space

 tonality

 value

4. Define the following architectural terms:

plan

section

elevation

5. Define the following sculptural terms:

high relief

low relief (bas-relief)

6. Write down two types of material that could be used in creating subtractive sculpture:

 a. b.

7. Write down two types of material that could be used in creating additive sculpture:

 a. b.

DISCUSSION QUESTIONS

1. Why is the establishment of a correct chronological sequence important to art historians?

2. What is iconography and what are its functions in art-historical study?

3. What is "deconstruction" and how does it affect the study of art history?

4. Discuss the difference between the likeness of an object and a representation of it.

1. Correct chronological sequence is important to understand the period style which reflects the ways of thinking of the time, the thought patterns of the artists & their culture with respect to the meaning of life and of art.

PART ONE

THE ANCIENT WORLD

CHAPTER 1

THE BIRTH OF ART

TEXT PAGES 24–39

1. Define the following terms:

 corbeled vault

 cromlech

 dolmen

 lintel

 megalith

 menhir

 twisted perspective

2. List four caves or caverns that contain Paleolithic paintings.

 a. c.

 b. d.

 What stylistic characteristics are shared by the paintings in these caves?

 a.

 b.

 c.

 d.

 What function are they believed to have served?

3. How does the "Chinese Horse" (FIG. 1-5) illustrate the idea that the painting was done for "magical" purposes?

4. What role did natural rock formations play in the creation of Paleolithic wall art?

5. The figurine known as the *Venus of Willendorf* (FIG. 1-8) was probably used for what purpose?

6. What new type of subject matter became important in the Mesolithic rock-shelter paintings?

 In what ways do these works differ from Paleolithic cave paintings?

 a.

 b.

 c.

7. List two achievements of Neolithic peoples that changed the economic basis of their lives:

 a. b.

 List two achievements that changed their intellectual lives:

 a. b.

8. Name one country where important megalithic remains can be found:

9. Archeological findings indicate that civilization did not originate in the Nile River valley of Egypt, as was earlier believed, but developed in grassy uplands in settlements like Jericho, located in _____ and dating from the _____ millennium B.C., and Çatal Hüyük, located in _____.

10. The first known permanent stone fortifications were built at the site of _____ around _____ B.C.

11. What possible purpose might the head illustrated in FIG. 1-15 have served?

12. The extensive remains found in Çatal Hüyük, which flourished between _____ and _____ B.C., demonstrate the evolution of the economy from _____ to _____.

13. Two advantages of the absence of streets in Çatal Hüyük were:

 a. b.

14. What subjects were portrayed in the wall paintings of Çatal Hüyük?

 a. b.

 What type of statuettes was most popular?

15. List three changes in artistic production that paralleled the shift from a food-gathering to a food-producing economy:

 a. c.

 b.

16. When is Stonehenge thought to have been erected?

 By what means has the dating been established?

17. Locate the following sites on the map in the Study Guide on page 16:

 Jericho Çatal Hüyük

DISCUSSION QUESTIONS

1. Compare the rendition of the human being depicted in FIG. 1-7 with the animal in the same scene and in FIG. 1-5. What might account for the differences in style?

2. Compare the style of the marching warriors in FIG. 1-13 with the human being depicted in FIG. 1-7. What is represented in the two scenes?

3. In what way did the social and economic changes that took place in human development between the Paleolithic and Neolithic periods affect the art produced in each period?

4. What do archeologists generally consider the original purpose of Stonehenge to have been? What evidence supports this belief?

5. Compare the Seated Goddess from Çatal Hüyük (FIG. 1-18) with the *Venus of Willendorf* (FIG. 1-8). In what ways are they similar and how do they differ in their forms and in their probable purposes?

Using the timeline at the beginning of Chapter 1 in the text, complete the following information.

SUMMARY OF PREHISTORIC ART

a. The Old Stone Age is called the _____ period.

It extends from approximately _____ B.C. to _____ B.C.

b. The Middle Stone Age, or the _____ period, is dated:

in the Near East from _____ B.C. to _____ B.C.

and in Europe from _____ B.C. to _____ B.C.

c. The New Stone Age, or the _____ period, is dated:

in the Near East from _____ B.C. to _____ B.C.

and in Europe from _____ B.C. to _____ B.C.

The great paintings of Lascaux and Altamira were painted during the _____ period.

The *Venus of Willendorf* was carved during the _____ period.

Jericho and Çatal Hüyük were founded during the _____ period.

Fill in the chart below as much as you can from memory; then check your answers against the text and complete the chart.

	Typical Examples	Stylistic Characteristics	Significant Historical Events, Idea, etc.
Paleolithic Painting			
Paleolithic Sculpture			
Mesolithic Painting			
Neolithic Structures			
Neolithic Painting and Sculpture			

CHAPTER 2

ANCIENT NEAR EASTERN ART

TEXT PAGES 40–63

1. Define or identify the following terms:

 apadana

 citadel

 city-state

 cuneiform

 cylinder seal

 Gilgamesh

 Inanna

 intaglio

 Ishtar

 lamassu

 rhyton

 votive figure

 ziggurat

2. When was the area between the Tigris and the Euphrates rivers settled?

 What was it called?

3. Name two civilizations that had ties to ancient Mesopotamia:

 a. b.

4. What Sumerian achievement is referred to by the term "fertile crescent"?

5. List three characteristics of Sumerian religion:

 a.

 b.

 c.

6. List four important Sumerian contributions to human development:

 a. c.

 b. d.

7. What do many scholars believe to be the meaning of the exaggerated eyes of Sumerian figures?

8. List three conventions found in Sumerian pictorial art as seen in the *Standard of Ur* (FIG. 2-8):

 a. c.

 b.

 Why is this treatment of form called "conceptual" rather than "optical"?

9. Who was Sargon and why is he important for the history of art?

 Who was Gudea?

10. Who was Naram-Sin?

 How is he represented on the Victory Stele of Naram-Sin (FIG. 2-13)? Note the position of the various parts of his body and his size in relation to the other figures.

11. What is the significance of the Stele of Hammurabi?

12. When was the great lion gate constructed by the Hittites at Boghazköy in Anatolia?

 What was its importance?

13. The Elamite kingdom flourished around _____ B.C. in the country now known as _____.

14. List three Mesopotamian stylistic conventions found in the Elamite statue of Queen Napirasu (FIG. 2-17):

 a. c.

 b.

15. The Assyrian Empire was located in _____ and dominated this area from approximately _____ to _____ B.C.

16. The royal citadel of Sargon II was located in the city of _____. It is thought that many of the rooms of this gigantic palace were covered by vaults. What evidence is there for this hypothesis?

17. The doorway of the royal citadel of Sargon II was guarded by figures of _____.
 List four stylistic features of these creatures:.

 a. c.

 b. d.

18. What subjects were commonly portrayed in Assyrian reliefs?

 List three characteristics of Assyrian relief sculpture that create an impression of violence and brutality.

 a.

 b.

 c.

19. One of the seven wonders of the ancient world was created by Nebuchadnezzar. What was it and where was it located?

20. The Ishtar Gate (FIG. 2-24), which was built in the city of _____, was decorated with representations of the _____ of Marduk and the _____ of Adad. All its surfaces were covered with _____.

21. The Persian dynasty founded by Cyrus in the sixth century B.C. was known as the _____ dynasty. It came to an end with the death of Darius III after his defeat at Issus by _____.

22. At its height in the fifth century B.C., the Persian empire extended from the _____ River in the west to the _____ River in the east.

23. The great palace at Persepolis was erected in the _____ century under _____ and _____ to symbolize Persian imperial power. The architects created a powerful synthesis of architectural and sculptural elements drawn from the cultures of _____, _____, and _____.

24. List four architectural features of the palace of Persepolis.

 a. c.

 b. d.

25. What subjects were depicted in the reliefs on the walls of the terrace and staircases of the palace at Persepolis?

 The following stylistic features can be found in these reliefs:

 a. c.

 b. d.

26. Locate the following sites or areas on the map on Study Guide page 16:

Ur	Boghazköy	Anatolia
Khorsabad	Assyria	Nimrud
Babylon	Sumer	Nineveh
Persepolis	Persia	

 Locate and label the Tigris and Euphrates rivers and the Mediterranean Sea.

DISCUSSION QUESTIONS

1. Discuss the social and economic changes that took place in the ancient Near East that made possible the beginning of what we call civilization.

2. How did the religion practiced by Sumerians differ from that practiced by Paleolithic hunters? What was the relationship between religion and the state in ancient Sumer?

3. Compare the statuettes from the Abu Temple (FIG. 2-6) with the representations of Gudea (FIG. 2-14) and Queen Napirasu (FIG. 2-17). How might the media used have affected the style?

4. Compare the conventions used in depicting the figures in the relief from Persepolis (FIG. 2-28) with those used in earlier representations like the *Standard of Ur* (FIG. 2-8), the Victory Stele of Naram-Sin (FIG. 2-13), and the relief of Ashurnasirpal II (FIG. 2-20).

5. Compare the layout and organization of the town of Çatal Hüyük (FIG. 1-16) with that of the citadel of Sargon II at Khorsabad (FIG. 2-18) and the palace complex at Persepolis (FIGS. 2-25 and 2-26). What seem to have been the major concerns of the creators of each complex? What materials and building techniques were utilized by each?

Using the timeline at the beginning of Chapter 2 in the text, enter the approximate dates for the following periods. Then fill in the chart as much as you can from memory; check your answers against the text and complete the chart.

SUMMARY OF SUMERIAN ART

Early Dynastic Period: _____ B.C. to _____ B.C.
Third Dynasty of Ur (Neo-Sumerian Period): _____ B.C. to _____ B.C.

	Typical Examples	Stylistic Characteristics	Historical Factors
Sumerian Architecture			Rulers: Principal Gods:
Sumerian Sculpture			Important Cities: Political Structure:
Neo-Sumerian Sculpture			Cultural Achievements:

SUMMARY OF AKKADIAN, BABYLONIAN, AND ASSYRIAN ART

Akkadian Dynasty: _____ B.C. to _____ B.C.
Old Babylonian Period: _____ B.C. to _____ B.C.
Assyrian Empire: _____ B.C. to _____ B.C.

	Typical Examples	Stylistic Characteristics	Significant Historical People, Events, Ideas, etc.
Akkadian Sculpture			
Babylonian Sculpture			
Assyrian Architecture			
Assyrian Sculpture			

14

SUMMARY OF NEO-BABYLONIAN, ACHAEMENID PERSIAN, AND SASANIAN ART

Neo-Babylonian Kingdom: _____ B.C. to _____ B.C.
Achaemenid: _____ B.C. to _____ B.C.
Persian Empire: _____ B.C. to _____ B.C.
Sasanian Dynasty: _____ B.C. to _____ B.C.

	Typical Examples	Stylistic Characteristics	Significant Historical People, Events, Ideas, etc.
Neo-Babylonian Art			
Achaemenid Persian Architecture			
Achaemenid Persian Sculpture			
Sasanian Art			

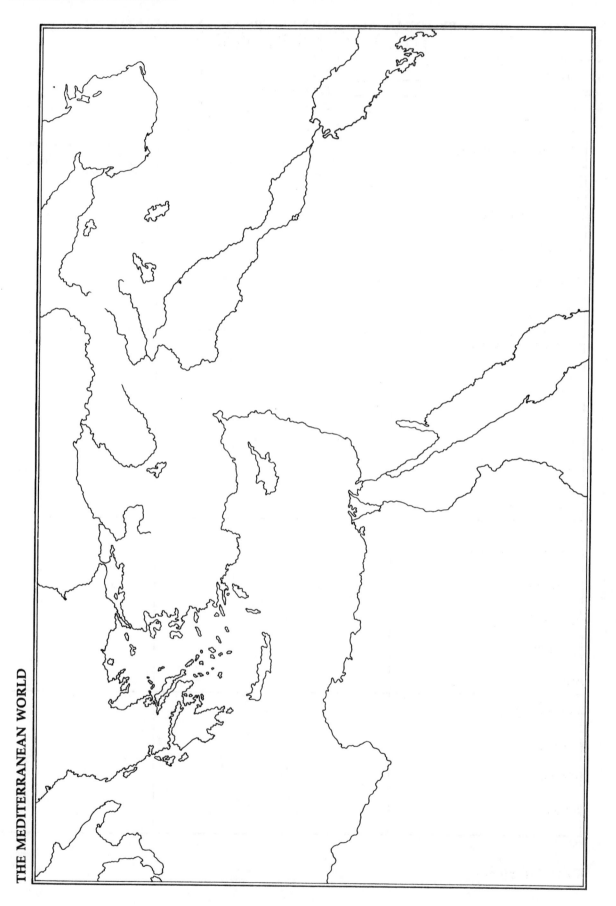

THE MEDITERRANEAN WORLD

CHAPTER 3
EGYPTIAN ART

TEXT PAGES 64–97

1. Define the following terms:

 ben-ben

 canon of proportion

 caryatid

 clerestory

 fresco secco

 hieroglyphic writing

 hypostyle hall

 ka

 necropolis

 pylon

 reserve column

2. Identify the following:

 Akhenaton

 Amarna style

 Amen-Re

 Aton

 Book of the Dead

 Hatshepsut

 Hyksos

 Imhotep

 Isis.

 Khafre (Chephren)

Menes

Nefertiti

Osiris

Ramses II

Tutankhamen

3. Briefly describe the role played by the Nile in the development of Egyptian civilization.

4. What are the boats in the painting from the Predynastic tomb at Hierakonpolis (FIG. 3-1) thought to symbolize?

5. The *Palette of Narmer* (FIG. 3-2), which was created about 3000 B.C., is extremely important in Egyptian history and art for several reasons. Politically, it documents:

Culturally, it records two important facts—

a. about religion:

b. about writing:

Artistically, it embodies conventions that will dominate Egyptian official art to the end of the New Kingdom, namely

a.

b.

c.

6. Describe the function and basic structure of a mastaba.

7. What was the serdab?

8. Who was Re and what relationship was he supposed to have had to the Egyptian pharaohs?

9. In what way do the pyramids of Gizeh differ from King Zoser's pyramid at Saqqara?

10. Describe the post-and-lintel construction system.

11. What does the falcon symbolize in the statue of Khafre (FIG. 3-13)?

 List four stylistic characteristics of the statue.

 a.

 b.

 c.

 d.

12. The pyramid and mastaba tombs so popular in the Old Kingdom were replaced by _____ tombs in the Middle Kingdom.

The three basic units of Egyptian architecture seen in these tombs are

a.

b.

c.

13. What did the Hyksos introduce to Egypt that revolutionized warfare?

14. List four major features of a typical pylon temple.

a.

b.

c.

d.

15. List two types of capitals used in the hypostyle hall at Karnak.

a. b.

16. In what century did Akhenaton proclaim the monotheistic religion of Aton and move his capital to Tell el-Amarna?

17. What was the major effect of the new Amarna style on figural representation?

18. What three new features can be seen in the painted relief of King Smenkhkare and Meritaten (FIG. 3-39)?

a.

b.

c.

19. Although Ramses II lived after Akhenaton, the pillar statues that were carved for the interior of his temple (FIG. 3-27) ignore many of the stylistic features developed by the Amarna artists. Compare the figures from the Temple of Ramses II with the pillar statue of Akhenaton (FIG. 3-36); note particularly the differences in the proportions of the figures.

 Akhenaton Ramses II

What political factors might account for these differences?

20. Which stylistic features used in the decoration of the chest reproduced in FIG. 3-42 suggest that the chest could not have been created during the Old or Middle Kingdoms?

21. Locate the following on the map on Study Guide page 16:

Gizeh	Tell el-Amarna	Luxor
Saqqara	Karnak	Abu Simbel
Beni Hasan	Thebes	Hierakonpolis

Locate the Nile River and the Red Sea.

DISCUSSION QUESTIONS

1. Discuss the use of convention and realism in Egyptian relief carving and painting. What types of subjects generally were treated more conventionally? Why? (Note particularly FIGS. 3-18, 3-19, 3-20, 3-34, 3-35, and 3-39.)

2. Compare the portrait of Sesostris III (FIG. 3-24) with those of Khafre (FIG. 3-13) and of Queen Nefertiti (FIG. 3-37). What differences do you see, and how might these differences reflect changed social conditions?

3. Compare the Egyptian pyramid of Zoser (FIG. 3-4) with the ziggurat at Ur (FIG. 2-4). In what ways are they similar? How do they differ? What was the function of each?

4. What do the Great Pyramids of Gizeh (FIGS. 3-8 to 3-10) and the palace at Persepolis (FIGS. 2-25 and 2-26) say about the major concerns of the men and the societies that commissioned them?

5. Compare the rock-cut tombs at Beni Hasan (FIGS. 3-21 to 3-23) with the temples of Hatshepsut (FIG. 3-25) and Ramses II (FIGS. 3-26 and 3-27). In what ways are they similar? How do they differ? In what ways do all these tombs relate to temples such as the Temple of Amen-Re at Karnak (FIGS. 3-29 and 3-30)?

6. Compare the way the Egyptians depicted animals (FIGS. 3-19, 3-20, and 3-34) with the way animals were depicted by the artists of ancient Mesopotamia (FIGS. 2-8, 2-10, 2-21, 2-22, and 2-23) and those of Paleolithic Europe (FIGS. 1-1, 1-2, 1-4 to 1-7, 1-11, and 1-12). Which artists seem to portray them most naturally? What part does abstract pattern play in each? Which figures do you like best? Why?

7. Discuss the role that death played in Egyptian art. What relation did it have to the development of portraiture?

8. What is the difference between conceptual and optical approaches to art?

Using the timeline at the beginning of Chapter 3 in the text, enter the approximate dates for the following periods. Fill in the chart as much as you can from memory; check your answers against the text and complete the chart.

SUMMARY OF EGYPTIAN ART—PREDYNASTIC TO OLD KINGDOM

Predynastic Period: _____ B.C. to _____ B.C.
Early Dynastic Period: _____ B.C. to _____ B.C.
Old Kingdom: _____ B.C. to _____ B.C.

	Typical Examples	Stylistic Characteristics	Significant Historical People, Events, Ideas, etc.
Predynastic Sculpture			Geographic Influences: Gods:
Old Kingdom Architecture			Rulers:
Old Kingdom Sculpture			Social Structure:
Old Kingdom Painting & Relief			Religious Beliefs:

SUMMARY OF EGYPTIAN ART—MIDDLE AND NEW KINGDOMS

Middle Kingdom: _____ B.C. to _____ B.C.
New Kingdom: _____ B.C. to _____ B.C.
Amarna Period: _____ B.C. to _____ B.C.

	Typical Examples	Stylistic Characteristics	Significant Historical People, Events, Ideas, etc.
Middle Kingdom Art			
New Kingdom Architecture			
New Kingdom Painting & Sculpture			
Amarna Period Painting & Sculpture			

CHAPTER 4
AEGEAN ART

1. Define the following terms:

 ashlar masonry

 bastion

 corbeled arch

 Cyclopean walls

 dromos

 faïence

 Linear B

 repoussé

 tell

 tholos

 wet (or true) fresco

2. Identify and briefly state the importance of the archeological work of each of the following:

 Heinrich Schliemann

 Arthur Evans

3. Identify the following:

 Minoan

 Helladic

 Cycladic

 Mycenaean

 Thera

4. Write down three characteristics that differentiate the culture of the ancient Aegean civilizations from those of the Near East.

a.

b.

c.

5. List three stylistic characteristics of the Early Bronze Age statuettes from the Cyclades.

a.

b.

c.

6. The "old" palaces of Crete are thought to have been built in the Middle Minoan period, around the year _____. They were destroyed around _____.

7. When did the potter's wheel come into use on Crete?

What difference did it make in the potter's work?

8. The golden age of Crete developed when the "new" palaces were built around _____ and lasted until they were destroyed, which was around _____.

9. List four characteristics of the palace at Knossos.

a.

b.

c.

d.

10. In what way did the shape of a Minoan column differ from that of other columns? Draw a small sketch of a Minoan column in the margin of this page.

11. In Minoan painting, human beings were most often represented in profile pose with a full-view eye, similar to conventions observed in Egypt and Mesopotamia, but they can be identified as Minoan because:

12. Which characteristics of Minoan ceramic decoration are apparent in the Late Minoan Marine style octopus jar (FIG. 4-12)?

 a.

 b.

 c.

13. What is particularly significant about the depiction of the human faces on the Harvesters Vase (FIGS. 4-14 and 4-15)?

14. List three characteristics of Minoan sculpture as seen in the Snake Goddess (FIG. 4-16).

 a.

 b.

 c.

15. What source seems to have influenced the composition of the Lion Gate of Mycenae?

16. Describe the structure of a beehive tomb. Sketch one in the margin.

17. Locate the following on the map on Study Guide page 32:

 Aegean Sea Tiryns
 Crete Vaphio
 Cyclades Troy (Ilium)
 Knossos Thera
 Mycenae

DISCUSSION QUESTIONS

1. What are the current theories concerning the origin and demise of the Minoan culture and the relationship between Minoans and Mycenaeans?

2. Select a Minoan fresco and an Egyptian example and compare them. What differences do you see in the artists' approaches to composition and form, particularly in the depiction of motion and vitality?

3. In what ways does the palace at Knossos (FIGS. 4-3 to 4-5) differ from the palace of Sargon II at Khorsabad (FIG. 2-18), from the palace of Darius at Persepolis (FIGS. 2-25 and 2-26), and from the citadel of Tiryns (FIGS. 4-17 to 4-19)? What do these differences seem to reflect about the major concerns of each civilization?

4. What explanation can you give for the obvious difference in style between the Vaphio Cup (FIG. 4-26) and the Warrior Vase (FIG. 4-28), which were both found in Mycenaean graves?

Using the timeline at the beginning of Chapter 4 in the text, enter the approximate dates for the following periods. Fill in the charts as much as you can from memory; check your answers against the text and complete the charts.

SUMMARY OF MINOAN ART

Early Minoan Period:	_____	B.C. to	_____	B.C.
Middle Minoan Period:	_____	B.C. to	_____	B.C.
Old Palace Period:	_____	B.C. to	_____	B.C.
New Palace Period:	_____	B.C. to	_____	B.C.
Late Minoan Period:	_____	B.C. to	_____	B.C.

	Typical Examples	Stylistic Characteristics	Significant Historical People, Ideas, Events, etc.
Middle Minoan Ceramics			
Late Minoan Ceramics			
Minoan Architecture			
Minoan Sculpture			
Minoan Painting			

SUMMARY OF CYCLADIC AND MYCENAEAN ART

Early Helladic Period: _____ B.C. to _____ B.C.
Middle Helladic Period: _____ B.C. to _____ B.C.
Late Helladic (Mycenaean) Period: _____ B.C. to _____ B.C.

	Typical Examples	Stylistic Characteristics	Significant Historical People, Ideas, Events, etc.
Cycladic Sculpture			
Mycenaean Architecture			
Mycenaean Sculpture			
Mycenaean Ceramics			
Mycenaean Metalwork			

Using the timelines at the beginning of Chapters 2 through 4 in the text, fill in the dates for the various periods of Egyptian and Near Eastern art that are indicated below; then correlate the various periods of Minoan and Helladic art with them.

COMPARATIVE CHRONOLOGY

	Egypt	Near East	Crete	Greece
3500 B.C.	Predynastic (-)			
3000 B.C.	Early Dynastic (-)	Sumerian (-)		
2500 B.C.	Old Kingdom (-)	Akkadian (-) Neo-Sumerian (-)		
2000 B.C.	Middle Kingdom (-)			
1500 B.C.	New Kingdom (-)			
1000 B.C.	Late Period (-)	Assyrian (-) Neo-Babylonian (-)		
500 B.C.		Achaemenid Persian (-)		

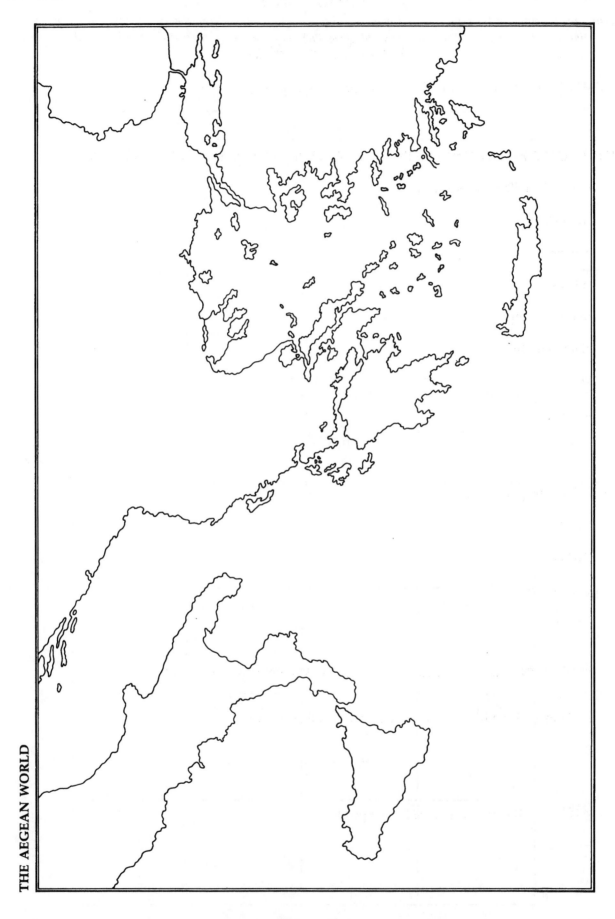

THE AEGEAN WORLD

CHAPTER 5

GREEK ART

TEXT PAGES 116–183

THE GEOMETRIC, ORIENTALIZING, AND ARCHAIC PERIODS TEXT PAGES 119–140

1. Define the following terms:

 encaustic

 engobe

 entasis

 foreshortening

 gigantomachy

 kore

 kouros

 naos

2. Identify the following:

 Dipylon

 Exekias

 Euphronios

 Homer

3. For the Greeks, _____ was the "measure of all things."

4. In Greek philosophy, what set man apart from other creatures?

5. What form did the Greeks give to their gods?

6. Who were the Dorians?

 Who were the Ionians?

7. What was the significance of the Olympiad of 776 B.C.?

8. List three characteristics typical of vase decoration from the Geometric period.

 a.

 b.

 c.

9. The Greek statuette known as the *Mantiklos Apollo*, shown in FIG. 5-4, is probably inspired by Near Eastern prototypes, but differs from them by depicting the figure:

10. Why was the seventh century B.C. known as the "Orientalizing" period in Greek art?

 New subjects like _____ that appeared on Greek vases during this time show the influence of motifs borrowed from or inspired by _____ and _____ works of art.

11. What effect did the establishment of a Greek trading company in Egypt in the seventh century B.C. have on Greek art?

12. Name the earliest known Greek temple with sculptured decoration:

13. List three characteristics of the Daedalic style:

 a.

 b.

 c.

14. Monumental freestanding sculpture first appeared in Greece around _____ in the _____ period.

15. What characteristics do sixth-century B.C. kouros figures share with Egyptian statues?

 In what respects do they differ from them?

16. What do the authors believe the meaning of the "archaic smile" to have been?

17. Which parts of Greek statues were ordinarily painted?

18. Describe the different visual effects created by the garments worn by the *Peplos Kore* (FIG. 5-12) and the Ionian Kore (FIG. 5-13).

19. What was the major function of a Greek temple?

20. What did the Greeks believe was embodied by the harmonious proportions of their temples and their music?

21. Draw simple diagrams of the following types of temples and identify the naos of each:

 a. temple in antis c. prostyle temple

 b. amphiprostyle temple d. peripteral temple

22. List four differences between the Doric and Ionic orders.

Doric	Ionic
a.	a.
b.	b.
c.	c.
d.	d.

23. Label the parts on the following diagrams and indicate the architectural order for each half of the figure below.

shaft volute pediment stylobate
capital entablature triglyph echinus
abacus frieze metope cornice
architrave

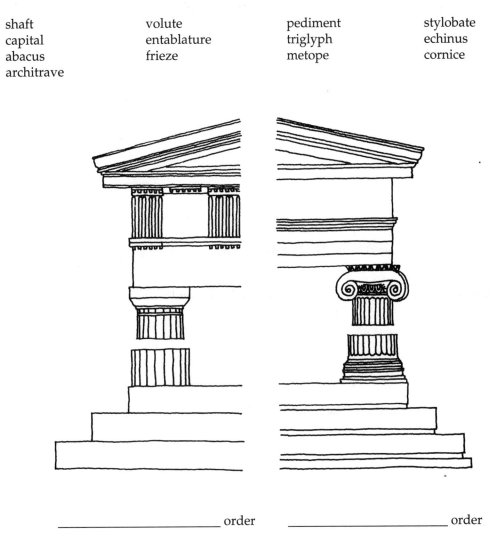

_____ order _____ order

24. On what parts of a Greek temple was sculptural decoration commonly used?

25. What was the function of the figures of Medusa and the panthers on the pediment of the Temple of Artemis at Corfu?

26. What features of the facade of the Treasury of the Siphnians at Delphi (FIGS. 5-20 and 5-21) identify it as an Ionic building?

27. What are the main compositional problems of pedimental sculpture? How were they solved in the Temple of Aphaia at Aegina (FIG. 5-30)?

28. Describe the black-figure technique of pottery decoration.

Describe the red-figure technique of pottery decoration.

Name two painters who worked in the black-figure style.

a. b.

Name two painters who worked in the red-figure style.

a. b.

Who is generally given credit for the invention of the red-figure technique?

29. Locate the following on the map on Study Guide page 32:

Aegina Ionia
Argos Paestum
Attica Peloponnesos
Ilium (Troy)

DISCUSSION QUESTIONS

1. How were the different conceptions of the individual in the Greek and Sumerian civilizations reflected in their art?

2. Compare the Minoan Marine Style octopus jar from Palaikastro (FIG. 4-12) with the Greek Geometric krater from the Dipylon cemetery (FIG. 5-2). How does the decoration of each relate to the shape of the vase, and what does the subject matter of each tell us about the people who made them?

3. Compare the kouros from Anavysos (FIG. 5-11) with the Egyptian statue of Mentemhet (FIG. 3-45). What similarities and what differences do you see?

4. Compare the structure and function of the Egyptian Temple of Horus at Edfu (FIG. 3-32) with the Greek Temple of Aphaia at Aegina (FIGS. 5-28 and 5-29). Name the various parts of each structure.

THE EARLY AND HIGH CLASSICAL PERIODS TEXT PAGES 140–160

1. Identify or define the following:

 Amazonomachy

 chryselephantine

 contrapposto

 Delian League

 herm

 lekythos (pl. lekythoi)

 Lord Elgin

 Nike

 Pericles

 Polygnotos of Thasos

 Vitruvius

2. The Persians sacked Athens in the year _____.

3. What was the significance of the Battle of Salamis?

4. The sculptures of the east pediment of the Temple of Zeus at Olympia represent what mythological subject?

5. What is represented on the metope from the Temple of Zeus at Olympia (FIG. 5-36)?

 How is this subject related to the site of the temple?

 In what way does the style of these figures lead scholars to call the Early Classic phase of Greek art the "Severe Style"?

6. Describe contrapposto:

 List two early examples of figures that demonstrate it:

 a. b.

7. Briefly describe the *cire perdue* method of casting bronze.

8. What attribute would identify the bronze figure from Artemision (FIG. 5-40)

 as Zeus?

 as Poseidon?

9. The *Diskobolos* (FIG. 5-41) was created by the sculptor _____ about
 _____ B.C. What features of the *Diskobolos* are characteristic of Early Classical sculpture?

10. One of the most frequently copied Classical statues was the *Doryphoros* by _____.
 Briefly describe his principle of symmetria.

11. What was the main purpose of the Parthenon?

 Who were its architects?

 Who designed its sculptural decorations?

12. What was the basic style of the Parthenon?

 Two Ionic elements used in it are:

 a. b.

13. Like Polykleitos, the creators of the Parthenon believed that beauty was achieved by the use of harmonious mathematical proportions. List three elements of the Parthenon that utilized the mathematical ratio of 9 to 4:

 a. c.

 b.

14. Describe the *Athena Parthenos*:

15. In what ways do the figures from the east pediment of the Parthenon (FIGS. 5-52 and 5-53) differ from those of the east pediment of the Temple of Zeus at Olympia (FIGS. 5-34 and 5-35)?

 a.

 b.

 c.

16. What do the metopes of the Parthenon depict, and what are they thought to symbolize?

17. What is represented on the Parthenon's inner frieze?

 List two features that illustrate the Athenians' view of their own importance:

 a.

 b.

18. What is the Propylaia and what architectural orders were used in it?

19. Two Ionic buildings on the Athenian Acropolis are:

 a. b.

20. Why is the Erechtheion an unusual building?

 What explanations have been given for its unusual features?

21. List three stylistic features that characterize the relief of Nike adjusting her sandal (FIG. 5-62).

 a.

 b.

 c.

22. What was used to mark Athenian graves during the:

 Geometric period?

 Archaic period?

 Classical period?

23. The vase decoration of the Niobid Painter is thought to reflect the style of the mural painter
 _____. In what way did his style break with the traditional decorative style?

24. The use of the white-ground technique was most popular on vases known as _____.
 What were its advantages over the black-figure or red-figure techniques?

 What were its disadvantages?

25. Locate the following on the map on Study Guide page 32:

Athens Olympia
Delphi

DISCUSSION QUESTIONS

1. Who was responsible for the creation of the Egyptian Temple of Amen-Re (FIGS. 3-28 and 3-29) and who was responsible for the creation of the Greek Parthenon (FIGS. 5-47 to 5-49)? How does the esthetic effect produced by each reflect the political and religious systems of the two cultures?

2. What are the primary changes you see in the treatment of the human figure when you compare the kouros from Attica (FIG. 5-9) with the bronze warrior from Riace (FIG. 5-38) and the *Doryphoros* (FIG. 5-42)? Note the changing proportions, the depiction of motion, and the conception of the figure in space.

3. Discuss the development of pedimental sculpture from the point of view of narrative and formal cohesiveness as seen in the pediments of Corfu (FIGS. 5-18 and 5-19), Aegina (FIGS. 5-30 to 5-32), Olympia (FIGS. 5-34 and 5-35), and the Parthenon (FIGS. 5-52 and 5-53).

THE LATE CLASSICAL AND THE HELLENISTIC PERIODS TEXT PAGES 161–183

1. Who fought against whom in the Peloponnesian War?

 Who won?

2. List three ways in which Greek political and social life changed after the Peloponnesian War:

 a.

 b.

 c.

3. Who was Philip of Macedon?

 Alexander?

4. In what major ways did fourth-century Greek sculpture differ from that of the fifth century?

Point out some qualities of Praxiteles' Hermes and the infant Dionysos (FIG. 5-70) that express these differences.

a.

b.

c.

d.

5. The original Aphrodite of Knidos, one of the first Greek female nudes, was carved by _____ in the _____ century.

6. A quality not generally found in fifth-century sculpture appears in the work of Skopas. What is it?

7. List two innovations that Lysippos made in figure sculpture.

a.

b.

8. Whom did Alexander the Great select to do his official portrait?

9. What is the difference between pebble mosaics and tesserae mosaics?

Give an example of each:

pebble: tesserae:

10. What concerns of Classic Greek painters were to characterize Western painting from the Renaissance through the nineteenth century?

11. What were the functions of the following features of the theater at Epidauros (FIG. 5-80)?

auditorium or cavea

orchestra

skene

12. The main advantage of a Corinthian capital over an Ionic capital was:

13. The grid pattern or "checkerboard" plan, which was used in many Hellenistic cities, is generally associated with the architect _____.

14. The subject depicted in the frieze on the Altar of Zeus from Pergamon (FIGS. 5-89 and 5-90) was:

What devices were used to emphasize the anguish and drama of the theme?

a.

b.

c.

What did the subject portrayed symbolize?

15. What distinctive features identify the figures on Attalos' victory monument from Pergamon as Gauls?

16. Note stylistic characteristics that identify the *Nike of Samothrace* (FIG. 5-93) as a Hellenistic sculpture:

17. What concerns were shared by the sculptors of the Aphrodite from Delos (FIG. 5-95) and the *Barberini Faun* (FIG. 5-97)?

18. List three works that you think best represent the realistic bent of Hellenistic sculptors:

a c.

b.

19. How does Polyeuktos' portrait of *Demosthenes* (FIG. 5-100) illustrate the changed Hellenistic view of the purpose of portraiture?

20. Three Hellenistic centers of culture were

 a. c.

 b.

21. The Temple of Apollo at Didyma (FIGS. 5-84 and 5-85) is called a _____ temple because it has two colonnades surrounding the naos. It is also a hypaethral temple because:

 List four ways in which it differs from Classical Greek temple types:

 a.

 b.

 c.

 d.

22. What subject was depicted in the statue of Laocoön and his sons (FIG. 5-101)?

23. List two works created by the Rhodian sculptors Hagesandros, Athanadoros, and Polydoros.

 a. b.

24. Define the following terms:

 agora

 colonnade

 peristyle

 stoa

25. Locate the following on the map on Study Guide page 32:

Corinth Pella Samothrace
Macedonia Priene
Miletos Pergamon

DISCUSSION QUESTIONS

1. What is meant by "the problem of the corner triglyph" in Doric architecture? How did Ionic capitals present problems at the corners, and how did Greek architects attempt to solve these problems?

2. How did social and political conditions of fifth-century Athens differ from those of the Hellenistic period? In what ways do the figures of Dionysos (Herakles?) from the Parthenon (FIG. 5-52) and the Dying Gaul (FIG. 5-92) reflect these conditions?

3. Select three figures that you think best demonstrate the development of the female figure in Greek sculpture—one each from the Archaic, the Classic, and the Hellenistic periods. How does each illustrate the stylistic characteristics of her period?

4. What is the social significance of the work done by the fifth-century architect Hippodamos?

5. Compare the Hellenistic Boxer (FIG. 5-98) with representations of fifth-century athletes like Myron's *Diskobolos* (FIG. 5-41) and Polykleitos' *Doryphoros* (FIG. 5-42). How do they differ in emotional impact, and what formal differences contribute to those effects?

SUMMARY: THE ART OF GREECE TEXT PAGES 116–183

Identify briefly the following gods, goddesses, heroes, etc.

Aphrodite

Apollo

Artemis

Athena

centaur

Dionysos

gorgons

Hera

Herakles

Hermes

Laocoön

Lapith

Medusa

Nike

Zeus

Using the timeline at the beginning of Chapter 5 in the text, enter the appropriate dates for the following periods. Fill in the charts as much as you can from memory; then check your answers against the text and complete the charts.

CHRONOLOGY OF GREEK ART

Proto-Geometric Period:	_____ B.C. to	_____ B.C.
Geometric Period:	_____ B.C. to	_____ B.C.
Orientalizing Period:	_____ B.C. to	_____ B.C.
Archaic Period:	_____ B.C. to	_____ B.C.
Classical Period:	_____ B.C. to	_____ B.C.
Early Classical (Severe):	_____ B.C. to	_____ B.C.
High Classical:	_____ B.C. to	_____ B.C.
Late Classical:	_____ B.C. to	_____ B.C.
Hellenistic Period:	_____ B.C. to	_____ B.C.

	Political Leaders and Events	Cultural & Scientific Developments
Geometric & Archaic Periods		
Classical Period		
Hellenistic Period		

SUMMARY OF GREEK VASE PAINTING AND MOSAICS

	Typical Examples	Stylistic Characteristics	Artists
Geometric Vase Painting			
Archaic Vase Painting			
Classical Vase Painting			
Classical Mosaics			

SUMMARY OF GREEK ARCHITECTURE

	Typical Examples	Stylistic Characteristics & Order
Archaic		
Classical		
Hellenistic		

SUMMARY OF GREEK SCULPTURE

	Typical Examples	Stylistic Characteristics	Artists
Geometric			
Archaic			
Early Classical (Severe)			
High Classical			
Late Classical			
Hellenistic			

CHAPTER 6

ETRUSCAN ART

TEXT PAGES 184–197

1. Define the following terms:

 chimera

 fibula

 necropolis

 tufa

 tumulus

2. Most modern scholars believe that the Etruscans were the result of a fusion of peoples from _____ who intermixed with the native populations during the _____.

3. The development of Etruscan art was strongly influenced by the Greek colonization of Italy in the _____ and _____ centuries B.C.

4. Name four important Etruscan settlements.

 a. c.

 b. d.

5. What was the basis of their wealth?

6. The earliest examples of Etruscan monumental stone sculpture were influenced by _____ motifs.

7. List five architectural characteristics of Etruscan temples that distinguish them from Greek temples.

 Etruscan temple Greek temple
 a. a.

 b. b.

 c. c.

d. d.

e. e.

8. One subject commonly painted in early Etruscan tomb interiors was:

9. List three stylistic characteristics of the Apollo from Veii (FIG. 6-4) that distinguish it as Etruscan.

a.

b.

c.

Where was it originally placed?

10. What were the favorite materials of Etruscan sculptors?

a. b.

11. What do the sarcophagus in FIG. 6-5 and the wall painting shown in FIG. 6-9 tell us about the position of women in ancient Etruria as opposed to their position in ancient Greece?

12. How were Etruscan tumuli constructed?

What did they most resemble?

13. What conventions of skin color did many Mediterranean cultures utilize to distinguish men and women?

14. Why is the Etruscan Capitoline Wolf (FIG. 6-11) so famous?

15. In what ways does the *Mars of Todi* (FIG. 6-13) emulate Greek figures?

 In what ways does it differ?

16. Describe the medium and technique used for decorating the *Ficoroni Cista* (FIG. 6-15).

17. What is an arcuated gateway?

18. By what date had the Etruscans been absorbed by Rome?

19. Locate the following on the map on Study Guide page 73:

 Vulci Tarquinia
 Veii Cerveteri

DISCUSSION QUESTIONS

1. Compare the Apollo from Veii (FIG. 6-4) with the Riace Warrior (FIG. 5-38). Explain how the typical Etruscan features of the former contrast with the typical Greek features of the latter. How are these influences combined in the *Mars of Todi* (FIG. 6-13)?

2. How do the style, color, subject matter, and mood of an Etruscan fresco (FIG. 6-9) compare with those of a Greek vase painting (FIG. 5-66)?

3. In what way were the Etruscan rise to and fall from power reflected in the decoration of Etruscan tombs?

SUMMARY: ETRUSCAN ART TEXT PAGES 184–197

Using the timeline at the beginning of Chapter 6, enter the appropriate dates for the following periods. Fill in the charts as much as possible from memory; then check your answers against the text and complete the charts.

SUMMARY OF ETRUSCAN ART

Villanovan Period:	_____ B.C. to	_____ B.C.
Orientalizing Period:	_____ B.C. to	_____ B.C.
Archaic Period:	_____ B.C. to	_____ B.C.
Classical Period:	_____ B.C. to	_____ B.C.
Hellenistic Period:	_____ B.C. to	_____ B.C.

	Typical Examples	Stylistic Characteristics	Significant Historical People, Events, Ideas, etc.
Architecture			
Painting			
Sculpture			

CHAPTER 7

ROMAN ART

TEXT PAGES 198–255

1. List five ways in which the modern Western world has been influenced by the Romans:

 a.

 b.

 c.

 d.

 e.

2. When did Romulus traditionally found the city of Rome?

 When was the Roman Republic established?

3. Define the following:

 arcuated entablature

 barrel vault

 basilica

 caldarium

 coffering

 continuous narration

 encaustic

 frigidarium

 groin vault

 oculus

 pseudoperipteral

taberna

tempera

tepidarium

4. The two cultures whose art most strongly influenced that of Rome were _____ and _____.

5. What two features does the temple of "Fortuna Virilis" (FIG. 7-1) draw from Etruria?

 a.

 b.

 From Greece?

 a.

 b.

 What element is distinctly Roman?

6. List four non-Greek features of the Temple of "the Sibyl" ("Vesta") at Tivoli (FIG. 7-2).

 a.

 b.

 c.

 d.

 What is the style of the temple plan?

7. How does the Sanctuary of Fortuna Primigenia (FIG. 7-3) manifest the "Roman imperial spirit"?

8. What technical developments enabled the Romans to create an architecture of space rather than of sheer mass?

9. What was the major function of Roman Republican portrait sculpture?

 What stylistic features differentiate Roman Republican portraits from Greek examples?

10. How does the statue of the general from Tivoli (FIG. 7-6) demonstrate the mix of Greek and Roman features?

11. How did the style used by ordinary Romans for their funerary monuments differ from that used by the patricians (upper class)?

12. What catastrophic event has enabled modern scholars to learn so much about life in a Roman town?

 When did it take place?

13. Briefly describe the following features of Pompeii:

 forum

 basilica

 amphitheater

14. Briefly describe the following features of a typical Pompeian house:

 atrium

 impluvium

cubicula

triclinium

peristyle garden

15. Briefly describe the following painting styles found in Pompeii and its vicinity and/or Rome:

 1st Style

 2nd Style

 3rd Style

 4th Style

16. List three pictorial devices used by Roman painters to suggest depth:

 a.

 b.

 c.

17. Describe the "Arcadian spirit."

18. What are the scroll, stylus, and writing tablet seen in the double portrait from Pompeii (FIG. 7-26) intended to symbolize?

19. What date marks the change from the Roman Republic to the Roman Empire?

 What happened?

20. Who was Octavian?

21. What was the Pax Romana?

22. What was the stylistic inspiration of the portrait of Augustus found at Primaporta?

 What is the political message of the figure?

23. In what respects do the reliefs from the Ara Pacis Augustae (FIGS. 7-32 and 7-33) resemble the Parthenon frieze (FIG. 5-56)?

 a.

 b.

 c.

 How do they differ from it?

 a.

 b.

 c.

24. Name a building erected in France in the Neo-Classical Augustan style:

 This architectural style was admired by the American President _____ and the
 Roman architectural writer _____, whose work influenced Renaissance architects.

25. What was the function of the great Pont du Gard erected at Nîmes?

26. How did Roman architects use concrete in the construction of the Porta Maggiore, and what effects did
 they achieve?

27. When was the Roman Colosseum completed?

 How many people could it hold?

 What material was used in the construction, and how was the immense structure supported?

 What type of decoration was used on its exterior?

28. Describe the Roman rusticated masonry style.

29. In what sequence, from the ground up, were the Greek orders used for the decoration of multistoried
 Roman buildings?

 a. b. c.

 On what esthetic considerations was the sequence based?

30. How did Flavian portraits differ from those done during the Republic?

31. The subjects depicted in the reliefs on the Arch of Titus were:

 a.

 b.

32. What type of plan was used at Timgad?

 Describe it.

33. What major complex did Trajan build in Rome?

 Who was its architect?

 List three architectural features of the Basilica Ulpia.

 a.

 b.

 c.

34. What was portrayed on the Column of Trajan?

 In what form was it presented?

35. List two types of vaults that were used in the tabernas of Trajan's market and describe how each was constructed.

 a.

 b.

36. What events took place in the Circus Maximus?

37. Roman portrait sculpture shows a fluctuation between two opposite artistic tendencies. What are they?

 a.

 b.

38. Name an emperor, other than Augustus, who commissioned art that showed strong Greek influence.

39. Which revolutionary architectural concept finds its fullest expression in the Roman Pantheon (FIGS. 7-55 to 7-57)?

 Who may have been its designer?

 The center of its dome is pierced by a circular opening called the _____.

40. What principle does Hadrian's villa share with the second-century tomb from Petra (FIG. 7-59)?

41. What is an insula (pl. insulae)?

 What material was used to construct the insula at Ostia?

42. What sorts of scenes were painted on the funerary plaques found at Ostia?

43. What is the significance of the scene of the apotheosis of Antoninus Pius?

 Describe the difference in the styles used on the two panels done for Antoninus Pius (FIGS. 7-64 and 7-65).

44. How does the mood conveyed by the equestrian portrait of Marcus Aurelius (FIG. 7-66) differ from late portraits of him like the one shown in FIG. 7-67)?

45. What change in burial practices caused sarcophagi to become so popular during the second century?

What types of themes were used to decorate them?

46. In what country were Faiyum portraits produced?

List two materials that were used to paint them.

a. b.

47. Which emperor was portrayed with his family in a small painting found in Egypt?

48. List three factors that demonstrated the decline of Roman power by the late second century.

a.

b.

c.

49. What functions, other than sanitary ones, did the Roman baths fulfill?

What type of vaults were used for the frigidarium of the Baths of Caracalla?

50. How does the nude portrait of Trebonianus Gallus (FIG. 7-77) reflect the art of the so-called "soldier emperors"?

51. What reason can be given for the popularity of the philosopher theme on third-century sarcophagi?

52. What is most distinctive about the structure of the Temple of Venus at Baalbek?

53. List four characteristics of fourth-century Roman sculpture that are illustrated by the portraits of the tetrarchs (FIG. 7-81) in the facade of San Marco in Venice.

 a.

 b.

 c.

 d .

54. What was the model for Diocletian's palace at Split?

 What feature of the peristyle court of the palace was to be of great importance to the development of medieval architecture?

55. List two aspects of the mosaics of the Piazza Armerina that reflect the Classical tradition.

 a.

 b.

56. What was the political and religious significance of the Battle of the Milvian Bridge?

57. What events are often used to mark the beginning of the Middle Ages?

 a.

 b.

58. What reasons can be given for Constantine's reuse of second-century sculpture on his triumphal arch?

 a.

 b.

59. What type of vaulting was used to construct the Basilica Nova of Constantine (FIGS. 7-89 and 7-90)?

60. What was the function of the Aula Palatina in Trier?

What technical development made its large windows possible?

61. What is the significance of the Christogram on Constantine's coin portrait (FIG. 7-93)?

62. Locate the following on the map on Study Guide page 73:

Faiyum	Herculaneum
Pompeii	Nîmes
Rome	Palestrina
Trier	Split

DISCUSSION QUESTIONS

1. What different building techniques were used and what esthetic effects were achieved by the architects of the Sanctuary of Fortuna Primigenia (FIG. 7-3) and the Mortuary Temple of Queen Hatshepsut (FIG. 3-25)?

2. What is meant by the term *illusionism*? How is illusionism used in Roman painting?

3. If the Greek genius expressed itself in art, science, and philosophy, in what fields did the more practical Romans excel? How are these differing concerns reflected in the surviving monuments of the two cultures?

4. How did the Romans and the Greeks differ in their conception of architectural space? Include in your discussion the Greek Parthenon (FIGS. 5-47 to 5-49), the Roman Pantheon (FIGS. 7-55 to 7-57), the Baths of Caracalla (FIGS. 7-74 and 7-75), and the Piazza Armerina (FIG. 7-84). How did the building techniques used by each determine the types of spaces that could be constructed?

5. How were both realistic and Greek idealizing characteristics incorporated in the Ara Pacis Augustae (FIGS. 7-31 to 7-33)? What was the purpose of the work? How did its iconography reflect that purpose?

6. Name three works commissioned by Augustus and describe their political implications.

7. How do the reliefs on the Column of Trajan (FIG. 7-49) differ from those on the Ara Pacis Augustae (FIGS. 7-32 and 7-33), the Arch of Titus (FIGS. 7-44 and 7-45) and the funerary relief of a circus official (FIG. 7-53)?

8. Discuss the development of Roman portraiture by comparing and contrasting the heads of a Republican Roman patrician (FIG. 7-5), Augustus (FIG. 7-29), Vespasian (FIG. 7-41), Caracalla (FIG. 7-72), Trajan Decius (FIG. 7-76), and Constantine (FIG. 7-88).

9. Analyze the stylistic differences between the reliefs from the Arch of Constantine (FIG. 7-87), the Arch of Titus (FIGS. 7-44 and 7-45), the Column of Antoninus Pius (FIGS. 7-64 and 7-65), and the Parthenon (FIGS. 5-54 to 5-56). In what ways do the style and the subject matter of these reliefs reflect the social, religious, and political concerns of the society for which each was made?

10. What do the differences between Diocletian's palace at Split (FIG. 7-82) and Hadrian's villa at Tivoli (FIG. 7-58) say about changes in the political situation between the second and fourth centuries?

SUMMARY OF ROMAN HISTORICAL AND CULTURAL BACKGROUND

Roman Republic: _____ B.C. to _____ B.C.
Early Empire: _____ B.C. to A.D. _____
High Empire: A.D. _____ to _____
Late Empire: A.D. _____ to _____

	Significant People	Political and Historical Events	Cultural Factors and Influences
Roman Republic			
Early Empire			
High Empire			
Late Empire			

SUMMARY OF ROMAN EMPERORS

Find dates for the following and put them in the correct order:

Julio-Claudians, Constantine, Flavians, Augustus, Diocletian, Trajan, Antonines, Severans.

SUMMARY OF ROMAN PAINTING

	Typical Examples	Stylistic Characteristics
First Style or _____ Style		
Second Style		
Third Style		
Fourth Style		

SUMMARY OF ROMAN ARCHITECTURE

	Typical Examples	Stylistic Characteristics
Roman Republic		
Early Empire		
High Empire		
Late Empire		

SUMMARY OF ROMAN SCULPTURE

	Typical Examples	Stylistic Characteristics
Roman Republic		
Early Empire		
High Empire		
Late Empire		

ETRUSCAN AND ROMAN WORLDS

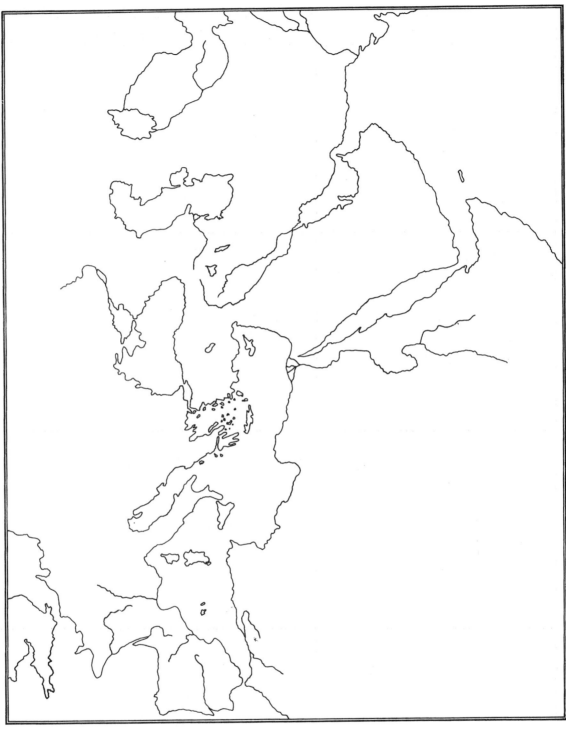

EARLY CHRISTIAN ART

TEXT PAGES 256–279

1. Define the following terms:

 ambulatory

 apse

 catacomb

 cathedra

 codex

 cubiculum (cubicula)

 loculus (loculi)

 mausoleum

 narthex

 nave

 parchment

 transept

 tufa

 vellum

2. List three features of the third-century frescoes of Dura-Europos that would come to dominate Byzantine art:

 a.

 b.

 c.

3. The Roman emperor _____ recognized Christianity in the year _____.

4. What was the importance of the catacombs for the Early Christians?

5. What is the primary distinction between Early Christian and Late Roman works of art?

6. What did the story of Jonah symbolize for Early Christians?

7. How was Christ most often represented prior to Constantine, during the periods of persecution under Trajan Decius and Diocletian?

 a. b.

 List three attributes he acquired after Christianity became the official state religion.

 a. b. c.

 From what source were these attributes taken?

 What was their purpose?

8. Why were large statues of Christ extremely rare in Early Christian art?

9. Two architectural sources for the Early Christan basilica of Old St. Peter's in Rome were

 a. b.

 How did Early Christian builders modify the plan of the Roman pagan basilica in order to convert it to Christian use?

10. Copy the plan of St. Peter's (FIG. 8-8) and label the following parts:

 atrium apse narthex
 nave transept

11. How does Santa Costanza (FIGS. 8-10 and 8-11) differ from basilican churches?

What may have been its original purpose?

12. In what ways, other than subject matter, can Early Christian mosaics be distinguished from earlier Roman examples?

a.

b.

What qualities of the mosaic medium made it the favorite of Early Christian and Byzantine artists?

13. Identify Sol Invictus and explain his appearance in Early Christian art.

14. List the imperial attributes assimilated by Christ that are illustrated in the mosaic from Santa Pudenziana in Rome (FIG. 8-14).

a. c.

b.

Which of the Four Evangelists is associated with each of the following symbolic creatures?

Winged man: Lion:

Ox: Eagle:

15. What Roman illusionistic elements were retained in the Early Christian mosaic portraying the parting of Lot and Abraham (FIG. 8-15)?

What new formal elements that point toward later medieval art appear in this mosaic?

What was their purpose?

16. When did Rome fall to Alaric?

17. Ravenna became the capital of the Western Empire in the _____ century.

18. Who was Galla Placidia?

 Who was Theodoric?

19. What type of plan was used in the mausoleum of Galla Placidia (FIGS. 8-16 and 8-17)?

20. List two remnants of Roman illusionism that can be found in the mosaic of Christ as the Good Shepherd in the mausoleum of Galla Placidia (FIG. 8-18).

 a.

 b.

21. The three-aisled basilica erected in Ravenna by Theodoric in the sixth century is now known as

 _____.

22. Name two features of the mosaics in the Church of St. George at Thessaloniki that will become standard for Byzantine art:

 a.

 b.

23. What is the significance of the so-called "Nicomachi-Symmachi" diptych?

24. In what ways does the ivory carving of St. Michael the Archangel (FIG. 8-23) reflect classical prototypes?

What new compositional devices are used?

What is the meaning of the globe surmounted by the cross?

25. List four departures from the classical tradition that are apparent in the diptych of Anastasius I that was carved in 517 (FIG. 8-24).

a.

b.

c.

d.

26. The style of the *Vatican Vergil* (FIG. 8-25) is reminiscent of that used in _____, while the repetition of figures in the *Vienna Genesis* (FIG. 8-26) is closer to the technique used in _____.

DISCUSSION QUESTIONS

1. Compare the basilica of Old St. Peter's (FIG. 8-8) with the reconstruction of the Aula Palatina (FIGS. 7-91 and 7-92). What similarities and what differences do you see in the plans, elevations, and building materials used? How did the purposes of the varying parts of the two buildings differ? How was the more "spiritual" purpose of the Early Christian building reflected in the structure?

2. What is meant by the "denaturing" of art during the Late Roman and Early Medieval periods?

3. Compare the ivory carving of St. Michael the Archangel (FIG. 8-23) with the Diptych of Anastasius (FIG. 8-24); note the features of each that reflect the classical naturalistic tradition and those that look forward to the style of the Middle Ages.

4. Compare the illumination from the *Vatican Vergil* (FIG. 8-25) with the Roman *Odyssey* landscape fresco (FIG. 7-20) and the scene from the *Rossano Gospels* (FIG. 8-27). How are perspective, illusionism, modeling with light and shade, and naturalism handled in each?

SUMMARY OF EARLY CHRISTIAN ART TEXT PAGES 256–279

Using the timeline at the beginning of Chapter 8, enter the appropriate dates for the following periods. Fill in the charts as much as possible from memory; then check your answers against the text and complete the charts.

Pre-Constantinian: _____ to _____
Constantinian: _____ to _____
Post-Constantinian: _____ to _____
Fall of Rome to the Visigoths: _____ to _____

	Typical Examples	Stylistic Chararcteristics	Significant Historical People, Events, Ideas, etc.
Catacombs			
Architecture			
Mosaics & Paintings			
Illuminated Manuscripts			
Luxury Arts & Sculpture			

SELF-QUIZ

PART I: THE ANCIENT WORLD

I. Matching. Choose the culture or period in the right column that best corresponds to the monument or site in the left column and enter the appropriate letter in the space provided.

_____ 1. Stele with law code of Hammurabi

_____ 2. Colosseum

_____ 3. Basilica of Old St. Peter's

_____ 4. Lascaux

_____ 5. Palaces of Xerxes and Darius at Persepolis

_____ 6. Palace at Knossos

_____ 7. "Treasury of Atreus"

_____ 8. Erechtheion

_____ 9. Insula at Ostia

_____ 10. Temple of Hera I at Paestum

_____ 11. Stonehenge

_____ 12. Tell el-Amarna

_____ 13. Baths of Caracalla

_____ 14. Mortuary Temple of Hatshepsut

_____ 15. *Standard of Ur*

_____ 16. Pyramid of Khafre

_____ 17. Tombs at Cerveteri

_____ 18. Parthenon

_____ 19. Ziggurat at Ur

_____ 20. *Capitoline Wolf*

_____ 21. Fortifications at Tiryns

_____ 22. Temple of Amen-Re, Karnak

_____ 23. Rock-cut tombs of Beni Hasan

_____ 24. Pantheon

_____ 25. Town plan of Priene

_____ 26. Altar of Zeus at Pergamon

_____ 27. Ishtar Gate

_____ 28. Dipylon cemetery

_____ 29. Victory stele of Naram-Sin

_____ 30. *Harvesters Vase*

a. Paleolithic

b. Neolithic

c. Egyptian, Old Kingdom

d. Egyptian, Middle Kingdom

e. Egyptian, New Kingdom

f. Sumerian

g. Assyrian

h. Neo-Babylonian

i. Achaemenid Persian

j. Akkadian

k. Minoan

l. Mycenaean

m. Greek Geometric

n. Greek Archaic

o. Greek Early and High Classical

p. Greek Hellenistic

q. Etruscan

r. Roman

s. Early Christian

II. **Matching.** Choose the name in the right column that best corresponds to the art work in the left column (artist matched to work, patron matched to work, etc.) and enter the appropriate letter in the space provided.

_____ 31. Ara Pacis Augustae	a. Praxiteles
_____ 32. Stepped Pyramid of King Zoser	b. Constantine
_____ 33. Statue of Hermes and the infant Dionysos	c. Lysippos
_____ 34. Attic black-figure amphora of Ajax and Achilles playing a game	d. Iktinos and Kallikrates
	e. Polykleitos
_____ 35. Bronze equestrian statue from the Capitoline Hill	f. Marcus Aurelius
_____ 36. Colosseum	g. Darius
_____ 37. Diskobolos	h. Imhotep
_____ 38. Sculpture from Parthenon	i. Vespasian
_____ 39. Domus Aurea	j. Trajan
_____ 40. Amarna style	k. Severus and Celer
_____ 41. *Doryphorus*	l. Exekias
_____ 42. Palace at Persepolis	m. Myron
_____ 43. Column with narrative reliefs	n. Augustus
_____ 44. Fourth-century basilica in Rome	o. Phidias
_____ 45. Palace at Spalatum (Split)	p. Hadrian
_____ 46. Ficoroni Cista	q. Akhenaton
_____ 47. Temple at Abu Simbel	r. Ashurnasirpal II
_____ 48. Mausoleum in the shape of a cross	s. Theodoric
_____ 49. Sant'Apollinare Nuovo	t. Galla Placidia
_____ 50. *Apoxyomenos*	u. Mnesikles
_____ 51. Pantheon	v. Diocletian
_____ 52. Parthenon	w. Novios Plautios
_____ 53. Propylaia	x. Ramses II
_____ 54. Citadel at Khorsabad	y. Sargon II
_____ 55. Reliefs from Nimrud	

III. **Multiple Choice.** Circle the most appropriate answer.

56. Mycenae and Troy were excavated by a. Woolley b. Champollion c. Evans d. Akhenaton e. Schliemann

57. Figurines of priestesses or goddesses holding snakes would most likely be found in a. Nimrud b. Knossos c. Mycenae d. Khorsabad e. Deir el-Bahri

58. The Ishtar Gate was built under a. Ashurbanipal b. Sargon c. Nebuchadnezzar d. Akhenaton e. Hammurabi

59. The Persians took over the use of large, winged bull-man guardian figures from the a. Sumerians b. Minoans c. Greeks d. Egyptians e. Assyrians

60. The Mycenaean civilization went into a marked decline either because of internal warfare or invasions from the north about a. 1500 B.C. b. 1200 B.C. c. 1000 B.C. d. 800 B.C. e. 600 B.C.

61. Ka figures—images of the deceased and others—were important in the art of a. Egypt b. Paleolithic Europe c. Archaic Greece d. Sumer e. Crete

62. Statuettes from the Abu Temple at Tell Asmar date from a. the Babylonian period under Hammurabi b. the Early Dynastic period of Sumerian domination c. the Assyrian Empire d. the Neo-Babylonian period e. the Persian Empire

63. Mastaba was the name applied to a. a Mesopotamian ziggurat b. a type of Old Kingdom Egyptian tomb c. a megalithic tomb d. an Egyptian grave statue that served as a home for the soul e. a tomb shaped like the "Treasury of Atreus"

64. A megalithic stone circle was erected at a. Knossos b. Saqqara c. Khorsabad d. Ur e. Stonehenge

65. A Neolithic skull modeled in plaster to form the features of the deceased was found at a. Lascaux b. Memphis c. Çatal Hüyük d. Jericho e. Nimrud

66. An important Paleolithic site is a. Lascaux b. Nineveh c. Çatal Hüyük d. Persepolis e. Abu Simbel

67. A "palace-style" vase would most likely be found a. in the Royal Cemetery at Ur b. at Amarna c. in a ziggurat d. in an Egyptian tomb e. on the island of Crete

68. A Mycenaean architectural feature that is thought to have formed the basis for the structural plan of later Greek temples is the a. pylon b. megaron c. tholos d. atrium e. echinus

69. A Greek temple with a single row of columns around the exterior is known as a. a temple *in antis* b. a prostyle temple c. an amphiprostyle temple d. a peripteral temple e. a dipteral temple

70. During the Pre-Constantinian period and the early years of the Constantinian period, Christ was most often represented a. as Ruler of the World b. with a halo c. as the Good Shepherd d. on the cross e. as an infant

71. The Propylaia was a. a Roman temple b. an Etruscan fortification c. the entrance gate to the Acropolis d. part of the Forum of Trajan e. the palace of Nero

72. A relief showing the spoils from the Temple in Jerusalem is carved on the Arch of a. Constantine b. Titus c. Septimius Severus d. Trajan e. Diocletian

73. Pompeiian wall paintings of the Second Style were characterized by a. fantastic architecture based on the theater b. mere copies of inlaid stone material c. the wall seemingly opening out into an illusionistic space d. the wall divided into various sections, some sections being painted decoratively and others containing what seem to be panel paintings hung on the wall e. bas-relief panels

74. The courtyard in front of Old St. Peter's was called the a. atrium b. narthex c. nave d. bema e. pendentive

75. The subterranean burial grounds of the Early Christians were called a. megarons b. entablatures c. catacombs d. basilicas e. mandorlas

76. One of the favorite subjects of Greek Archaic sculptors was the standing, nude male figure that was called a a. kori b. tholos c. kylix d. kouros e. ka

77. The triangular section on top of a Greek temple is called the a. pediment b. echinus c. cornice d. stylobate e. acroterion

78. An amphiprostyle temple is characterized by a. a row of columns all around the exterior b. two columns in front plus pilasters formed by the extension of the side walls c. a row of columns across the front and back d. a double row of columns around the exterior

79. The *Aphrodite of Knidos* was carved by a. Phidias b. Praxiteles c. Lysippos d. Polykleitos e. Polydoros

80. The plan of Old St. Peter's in Rome was based on a. a Roman basilica or audience hall b. a hypostyle hall c. a Greek cross with barrel vaults d. a flat-roofed nave with two aisles e. a latin-cross plan with rib vaults

IV. Chronology Exercise. Put the letters corresponding to specific art works into the box under the appropriate date range. Fill in as many as you can without looking at the text. Then check the text for the remaining images.

81. 25,000–10,000 B.C.

82. 8,000–3,000 B.C.

83. 2,999–2,000 B.C.

84. 1,999–1,000 B.C.

85. 799–600 B.C.

86. 575–500 B.C.

87. 499–400 B.C.

88. 399–300 B.C.

89. 299–1 B.C.

90. A.D. 1–199

91. A.D. 200–299

92. A.D. 300-399

93. A.D. 400–699

A. Toreador Fresco, Knossos
B. Lion Gate, Mycenae
C. Column of Trajan, Rome
D. Kouros from Attica
E. Frescoes from Lascaux
F. Stele of Hammurabi
G. Queen Nefertiti
H. Cycladic idol
I. Laocoön
J. Pyramid of Khafre
K. Dying Gaul
L. Santa Costanza, Rome
M. "Treasury of Atreus," Mycenae
N. Stonehenge
O. *Harvesters Vase*
P. Villa of the Mysteries, Pompeii
Q. Standard of Ur
R. Catacomb of Callixtus
S. Temple of Zeus, Olympia
T. Temple of Athena Nike
U. Theater of Epidauros
V. Domus Aurea, Rome
W. Palace of Sargon II, Khorsabad
X. Ishtar Gate, Babylon
Y. Temple of Horus, Edfu
Z. Parthenon
AA. Pyramid of Zoser, Saqqara
BB. Shrine from Çatal Hüyük
CC. Mausoleum of Galla Placidia, Ravenna
DD. Coffin of Tutankhamen
EE. Praxiteles: Hermes and Dionysos
FF. Old St. Peter's, Rome
GG. Arch of Constantine, Rome
HH. Aula Palatina, Trier
II. Palace of Diocletian, Spalatum (Split)
JJ. Pantheon, Rome
KK. Aphrodite from Melos (*Venus de Milo*)
LL. Palace of Knossos
MM. Palace of Darius, Persepolis
NN. Colosseum, Rome
OO. Stele of Naram-Sin
PP. Polykleitos: *Doryphoros*
QQ. Temple of Apollo at Didyma
RR. Ara Pacis Augustae, Rome
SS. Apollo of Veii
TT. Charioteer of Delphi
UU. Tomb of the Leopards, Tarquinia
VV. Nike of Samothrace
WW. Ergotimos and Kleitos: *François Vase*
XX. Baths of Caracalla
YY. Niobid Painter
ZZ. Temple of Ramses II, Abu Simbel

V. Identification.

94. Compare the following reliefs, attributing each to a culture and providing an approximate date. Give the reasons for your attributions, citing stylistic characteristics of similar works you have studied.

A.

Culture: _____

Date: _____

B.

Culture: _____

Date: _____

Reasons:

95. What group built the building illustrated below? Approximately when was it erected? Give the reasons for your attributions, citing stylistic characteristics.

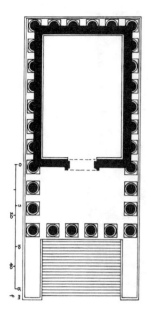

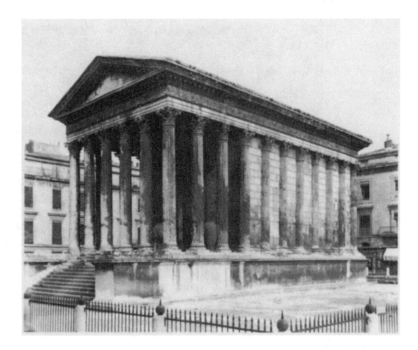

Culture: _____

Date: _____

Reasons:

96. Compare the following heads, attributing each to a culture and providing an approximate date. Give the reasons for your attributions.

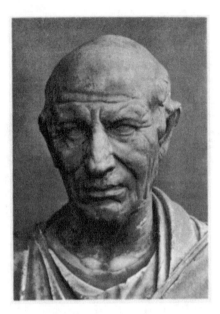

A. Culture: _____

 Date: _____

B. Culture: _____

 Date: _____

Reasons:

97. Attribute the following relief to a culture, period, and approximate date. Give the reasons for your attributions. What do you think this relief symbolizes?

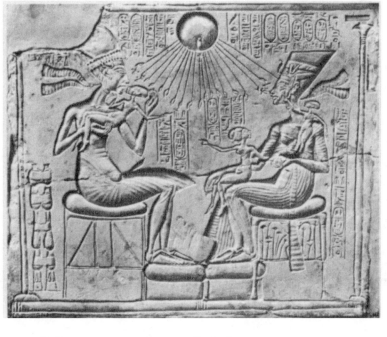

Culture: _____ Period: _____

Approximate date: _____

Reasons:

98. Compare the two works below, attributing each to a culture and providing an approximate date. Give the reasons for your attributions.

A. Culture: _____ Date: _____ B. Culture: _____ Date: _____

Reasons:

Part Two

THE MIDDLE AGES

CHAPTER 9

BYZANTINE ART

TEXT PAGES 284–317

1. Define the following terms:

 Anastasis

 aniconic

 conch

 cupola

 Eucharist

 hieratic

 icon

 iconostasis

 impost block

 mandorla

 Pantocrator

 paten

 pendentive

 refectory

 squinch

2. What city functioned as the center for the Byzantine empire?

 It was founded in _____ and it fell in _____.

3. What Arian belief did orthodox Christians consider to be heretical?

4. Who in the Byzantine world was considered to be Christ's vicar on earth?

 How did this belief affect the political and religious structure of the Eastern Empire?

5. Who were Justinian and Theodora?

6. Give the following information about the Church of Hagia Sophia in Constantinople:

 Meaning of its name:

 Patron:

 Architects:

 Construction material:

 Brief description of plan and structure:

 Main architectural features:

 How dome support differed from earlier domed buildings:

 Principal light source:

 Decoration of the dome:

 Part of the church reserved for the clergy:

 Part of the church reserved for members of the congregation:

Who could enter the sanctuary:

7. According to the mystic philosophy of Pseudo-Dionysius, what did light symbolize?

8. Briefly describe the plan and structure of San Vitale at Ravenna.

 What was the function of the gallery?

9. What is the subject of the mosaics of Justinian and Theodora (FIGS. 9–9 and 9–10) in the apse of San Vitale?

 What does Justinian's halo signify?

 What explanation is given for the curious overlapping of Justinian and Maximianus?

10. Explain the meaning of the following symbols from the apse mosaic of Sant'Apollinare in Classe (FIG. 9-13):

 Jeweled cross

 Three sheep below the cross

 Twelve sheep

 Compare the mosaic with that from the mausoleum of Galla Placidia (FIG. 8-18) and describe the stylistic changes that have occurred.

11. Who built the fortress monastery of St. Catherine on Mt. Sinai? When?

What is the subject of the apse mosaic (FIG. 9-14)?

List three stylistic features of the mosaic.

a.

b.

c.

12. What was the significance of icons in Byzantine worship?

13. What were the dates of the period of Iconoclasm?

What was its effect on the visual arts?

14. Describe the style of the murals of Santa Maria de Castelseprio (FIG. 9-16).

When are they thought to have been painted?

15. What earlier style was revived in the so-called *Paris Psalter* (FIG. 9-17)?

List three features that illustrate this derivation:

a.

b.

c.

and one that does not:

a.

16. The style of carving of the *Veroli Casket* (FIG. 9-18) shows the influence of _____.
It dates from the _____ century.

17. List three characteristics typical of Late Byzantine churches.

 a.

 b.

 c.

18. How does a squinch differ from a pendentive?

19. Describe two features that identify St. Mark's in Venice as a Byzantine building.

 a.

 b.

20. Religious architecture of "holy" Russia was most strongly influenced by the architecture of _____.

 What feature of late medieval Russian churches is most distinctly Russian?

21. The range of style during the Middle Byzantine Period is seen in a comparison of the mosaics of Daphne (FIG. 9-28) and the frescoes of Nerezi (FIG. 9-29). Briefly describe the style of each.

 Daphne:

 Nerezi:

22. What subject is represented in the mosaic of the west vault of St. Mark's in Venice (FIG. 9-30)?

 Briefly characterize the style of the mosaics of St. Mark's:

23. Byzantine influence is apparent in the mosaics of the Norman kings at _____ in _____ .

 The plan of the church is _____.

 The subject of the apse mosaic is _____.

24. What Byzantine characteristics are apparent in the icon called *The Vladimir Madonna* (FIG. 9-32)?

 a.

 b.

 c.

25. What is the theme of the fresco from the side chapel of the Mosque of the Káriye in Istanbul (FIG. 9-35)?

DISCUSSION QUESTIONS

1. Discuss the development of pictorial form from Roman illusionism to Byzantine pattern, noting the changes that you see in the treatment of the spatial setting and the solidity of the human body. Consider the mosaics from the Boscoreale cubiculum (FIG. 7-19), the *Allegory of Africa* (FIG. 7-85), *Christ Enthroned in Majesty, with Saints* (FIG. 8-14), *The Parting of Lot and Abraham* (FIG. 8-15), *Saint Onesiphorus and Saint Porphyrius* (FIG. 8-21), *Christ as the Good Shepherd* (FIG. 8-18), *The Miracle of the Loaves and the Fishes* (FIG. 8-20), *Justinian* (FIG. 9-9), and the apse mosaic of Sant'Apollinare in Classe (FIG. 9-13).

2. The apse mosaics of San Vitale have been said to embody the Byzantine ideal of "sacred kingship." What iconographic features of the mosaics illustrate this concept?

3. Select a Byzantine mosaic or painting from the Early, Middle, and Late periods. What features do they have in common that makes them Byzantine?

4. Discuss the development of Byzantine architecture considering *Hagia Sophia* (FIGS. 9-1 and 9-2), *Hosias Loukas* (FIGS. 9-20 and 9-21), *San Marco* in Venice (FIGS. 9-24 to 9-26), and the *Cathedral of the Annunciation* in Moscow (FIG. 9-34). In what way are these buildings related to each other and in what ways is each different?

5. Compare the scenes from the *Paris Psalter* (FIG. 9-17) and Rublev's *Old Testament Trinity* (FIG. 9-37) with the classical painting of the *Odyssey Landscapes* (FIG. 7-20). What similarities and differences do you see? Note the way space is depicted and the way the figures are modeled. What features of the *Paris Psalter* show the influence of classical painting?

Using the timeline at the beginning of Chapter 9 in the text, enter the appropriate dates for the following periods. Fill in the chart as much as you can from memory; then check your answers against the text and complete the chart.

SUMMARY OF BYZANTINE ART

Chronology:

Early Byzantine:	_____ to _____	
Iconoclasm to Restoration of Images:	_____ to _____	
Middle Byzantine:	_____ to _____	
Late Byzantine:	_____ to _____	

	Typical Examples	Stylistic Characteristics	Significant Historical People, Events, Ideas, etc.
Architecture at Ravenna			
Mosaics at Ravenna			
Early Byzantine Architecture			
Middle Byzantine Architecture			
Late Byzantine Architecture			
Later Mosaics			

SUMMARY OF BYZANTINE ART (continued)

	Typical Examples	Stylistic Characteristics	Significant Historical People, Events, Ideas, etc.
Panel and Wall			
Manuscripts			
Carved Ornaments			

CHAPTER 10

ISLAMIC ART

TEXT PAGES 318–343

1. Define the following terms:

 caliph

 calligraphy

 Hejira

 imam

 Islam

 jihad

 Koran (Qur'an)

 mihrab

 minbar

 minaret

 muezzin

 qibla

2. Who was Muhammad?

3. List five countries conquered by Muslim soldiers in the seventh century.

 a. c. e.

 b. d.

4. Islamic power in Spain continued from the _____ century until _____ when Granada fell to Ferdinand and Isabella. In spite of continued pressure, Constantinople did not fall to Muslim pressure until _____.

5. Point out two basic differences between the Islamic and Christian faiths.

 a.

 b.

6. Where and when did the following Islamic dynasties rule?

 Umayyads

 Abbasids

 Fatimids

7. List four features of the Great Mosque at Damascus that show the influence of the Greco-Roman world.

 a.

 b.

 c.

 d.

8. Why are there no human or animal forms in the mosaics of the Great Mosque at Damascus?

9. The enclosure of the Great Mosque at Qairawan measures approximately _____ by _____ meters.

 What Persian feature is seen in its architecture?

10. Briefly describe the early Islamic hypostyle system of construction.

11. What shape were the arches used in the hypostyle mosque at Córdoba?

12. Islamic ornament is characterized by

 a.

 b.

 c.

 d.

13. What seems to have been the purpose and function of the early Muslim palaces?

14. Why were stucco reliefs popular with Islamic builders?

 Some of the very richest examples of stucco decoration are found in the _____ ;
 they date from the _____ century.

15. What is a *madrasa?*

 How does the madrasa of Sultan Hasan in Cairo differ architecturally from a hypostyle mosque?

16. The most famous of all Islamic mausoleums is the _____ at _____
 which was built in the _____ century.

17. Who were the Ottoman Turks?

What new type of mosque did they develop? How did it differ from the hypostyle mosques favored in other Islamic countries?

18. Who was Sinan the Great?

19. What is important about the structure of the Selimiye Cami (FIGS. 10-24 to 10-26)?

20. List six of the so-called "dependencies" that were often connected to important mosques like the Selimiye Cami.

a. d.

b. e.

c. f.

21. Why were textiles so highly valued in the Islamic world?

22. List three types of objects that were often decorated with calligraphy:

a.

b.

c.

23. Why were monumental sculpture, mural painting, and panel painting so rare in early Islamic art?

24. The earliest Islamic illuminated manuscripts are dated about _____.

 Many of the finest manuscripts were created for the rulers of _____.

 What orthodox Islamic restriction apparently did not affect the illustration of secular books?

25. List three stylistic characteristics of Islamic illustration as seen in FIG. 10-31.

 a.

 b.

 c.

40. Locate the following on the map on Study Guide page 114:

Baghdad	Jerusalem
Córdoba	Mecca
Damascus	Mshatta
Granada	

 Using a pencil or pen, indicate on the map the areas under Muslim control by the ninth century.

DISCUSSION QUESTIONS

1. Study the reproductions of the following buildings: San Vitale (FIGS. 9-4 to 9-6), Hagia Sophia (FIGS. 9-1 to 9-3), the Mosque at Córdoba (FIGS. 10-7 to 10-11), the Selimiye Cami (FIGS. 10-24 to 10-26), the Church of the Katholikon (FIGS. 9-21, 9-23), and the Pantheon (FIGS. 7-55 to 7-57). Compare the lighting effects created by each and describe the means used to achieve such effects.

2. Compare the interplay of architectural mass and decoration found in the mausoleum of Sultan Hasan (FIGS. 10-20 to 10-22) with the Taj Mahal (FIG. 10-23).

3. Compare the treatment of volume and space in the illumination of *Laila and Majnun* (FIG. 10-31) with that in the *Paris Psalter* (FIG. 9-17). In what ways does the Persian miniature differ from the Byzantine one? What factors might account for the differences?

4. After having read the chapter, do you feel that the essential qualities of Islamic art distinguish it from or relate it to Western art? How?

Using the timeline at the beginning of Chapter 10 in the text, enter the appropriate dates for the following periods. Fill in the chart as much as you can from memory; then check your answers against the text and complete the chart.

SUMMARY OF ISLAMIC ART

Chronology:

Foundation and Expansion of Islam: _____ to _____
Conquest of Iraq, Syria, Egypt, and Persia: _____ to _____
Conquest of Spain: _____
Battle of Poitiers: _____
Conquest of Constantinople: _____
Fall of Granada: _____

	Typical Examples	Stylistic Characteristics	Significant Historical People, Events, Ideas, etc.
Architecture			
Architectural			
Book Illustration			
Object Art			

CHAPTER 11

EARLY MEDIEVAL ART IN THE WEST

TEXT PAGES 344–377

1. According to the map on page 344 of the text, to what areas did each of the following barbarian tribes migrate?

 Saxons Vandals
 Franks Burgundians
 Avars Lombards
 Ostrogoths Visigoths

2. Identify the following:

 Alcuin of York

 Attila

 Charlemagne

 liege-lord

 Master Wolvinius

 Normans

 Otto III

 serf

 St. Benedict of Nursia

 vassal

 Vikings

3. Define the following terms:

 bay

 cloisonné

 fibula

 interlace

 manuscript illumination

105

module

pier

prototype

stave church

westwork

zoomorphic

4. In what century did the Huns invade Europe?

5. Briefly describe the political and economic system known as feudalism.

6. What art form was the province of medieval women?

7. Name the only major institution to survive the fall of the Western Roman Empire.

8. The claim of temporal power brought the papacy into conflict with _____.

9. What was the importance of St. Benedict's rule for monastic establishments?

10. It has been said that medieval society was divided into three groups: "those who fight, those who pray, and those who work." What does this mean?

11. What were considered to be the major virtues during the Early Middle Ages?

12. Who were the Scythians, and how were they important to the development of the animal style?

13. Briefly describe the style of the decoration of early Germanic fibulae (FIG. 11-2).

14. What was found at Sutton Hoo, and what was its importance?

15. What do the authors believe was the major art form of the Early Middle Ages?

16. Name three artistic traditions that are reflected in the *Franks Casket* (FIG. 11-4).

 a.

 b.

 c.

17. The Celts of Ireland were converted to Christianity in the _____ century.

 What two factors best account for the independent development of their art?

 a.

 b.

18. What is meant by Hiberno-Saxon?

 Describe the features of the Hiberno-Saxon style that are found in the Tara Brooch (FIG. 11-6).

19. List three characteristics of the style utilized on the ornamental page from the *Book of Lindisfarne* (FIG. 11-7).

 a.

 b.

 c.

20. In comparison with the illumination of Hiberno-Saxon manuscripts, those produced by the monastic orders that accepted Roman orthodoxy are apt to be characterized by:

21. Why did medieval manuscript illuminators copy earlier examples rather than working directly from nature?

22. Where were Celtic high crosses originally placed?

 Draw a Celtic cross in the margin of this page.

 List three sources for their figural style.

 a.

 b.

 c.

23. Describe the style of the decoration on the Viking ship found near Oseberg, Norway (FIGS. 11-11 and 11-12).

24. When was Charlemagne crowned as head of the Holy Roman Empire?

 Where was his capital city?

 List two works commissioned by Charlemagne.

 a. b.

 Describe one important result of Charlemagne's project to retrieve the true text of the Bible.

25. List three ways in which the artist of the *Gospel Book of Archbishop Ebbo of Reims* (FIG. 11-15) has modified the style found in the *Gospel Book of Charlemagne* (FIG. 11-14).

 a.

 b.

 c.

26. Name a manuscript whose style is related to that of the *Utrecht Psalter* (FIG. 11-16).

 A related style is seen in the metalwork on the cover of the _____.

27. What was the function of the *Paliotto* at Sant'Ambrogio in Milan?

 Who was its designer?

28. What was the major art form of the Avars?

29. The Palatine Chapel of Charlemagne resembles the church of _____ in Ravenna, but is distinguished by:

 a.

 b.

30. What was the function of the *Torhalle* of Lorsch?

 On what was its form based?

31. Although the church of the monastery of St. Gall is a three-aisled basilica, it differs from its Early Christian prototypes in the following ways:

 a.

 b.

 c.

32. What feature found at St. Riquier, but not at St. Gall, was common to most Carolingian churches?

33. How did the Ottonian period derive its name?

 Its geographical center was the modern country of _____.

34. A major Ottonian building is the Abbey church of _____.

 It retains the following Carolingian features:

 a.

 b.

35. Describe the alternate-support system.

 What was its function?

 Why did it appeal to northern builders?

36. Who was Bishop Bernward?

37. The style of the figures on the bronze doors at St. Michael's at Hildesheim (FIG. 11-29) probably derives from manuscript illumination of the period. In what major way does it differ from its prototypes?

38. What two stylistic features seen in the *Lectionary of Henry II* (FIG. 11-31) were not apparent in earlier Carolingian illumination?

 a.

 b.

39. Locate the following on the map on Study Guide page 114:

Lindisfarne	Hildesheim
Sutton Hoo	Centula
St. Gall	Tours
Aachen	Reichenau
Oseberg	Lorsch
Milan	

DISCUSSION QUESTIONS

1. What factors do the authors believe inclined the Germanic tribes to adopt the animal style? What was its origin? By what means was it transmitted to them?

2. Compare the abstract decorative art of the Early Middle Ages in Europe as seen in the ornamental page from the *Book of Lindisfarne* (FIG. 11-7) with the Islamic decorative style as seen in the Ardebil Carpet (FIG. 10-27). In what ways do they resemble each other? What is distinctive about each?

3. Discuss the importance of Charlemagne's role in the history of art.

4. In what ways can the plan of St. Gall (FIG. 11-24) and the church of St. Michael's at Hildesheim (FIG. 11-27) be related to the Germanic sense of design, as manifested in Frankish ornaments (FIG. 11-2), and to the medieval way of thinking? What importance do these buildings have for the development of Romanesque architecture in northern Europe?

5. Discuss the historical and political factors represented by the image of the enthroned Otto III from his gospel book (FIG. 11-32). In what ways is this image related to the changing political and religious situation in Western Europe?

6. Compare the style and the technique used to create the *Paliotto* at Sant'Ambrogio in Milan (FIG. 11-19) with those of the doors of St. Michael's at Hildesheim (FIG. 11-29). What might have been the stylistic sources for each?

Using the timeline at the beginning of Chapter 11 in the text, enter the appropriate dates for the following periods. Fill in the chart as much as you can from memory; then check your answers against the text and complete the chart.

SUMMARY OF EARLY MEDIEVAL ART IN THE WEST

Migration Period and Germanic Kingdoms: _____ to _____
Carolingian Period: _____ to _____
Ottonian Period: _____ to _____

	Typical Examples	Stylistic Characteristics	Significant Historical People, Events, and Ideas etc.
Animal Style			
Germanic Art			
Early Manuscripts			
Carolingian Painting and Illumination			

SUMMARY OF EARLY MEDIEVAL ART IN THE WEST (continued)

	Typical Examples	Stylistic Characteristics	Significant Historical People, Events, and Ideas etc.
Ottonian Painting			
Carolingian Architecture			
Ottonian Architecture			

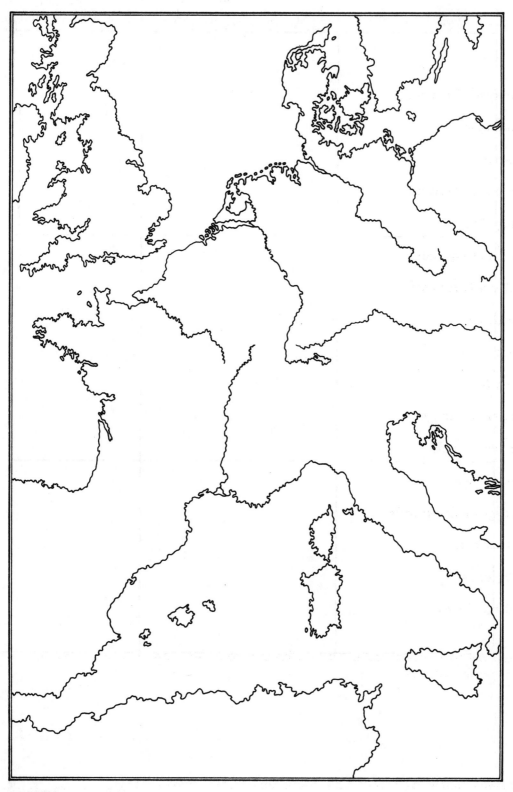

EUROPE

CHAPTER 12

ROMANESQUE ART

TEXT PAGES 378–413

1. Identify the following:

 Apocalypse

 Averroës

 Bernard of Clairvaux

 Bishop Odo

 Eleanor of Aquitaine

 Frederick Barbarossa

 Gislebertus

 Gregory VII

 Henry II

 Hildegard of Bingen

 Knights Templar

 Master Hugo

 Santiago de Compostela

 Scholasticism

 Wiligelmus

 William of Sens

2. Briefly describe the relationship between the growing towns and the feudal barons during the eleventh and twelfth centuries.

3. Two important monastic orders during the Romanesque period were the _____ and the _____.

4. Two effects of the Crusades were:

 a.

 b.

5. Define the following architectural terms:

 buttress

 chancel

 chateau fort

 choir

 compound pier

 corbel table

 crossing

 diaphragm arch

 groin vault

 incrustation

 pilaster

 radiating chapel

 rib vault

 sexpartite vault

 square schematism

 tribune

 tunnel vault

6. List five characteristics of Romanesque architecture:

 a.

 b.

 c.

 d.

 e.

7. What common experience made the use of stone vaults so important to Romanesque builders?

8. What advantage did stone vaults have over wooden roofs?

9. List four types of vaults used at St.-Philibert in Tournus.

 a. c.

 b. d.

 What was the advantage of the transverse barrel vaults used at St.-Philibert?

10. List three features of Romanesque pilgrimage churches seen in the church of St.-Sernin at Toulouse.

 a.

 b.

 c.

11. Why were so many Romanesque churches of such great size, even though they were frequently located in isolated places?

12. What was the purpose of the ambulatory with radiating chapels found in so many Romanesque churches?

13. The main drawback of barrel vaulting was

14. Label the following parts of the plan below: ambulatory, apse, bay, buttress, crossing, nave, transept, radiating chapel, aisles, choir.

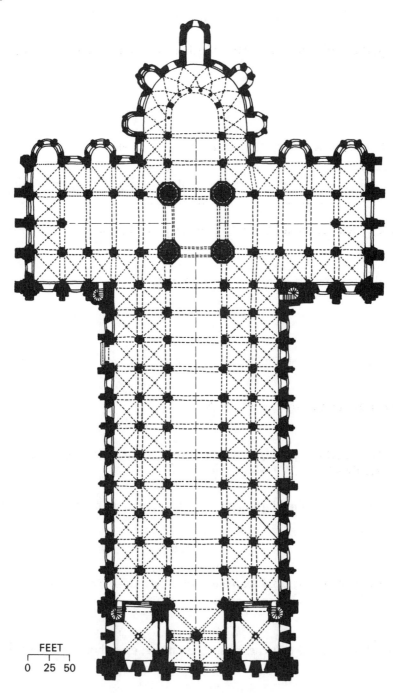

FEET
0 25 50

15. Name the two areas that demonstrate the greatest development of masonry vaulting during the Romanesque period.

 a. b.

16. It is generally thought that the German cathedral of _____ is one of the earliest fully vaulted Romanesque churches in Europe.

17. What dates are considered to be most probable for the construction of Sant'Ambrogio, Milan?

18. How do the proportions of height to width of Italian medieval churches compare to those of German churches?

19. The "master model of Norman Romanesque architecture" is the church of _____ at _____.

 It was built between _____ and _____.

 List four progressive features of the building that look ahead to later Gothic architecture:

 a.

 b.

 c.

 d.

20. William of Normandy conquered England in the year _____.

21. Two key elements of Gothic architecture were combined for the first time in the vaults of Durham Cathedral. What are they?

 a.

 b.

22. List three features that Pisa Cathedral shares with its Early Christian prototypes.

 a.

 b.

 c.

 List four features that distinguish it from them.

 a.

 b.

 c.

 d.

23. List two Tuscan Romanesque buildings in Florence.

 a. b.

24. The prototype of the stone carving of *Christic in Majesty* from St.-Sernin at Toulouse (FIG. 12-23) most likely
 was _____.

25. Label the following parts of a Romanesque portal on the diagram below: lintel, tympanum, archivolts,
 voussoir, trumeau, jambs.

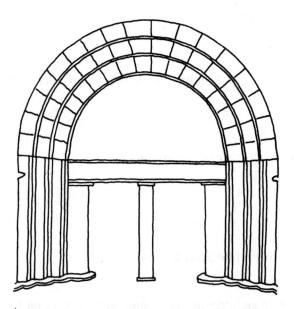

26. What subjects were carved on the facade of Modena Cathedral and how were they placed?

27. The subject carved on the tympanum at Moissac is _____.

 Typical Romanesque sculptural conventions seen in the figures of Moissac are

 a.

 b.

 c.

28. The subject of the west tympanum of St.-Lazare at Autun is:

29. The tympanum of the central portal of the narthex of La Madeleine at Vézelay shows:

 Why can it be said that the iconography of the tympanum of Vézelay was influenced by the Crusades?

30. List three characteristics that distinguish the style of the portal sculpture of St.-Trophîme at Arles from the styles of those at Vézelay and at Autun.

 a.

 b.

 c.

 To what influences can these differences be attributed?

31. What is depicted on the Bayeux tapestry?

 What technique was used to create it?

32. What stylistic features are shared by the fresco of *Christ in Majesty* from Santa Maria de Mur (FIG. 12-37) and the manuscripts from Saint-Omer (FIG.12-38) and Cîteaux (FIG. 12-39)?

 a.

 b.

 c.

33. How has the Romanesque style as seen in the Bury Bible (FIG. 12-40) been modified from earlier examples?

34. Describe the theme of Christ's Second Coming as illustrated in the tympanum at Moissac (FIG. 12-27) and in the Apocalypse of St.-Sever (FIG. 12-41).

What is the source of this imagery?

35. Locate the following on the map on Study Guide page 114:

Durham	Tournus	Speyer
Paris	Caen	Autun
Cluny	Vézelay	Moissac
Toulouse	Pisa	Florence
Arles	Bayeux	Modena

DISCUSSION QUESTIONS

1. What are the distinguishing features of the Romanesque style seen in the church of St.-Sernin at Toulouse (FIGS. 12-3 to 12-5) compared with the features of Old St. Peter's in Rome (FIG. 8-8)?

2. Describe the various evolutionary steps, in both plan and elevation, that led from the Carolingian to the Romanesque style in northern European churches.

3. What evidence do you see that the *Christ in Majesty* from St.-Sernin (FIG. 12-23) was derived from a metal prototype such as the scene from the cover of the *Codex Aureus of St. Emmeram* (FIG. 11-17)?

4. Compare the carvings from St.-Trophîme at Arles (FIG. 12-34) with the portal sculpture from Moissac (FIG. 12-27). What is the subject of each portal? How do they differ stylistically? Can you see any relationships to earlier medieval or classical styles?

5. What features indicate the common stylistic derivation of the fresco from Santa Maria de Mur (FIG. 12-37) and the apse mosaic from Monreale (FIG. 9-31)? What changes do you see?

6. What portents of change appear in the illumination depicting the scribe Eadwine from the *Canterbury Psalter* (FIG. 12-42)? Compare the treatment of the drapery and body of Eadwine with that in the illustrations from *The Life and Miracles of St. Audomarus* (FIG. 12-38).

7. Why do you think Bernard of Clairvaux was so disturbed by the sumptuous art of the churches? Do you agree with him?

Using the timeline at the beginning of Chapter 12 in the text, enter the appropriate dates for the following periods. Fill in the charts as much as you can from memory; then check your answers against the text and complete the charts.

SUMMARY OF ROMANESQUE ARCHITECTURE

Romanesque Period: _____ to _____

	Typical Examples	Stylistic Characteristics
Languedoc-Burgundy		
Germany-Lombardy		
Normandy-England		
Tuscany		

SUMMARY OF ROMANESQUE SCULPTURE AND PAINTING

	Typical Examples	Stylistic Characterisitics	Significant Historical People, Events, and Ideas, etc.
Sculpture			
Painting			
Manuscript Illumination			

124

CHAPTER 13

GOTHIC ART

TEXT PAGES 414–461

INTRODUCTION, EARLY GOTHIC, AND HIGH GOTHIC ART TEXT PAGES 416–445

1. Identify the following:

 Abbot Suger

 Albigensian crusade

 Bernard of Clairvaux

 Jean de Chelles

 Pope Innocent III

 Scholasticism

 St. Francis of Assisi

 St. Thomas Aquinas

 Vincent of Beauvais

2. What did a Gothic cathedral symbolize?

3. When and where did the Gothic style originate?

4. List some of the ways in which the social and economic structure of the Gothic period differed from that of the Romanesque.

5. Which country made the greatest progress toward a centralized state during the medieval period?

6. Which city could be considered as the intellectual center of Gothic Europe?

7. How did the songs sung by the thirteenth-century trouvères differ from the old *chansons de geste,* and what changes in the status of women did they reflect?

8. How was the new respect for women reflected in religious art and belief?

9. What was the primary historical importance of the Franciscan movement?

10. What building is considered to be the "cradle of Gothic art," and who was responsible for its construction?

11. List three of the features of the new choir at St.-Denis as described by Abbot Suger that are characteristic of the new Gothic style.

 a.

 b.

 c.

12. List the three structural and/or design features that characterize a Gothic vault.

 a.

 b.

 c.

 What are the advantages of the pointed arch over the round arch?

13. Describe the difference between medieval *scientia* and *ars*.

14. List three Romanesque features retained in Laon Cathedral.

 a.

 b.

 c.

 List three new Gothic features found in the cathedral.

 a.

 b.

 c.

15. Name the four parts of an Early Gothic elevation:

 a.

 b.

 c.

 d.

16. Describe the modification made in the nave elevation of Notre-Dame of Paris that changed it from Early to High Gothic.

 What was the purpose of the change?

17. The figures from the Royal Portal of Chartres Cathedral, the earliest and most complete surviving Early Gothic portals, were carved between _____ and _____.

 The following scenes are represented on the tympanum:

 Right: Left: Central:

The figures carved on the jambs represent:

In what ways do these jamb figures differ significantly from Romanesque figures?

a.

b.

c.

18. Define the following architectural terms:

chevet

triforium

rectangular-bay system

crossing spire

mullion

rayonnant style

19. What was the function of the flying buttress?

Why was it an essential element of the Gothic architectural vocabulary?

20. Label the following parts of a Gothic church on the diagram below: clerestory, flying buttress, nave arcade, triforium, vaults.

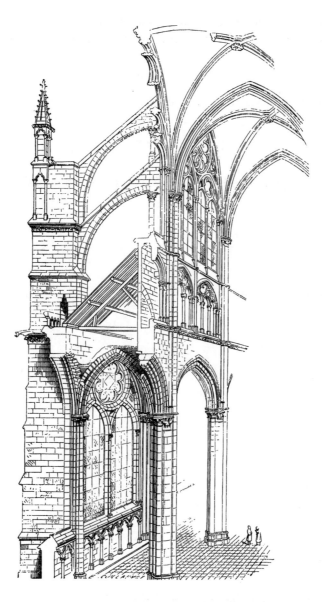

Is this an Early Gothic or High Gothic church?

21. Describe or draw the new bay structure of Chartres that was to become the norm for High Gothic buildings:

What spatial effect did this create?

22. What segment of an Early Gothic elevation was eliminated in High Gothic buildings?

What technical development made this possible?

23. How does the plan of Bourges Cathedral (FIG. 13-21) differ from that of Chartres (FIG. 13-17)?

Which design was more influential?

24. What are the similarities in the facades of Notre-Dame in Paris (FIG. 13-10) and Amiens Cathedral (FIG. 13-23)?

 a.

 b.

 What are the differences?

25. The rayonnant style developed in the second half of the _____ century and was associated with the court of _____.

26. What was the purpose of the Sainte-Chapelle in Paris?

How did its structure reflect that purpose?

27. Which of the great French cathedrals had the highest vaults? What happened to them?

28. Name a town whose defensive walls reflect the medieval concern for security:

29. What was the source of the iconographic programs of many of the great Gothic cathedrals?

30. How do the figures of *St. Martin, St. Jerome, and St. Gregory* from the Porch of the Confessors (FIG. 13-32) and the jamb figures from the Royal Portal of Chartres Cathedral (FIG. 13-15) illustrate the development of Gothic sculpture?

31. The jamb figures from the central portal of the west facade of Reims Cathedral are tied to the architecture by the following devices:

 a. b.

 The sculptor of the *Visitation* group was strongly influenced by the style of _____.

32. In what way did Hugh of St.-Victor liken stained-glass windows to the Holy Scriptures?

33. How did stained-glass windows change from the twelfth to the thirteenth century?

34. Who was Villard de Honnecourt?

 What did Villard use as the basis for drawing many of his figures?

35. What influences are seen in the illuminations of the *Psalter of St. Louis* (FIG. 13-38)?

 a.

 b.

 c.

DISCUSSION QUESTIONS

1. Discuss the change in the role of women during the Gothic period and how it relates to the cult of the Virgin Mary. What effect did these changes have on art?

2. What effect did the changing philosophical conception of the relation between the soul and the body have on Gothic sculpture?

3. Select a typical Early Gothic cathedral and a High Gothic cathedral and explain the factors that differentiate one from the other.

4. What are the major changes in medieval architectural sculpture in relation to its structural setting as seen in St.-Sernin at Toulouse (FIG. 12-23), St.-Pierre at Moissac (FIG. 12-27), the Royal Portal (FIG. 13-14) and Porch of the Confessors (FIG. 13-32) at Chartres, and the figures from Reims Cathedral (FIG. 13-34)?

LATE GOTHIC AND GOTHIC ART OUTSIDE OF FRANCE TEXT PAGES 445–461

1. During what century did the High Gothic style flourish, and when did the Late Gothic period begin?

2. List four factors that disrupted life in fourteenth-century Europe:

 a.

 b.

 c.

 d.

3. What feature of *The Virgin of Paris* (FIG. 13-39) was typical of much Late Gothic sculpture?

4. Name the illuminator of the *Belleville Breviary* and briefly characterize its style:

132

5. How were illuminators organized in the fourteenth century?

6. From what did the Late Gothic flamboyant style derive its name?

7. Why did architectural production decline in the Île-de-France during the fourteenth and fifteenth centuries?

8. An important example of French flamboyant Gothic architecture is the church of _____ in Rouen, the capital of _____.

9. List five features of Salisbury Cathedral that distinguish it from French Gothic:

 a.

 b.

 c.

 d.

 e.

10. The last English Gothic style, seen at Gloucester, is called _____.

 It is characterized by the following features:

 a.

 b.

11. Describe fan vaulting.

12. What is a chantry chapel?

13. How does the tomb effigy of Edward the Black Prince (FIG. 13-48) reflect the aristocratic virtues of his time?

14. The German cathedral of _____ was finished in the nineteenth century when the original thirteenth-century plan was discovered.

15. The church of St. Elizabeth at Marburg is an early example of a favorite German type of Gothic structure known as a _____.

 How does it differ from the standard basilican type of church, and what is the reason for the difference?

16. Briefly describe the style used in the depiction of the *Death of the Virgin* on the tympanum of the south transept portal of Strasbourg Cathedral.

17. Who were Ekkehard and Uta?

 What is significant about their appearance in a cathedral?

18. What features does the *Bamberg Rider* (FIG. 13-55) share with the figures from the Reims portal (FIG. 13-34)?

19. What is a pietà?

 What mood is created by the fourteenth-century example shown in FIG. 13-56?

20. Identify those features of Florence Cathedral that differentiate it from northern Gothic churches.

21. Why do the authors feel that the design of the Florentine campanile forecasts the ideals of Renaissance architecture?

22. How is the facade of Orvieto Cathedral related to those of French Gothic churches?

 In what major way does it differ?

23. What feature of Milan Cathedral is most "Italian"?

 What feature most reflects northern Gothic influence?

24. Why were Italian medieval town halls like the one at Siena constructed with heavy walls and battlements?

Why, by contrast, could the Doge's Palace at Venice be constructed without fortifications?

25. Locate the following on the map on Study Guide page 114:

Chartres	Laon	St. Denis
Reims	Amiens	Rouen
Gloucester	Strasbourg	London
Marburg	Naumburg	Cologne
Bamberg	Orvieto	Venice
Siena		

DISCUSSION QUESTIONS

1. What similarity do you see between the S-curve of *The Virgin of Paris* (FIG. 13-39) and that used by the Greek artist Praxiteles for the *Hermes* (FIG. 5-70)? In what ways are the two figures different?

2. In what ways has the classic French High Gothic structure as typified by Amiens Cathedral (FIGS. 13-23 to 13-26) been modified in the English and Italian buildings like Salisbury Cathedral (FIGS. 13-42 to 13-45) and Florence Cathedral (FIGS. 13-58, 13-59, 13-60)?

3. Compare the figures of *Ekkehard and Uta* from Naumburg (FIG. 13-54) with the figures from Reims (FIG. 13-34). How are the German figures related to the French prototypes? How do they differ?

4. The equestrian figure of the *Bamberg Rider* (FIG. 13-55) is reminiscent of that of the Roman emperor Marcus Aurelius (FIG. 7-66). Compare the stylistic treatment of horse and rider as well as the relation of each figure to the space surrounding it.

5. How did the representations of Christ change from Early Christian times through the Gothic period? Consider representations in an early catacomb fresco (FIG. 8-4), at San Vitale (FIG. 9-11), at Monreale (FIG. 9-31), at Moissac (FIG. 12-27), and the Gothic Pietà (FIG. 13-56). What historical factors do you think might have contributed to these different representations?

SUMMARY: GOTHIC ART TEXT PAGES 414–461

Using the timeline at the beginning of Chapter 13 in the text, enter the appropriate dates for the following periods. Fill in the charts as much as you can from memory; then check your answers against the text and complete the charts.

HISTORICAL SUMMARY OF GOTHIC PERIOD

Early Gothic Period: _____to _____
High Gothic Period: _____to _____
Late Gothic Period: _____to _____

Significant Religious Leaders and Events	Significant Political Leaders and Events	Cultural Developments

SUMMARY OF GOTHIC ARCHITECTURE

	Typical Examples	Stylistic Characteristics
French Early Gothic		
French High Gothic		
French Rayonnant		
French Late Gothic		
English		
German		
Italian		

SUMMARY OF GOTHIC SCULPTURE AND STAINED GLASS

	Typical Examples	Stylistic Characteristics
French Early Gothic Sculpture		
French High Gothic Sculpture		
German Gothic Sculpture		
Stained Glass		

SELF-QUIZ

PART II: THE MIDDLE AGES

I. **Matching.** Choose the style or period in the right column that best corresponds to the art work or site in the left column and enter the appropriate letter in the space provided.

_____ 1. Hagia Sophia

_____ 2. Amiens Cathedral

_____ 3. Sutton Hoo treasure

_____ 4. *Utrecht Psalter*

_____ 5. St.-Sernin at Toulouse

_____ 6. Speyer Cathedral

_____ 7. St.-Denis ambulatory

_____ 8. St. Michael's at Hildesheim

_____ 9. *Book of Lindisfarne*

_____ 10. *Gospel Book of Archbishop Ebbo*

_____ 11. *Gospel Book of Otto III*

_____ 12. Laon Cathedral

_____ 13. Salisbury Cathedral

_____ 14. Royal Portal at Chartres Cathedral

_____ 15. Palatine Chapel at Aachen

_____ 16. Portal sculpture at Reims Cathedral

_____ 17. St.-Maclou at Rouen

_____ 18. Chapel of Henry VII in London

_____ 19. Doge's Palace in Venice

_____ 20. Chartres Cathedral

_____ 21. St. Mark's, Venice

_____ 22. Durham Cathedral

_____ 23. Notre-Dame in Paris

_____ 24. St.-Étienne at Caen

_____ 25. Monastery at St. Gall

_____ 26. Oseberg ship burial

_____ 27. Palace at Mshatta

_____ 28. Milan Cathedral

_____ 29. Sainte-Chapelle in Paris

_____ 30. Alhambra, Granada

a. Migration period & Irish Christian

b. Carolingian

c. Ottonian

d. Languedoc-Burgundian Romanesque

e. German-Lombard Romanesque

f. Norman-English Romanesque

g. Tuscan Romanesque

h. Islamic

i. Early Gothic

j. High Gothic

k. Gothic rayonnant style

l. Late Gothic

m. Early Byzantine

n. Middle or Late Byzantine

II. Matching. Choose the identification in the right column that best corresponds to the name or term in the left column and enter the appropriate letter in the space provided.

_____ 31. Charlemagne

_____ 32. Villard de Honnecourt

_____ 33. Gislebertus

_____ 34. fibula

_____ 35. choir

_____ 36. archivolt

_____ 37. pier

_____ 38. cloisonné

_____ 39. westwork

_____ 40. Hiberno-Saxon

_____ 41. St. Gall

_____ 42. psalter

_____ 43. Bishop Bernward

_____ 44. St. Louis

_____ 45. triforium

_____ 46. William of Normandy

_____ 47. Justinian

_____ 48. Abbot Suger

_____ 49. chevet

_____ 50. madrasa

a. Carolingian church and monastery

b. sculptor of tympanum at Autun

c. conquered England in 1066

d. large primitive safety pin

e. the gallery between the arcade and clerestory

f. crowned Holy Roman Emperor in A.D. 800

g. combined Irish and Anglo-Saxon style

h. Byzantine emperor

i. a multi-storied mass with facade and towers on the western end of a medieval church

j. section of church reserved for the clergy

k. one of a series of concentric moldings in a Gothic or Romanesque portal

l. knob-like ornament on a pinnacle

m. book containing the Psalms of the Bible

n. a vertical, unattached masonry support

o. Bishop of Hildesheim

p. Gothic architect and draftsman

q. thirteenth-century French king

r. cleric who built St.-Denis

s. a pillar in the center of a Romanesque or Gothic portal

t. the eastern end of a church including choir, ambulatory, and radiating chapels

u. a process of enamelling using cells made of metal wire

v. a beam used to span an opening

w. fourteenth-century German king

x. theological school

III. Multiple Choice. Circle the most appropriate answer.

51. A trumeau would most likely be found a. on an Ionic temple b. as part of the doorway of a medieval cathedral c. as part of the support system of a beehive tomb d. as part of an Etruscan tomb e. in a medieval wall elevation above the arcade

52. Hagia Sophia in Constantinople was built about a. 400-450 b. 650 c. 530-540 d. 800-820 e. 1150-60

53. The *Book of Lindisfarne* is a. done in the Hiberno-Saxon style b. part of the Sutton Hoo find c. a Carolingian psalter d. a gospel book dating from around 800 e. a Byzantine manuscript

54. The west tympanum of St.-Lazare at Autun contains an illustration of a. the emperor and the empress presenting gifts to Christ b. the Last Judgment c. Christ and the twenty-eight elders of the Apocalypse d. the Madonna holding the Child e. the Last Supper

55. During the Carolingian period, Reims was most famous for a. its manuscripts b. its mosaic decoration c. its interlace carving d. its architecture e. its sarcophagi

56. A Gothic church is often distinguished from an Early Christian basilica by a. the use of transepts b. the use of nave and aisles c. the use of bays d. the use of a clerestory e. the use of an apse

57. Monumental sculpture first appeared on the facades of churches in a. seventh-century Italy b. eighth-century England c. ninth-century Spain d. eleventh-century Germany e. eleventh-century France

58. The animal interlace style was most popular among a. Byzantine architects b. Irish monks c. the Carolingians d. the Ottonians e. the thirteenth-century French

59. Triforium is the term used to describe a. the area where the nave intersects the transept b. the arch thrown across a barrel vault from one pier to the next c. an anteroom where sacred vestments are kept d. a blind arcade below the clerestory in Gothic nave walls e. an entrance porch where the unbaptized must stay during services

60. The founder of Islam was a. Ukhaydir b. Muhammad c. Mshatta d. Ali e. Masjid-i-Shah

61. Curtain walls would most likely be found in association with a. domes set on pendentives b. barrel vaults c. groin vaults d. corbeled vaults e. pointed rib vaults and flying buttresses

62. The earliest jamb or column statues that you have studied are found on the west portal of a. St. Michael's at Hildesheim b. St.-Pierre at Moissac c. Chartres Cathedral d. Amiens Cathedral e. Reims Cathedral

63. The centuries from about 350 to 750 are generally referred to as the a. Hellenistic period b. Middle Ages c. Migration period d. Carolingian period e. Ottonian period

64. The Gothic style of architecture developed in the region that is called a. the Rhineland b. Normandy c. Tuscany d. Languedoc e. Île-de-France

65. Which element of Gothic architecture is not found in some Romanesque examples? a. pointed arch b. rib vault c. towers d. flying buttresses e. latin-cross plan

66. Sutton Hoo is famous a. for its magnificent twelfth-century cathedral b. as the site of a battle in which the Normans conquered England c. as the site of a ship burial d. for its rock-cut tombs e. for its production of medieval manuscripts

67. Which of the following is *not* a Romanesque church? a. Durham Cathedral b. Hagia Sophia c. St.-Étienne at Caen d. Sant'Ambrogio in Milan e. St.-Sernin at Toulouse

68. The Portal of the Kings from the west facade of Chartres Cathedral dates from about a. 950 b. 1050 c. 1150 d. 1250 e. 1450

69. The Sutton Hoo treasure was found in a. England b. France c. eastern Germany d. the Pontic region of Russia e. Italy

70. The medieval church discussed that was highest in proportion to its width was a. Sant'Apollinare Nuovo b. Salisbury c. Amiens d. Hildesheim e. Beauvais

71. A sexpartite rib vault was typical of buildings in which style? a. Romanesque b. Early Gothic c. High Gothic d. Ottonian e. Carolingian

72. The sculptures of the tympanum at Moissac represent a. the Last Judgment b. Christ and the twenty-four Elders of the Apocalypse c. the Miracles of St. Firmin d. the Life of the Virgin e. the Mission of the Apostles

73. The windowed section on the nave wall above the aisle roofs of a church is known as the a. clerestory b. gallery c. triforium d. trumeau e. archivolt

74. The square east end is a distinguishing feature of the cathedral of a. Hildesheim b. Chartres c. Salisbury d. Amiens e. St.-Sernin

75. The niche that indicates the direction of Mecca is known as the a. mosque b. madrasa c. mihrab d. minaret e. imam

76. The primary medium used to decorate the apse of the church of Santa Maria de Mur in Catalonia was a. mosaic b. sculpture c. fresco d. stained glass e. gold and enamel

77. The art of stained glass was most highly developed during which period? a. Early Byzantine b. Carolingian c. Ottonian d. Romanesque e. Gothic

78. The greatest tendency toward realism is seen in which of the following medieval sculptures? a. tympanum of St.-Lazare at Autun b. trumeau figures from St.-Pierre at Moissac c. figures from the Porch of the Confessors at Chartres Cathedral d. the *Visitation* group at Reims Cathedral e. *Ekkehard and Uta* from Naumburg Cathedral

79. The greatest emphasis on the horizontal elements is found in the Gothic cathedral of a. Chartres b. Amiens c. Cologne d. Florence e. Beauvais

80. Which of the following is a hall church? a. Orvieto Cathedral b. St.-Sernin at Toulouse c. St. Elizabeth at Marburg d. Salisbury Cathedral e. Speyer Cathedral

IV. Chronology Exercise. Put the letters corresponding to specific art works into the box under the appropriate date range. Fill in as many as you can without looking at the text. Then check the text for the remaining images.

81. 6th-8th Centuries

82. 9th-10th Centuries

83. 11th Century

84. 12th Century

85. 13th Century

86. 14th Century

87. 15th–16th Centuries

A. *Book of Lindisfarne*
B. *Utrecht Psalter*
C. *Bayeux Tapestry*
D. Palace at Ukhaydir, Iraq
E. Bury BIble
F. *Codex Amiatinus*
G. Purse from Sutton Hoo burial
H. *Ekkehard and Uta*
I. *Psalter of St. Louis*
J. Frankish fibula
K. Laon Cathedral
L. Villard de Honnecourt notebook
M. *Gospel Book of Otto III*
N. *Bamberg Rider*
O. Oseberg ship
P. *Codex Aureus of St. Emmeram*
Q. *The Virgin of Paris*
R. *Visitation*, Reims Cathedral
S. Prophet from trumeau, St.-Pierre, Moissac
T. Great Mosque, Damascus
U. San Miniato al Monte
V. Gloucester Cathedral
W. Doors of St. Michael, Hildesheim
X. Dome of the Rock, Jersusalem
Y. Chapel of Henry VII, Westminster
Z. Plan of St. Gall
AA. Tomb of the Black Prince, Canterbury Cathedral
BB. Sainte-Chapelle, Paris
CC. Ambulatory & radiating chapels of St.-Denis
DD. Tympanum, Strasbourg Cathedral
EE. Beauvais Cathedral
FF. Royal Portal, Chartres Cathedral
GG. San Vitale, Ravenna
HH. Amiens Cathedral
II. Salisbury Cathedral
JJ. Rublev, *Old Testament Trinity*
KK. Porch of the Confessors, Chartres Cathedral
LL. Notre-Dame, Paris

V. Identification. Follow the instructions given in each question.

88. Compare the following manuscript pages, attributing each to a particular cultural period and providing an approximate date. Give the reasons for your attributions.

A. Period: _____

Date: _____

B. Period: _____

Date: _____

Reasons:

89. Compare the two sculptures below, attributing each to a particular period and providing an approximate date. Give the reasons for your attributions.

A. Period: _____

Date: _____

B. Period: _____

Date: _____

Reasons:

90. In what period, style, and century was the church below erected? To what group of churches is it related? What features demonstrate this relationship?

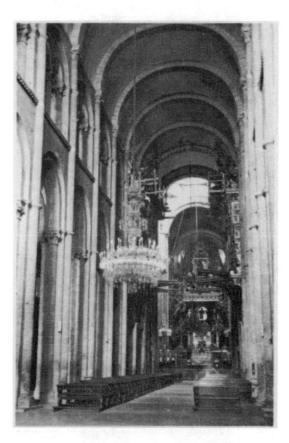

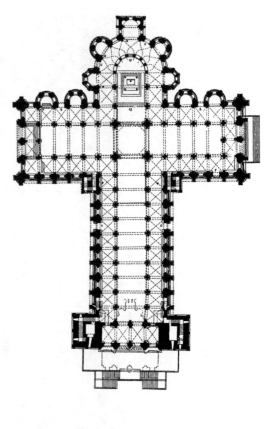

Period: _____

Century: _____

Stylistic affiliations:

91. Label as many parts of the medieval church illustrated below as you can. Identify and date the building. It contains features of two architectural styles: what are they?

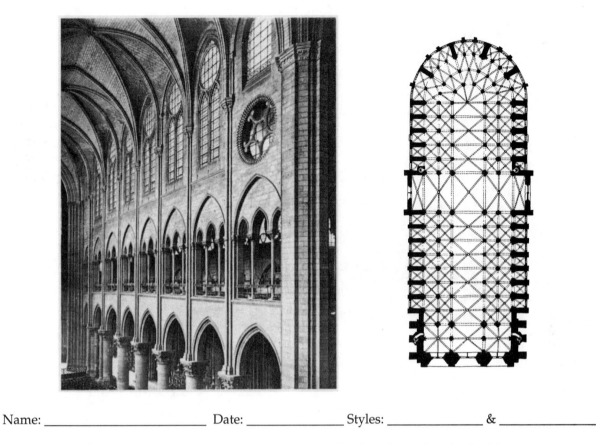

Name: _____ Date: _____ Styles: _____ & _____

Describe the architectural features that are characteristic of each style used in this building.

92. This mosque was influenced by a famous Christian building. Describe that building, noting when and where it was built. What architectural features do they have in common? When and where might this building have been built? What other Islamic structure can you relate to it? How do you know that this building is Islamic and not Christian?

Part Three

THE WORLD
BEYOND EUROPE

CHAPTER 14

THE ART OF INDIAN ASIA

TEXT PAGES 468–491

1. Identify or define the following:

 Bhagavad Gita

 chaitya

 chandi

 jataka

 karma

 mandala

 mudra

 rathas

 stupa

 sutra

 torana

 Upanishads

 urna

 ushnisha

 yakshas

 yakshis

2. During what millenium did the first great flowering of Indian art occur?

 Two important sites from this period are:

 a. b.

3. List two characteristics of Indian sculpture.

 a.

 b.

4. Name a comtemporary culture that had extensive trade links with the Indus Valley.

 What types of objects best illustrate the links?

5. What subjects were most commonly represented on the intaglio steatite seals of Mohenjo-Daro?

6. List three features of the figure shown at the right in FIG. 14-2 that indicate that it may represent a prototype of the Hindu god Siva.

 a.

 b.

 c.

7. At what date did the Aryan invasions of India begin?

 What religion did they bring?

8. Name two religions that developed in India in the sixth century B.C.

 a.

 b.

9. Who was Siddhartha?

 Asoka?

10. What was the model for Asoka's palace at Patna?

11. Briefly give the Buddhist meaning for the following symbols:

 lotus

 wheel

12. What was the model for the early Buddhist cave temples?

13. Where is the Great Stupa located?

 Describe at least two functions of the stupa.

14. Name four objects that are commonly used to symbolize the Buddha.

 a. b.

 c. d.

15. List two stylistic characteristics of the carving that decorates the toranas of the Great Stupa (FIG. 14-6).

16. What two stylistic features distinguish the chaitya hall at Karli (FIGS. 14-8 to 14-10)?

17. Briefly describe the difference between Hinayana and Mahayana Buddhism.

18. Which culture provided artistic models for the images of the Seated Buddha from Gandhara (FIG. 14-11)?

19. List three stylistic characteristics of the Mathura Buddha (FIG. 14-12).

a.

b.

c.

20. By what century had Hinduism regained supremacy in India?

21. Who was Siva?

22. What is the meaning of the three-headed figure of Siva at Elephanta (FIG. 14-16)?

23. The function of Siva's dance as Lord of the Dance was:

24. The primary function of a Hindu temple is:

25. Identify the following parts of a Hindu temple. (You may draw and label a sketch if you like.)

sikhara

mandapa

gopuram

26. List three Hindu temples and note the century each was built.

 a. century:

 b. century:

 c. century:

27. What put a stop to the development of Hindu architecture in northern India?

28. What particular art form produced under the Chola kingdom of south India was most outstanding?

29. List three characteristics of Gupta art that are apparent in the painting from Cave I at Ajanta (FIG. 14-23).

 a.

 b.

 c.

30. How was Indian painting affected by the Moslem conquests?

31. List four stylistic elements of the miniature of Krishna and Radha (FIG. 14-24).

 a.

 b.

 c.

 d.

32. Name two countries that adopted Mahayana Buddhism.

 a. b.

 Name one country that adopted Hinayana Buddhism.

33. In what country is the stupa of Borobudur located?

 In what century was it built?

 What is symbolized by the base and the four rectilinear tiers?

 by the upper four circular tiers?

 by the stupa on the uppermost terrace?

34. The *Ramayana* is an epic sacred to:

35. List three characteristics of the Early Khmer figure of Harihara created in the seventh century (FIG. 14-28).

 a.

 b.

 c.

36. Why is the Bayon at Angkor Thom (FIG. 14-32) considered to be the culmination of Indian temple architecture?

37. Locate the following on the map on Study Guide page 160:

India and Pakistan
Gandhara
Karli
Ajanta
Sri Lanka (Ceylon)
Thailand
Borobudur
Indus River
Angkor Wat

Mohenjo-Daro
Sanchi
Elephanta
Khajuraho
Polonnaruwa
Java
Cambodia (Kampuchea)
Himalayas

DISCUSSION QUESTIONS

1. Look at the Buddha from Gandhara (FIG. 14-11), the Siva from Elephanta (FIG. 14-16), the Roman figures from the Ara Pacis Augustae (FIGS. 7-32 and 7-33), the Gods and Goddesses from the Parthenon (FIG. 5-55) the figures of *St. Martin, St. Jerome, and St. Gregory* from Chartres (FIG. 13-32), the *Amorous Couple* from the chaitya hall at Karli (FIG. 14-10), and the relief from the Pergamon Altar of Zeus (FIG. 5-90). Which figures seem to be the most spiritual? What stylistic features do you think achieve this quality?

2. In what way does the function of a temple as residence of the god rather than as a hall for congregational worship affect the style of the architecture of Hindu and Greek temples? Compare the Hindu temples in Chapter 14 with a Greek temple in Chapter 5. What function does light play in each type of building? How is sculpture used in each?

3. What Greek and Medieval Christian figures can you think of that share the monumental calm and sense of timelessness of the Early Khmer figure of *Harihara* (FIG. 14-28)? What stylistic features do they have in common?

4. What different metaphysical views are represented by the image of Siva dancing (FIG. 14-22) and the Seated Buddha from Sarnath (FIG. 14-13)?

5. Discuss the iconography of Buddhism as seen in the stupa of Borobudur in Java (FIGS. 14-26 and 14-27).

6. What was the relationship between kings and temples in Angkor Wat? What did the temples of Angkor Wat symbolize?

Using the timeline at the beginning of Chapter 14 in the text, enter the appropriate dates for the following periods. Fill in the charts as much as you can from memory; then check your answers against the text and complete the charts.

SUMMARY OF INDIAN ART

Indus Valley Civilization	_____ B.C. to	_____ B.C.
Maurya (Asoka) Period	_____ B.C. to	_____ B.C.
Sunga Period	_____ B.C. to	_____ B.C.
Andhra Period	_____ B.C. to A.D.	_____
Kushan Period	A.D. _____ to	_____
Gupta Period	A.D. _____ to	_____
Later Hindu Dynasties	A.D. _____ to	_____
Muslim Dynasties	A.D. _____ to	_____

	Typical Examples	Stylistic Characteristics	Significant Historical People, Events, and Ideas etc.
Indus Valley Civilization			
Maurya (Asoka) Period			
Sunga Period			
Andhra Period			
Kushan Period			

SUMMARY OF INDIAN ART (continued)

	Typical Examples	Stylistic Characteristics	Significant Historical People, Events, and Ideas etc.
Gupta Period			
Later Hindu Dynasties			
Muslim			

SUMMARY OF JAVANESE AND CAMBODIAN ART

	Typical Examples	Stylistic Characteristics	Significant Historical People, Events, and Ideas etc.
Java			
Cambodia			

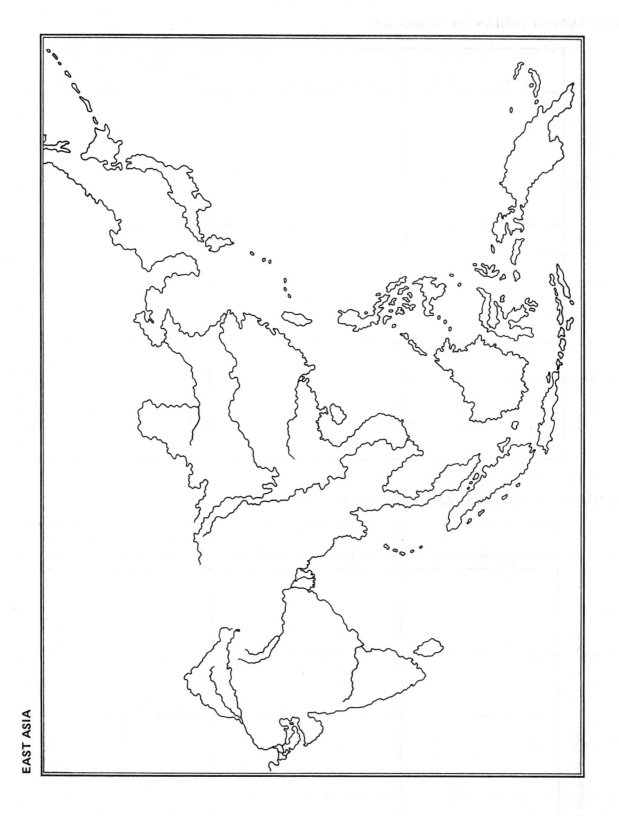

EAST ASIA

CHAPTER 15
THE ART OF CHINA AND KOREA

TEXT PAGES 492–527

1. Identify:

Confucius

Kublai Khan

Laozi (Lao-tzu)

2. Where was the prehistoric Chinese Yangshao culture located?

What was its major artistic form?

List three motifs that were used for decoration:

a. b. c.

3. What was the purpose of the inscribed bones used during the Shang period?

4. List six types of objects found in tombs of Shang rulers:

a. b.

c. d.

e. f.

5. The major art form during the Shang dynasty was:

6. List two adjectives that characterize the silhouette of Shang and Zhou bronzes and two phrases that characterize the decoration of each.

	Shang	Zhou
Silhouette:	_____	_____
	_____	_____
Decoration:	_____	_____
	_____	_____

7. Name one material other than bronze that was very popular for jewelry and ritual objects in the Late Zhou period:

8. What was found in excavations around the tomb mound of Emperor Shi Huangdi at Shaanxi?

9. What were the primary sources of the subject matter of the art of the Han dynasty?

 a.

 b.

10. List three stylistic characteristics of Han reliefs.

 a.

 b.

 c.

11. Briefly state why Buddhism was adopted in China during the Three Kingdoms period.

12. Describe three stylistic features, derived from Indian prototypes, that occur in the earliest Chinese images of Buddha.

 a.

 b.

 c.

13. Describe three features of the figure of Vairocana Buddha carved at Longmen (FIG. 15-10).

 a.

 b.

 c.

14. List three stylistic features of the figures that flank the Colossal Buddha from Longmen Caves (FIG. 15-10; see also FIG. 15-11).

 a.

 b.

 c.

15. How did the popularity of the Paradise Sects of Buddhism affect Buddhist art in China?

16. By what century had the landscape scroll apparently been developed?

17. List three fundamental differences between traditional Chinese and Western landscape painting:

 a.

 b.

 c.

18. What evidence do we have for the cosmopolitan character of the Tang court?

19. What effects did the new wave of Indian influence have on Chinese Buddhist art of the Tang period?

 a.

 b.

20. Describe the similarities you see between the poses of the Chinese *Bodhisattva* (FIG. 15-14) and *The Virgin of Paris* (FIG. 13-39).

21. List two devices that were used in the Tang painting *Palace Ladies* (FIG. 15-17) to give a sense of depth and space to the composition.

 a.

 b.

22. List the names of two famous painters of the Tang period.

 a. b.

23. List four types of figurines found in Tang tombs:

 a. c.

 b. d.

24. What kind of perspective was used in the Chinese painting of the *Paradise of Amitabha* (FIG. 15-15)?

25. Write down Jing Hao's criteria for the classification of "divine" painting.

 What does he place in the lowest category of painting?

26. Describe the stylistic characteristic that the following Song painters had in common: Dong Yuan, Ju Ran, Fan Kuan, and Guo Xi.

27. What influence did calligraphy have on Chinese painting?

28. Name three elements that are typical of Southern Song landscape painting.

 a.

 b.

 c.

29. How did the beliefs of the Zen sect of Buddhism influence art?

30. The technique of incised designs showing through a colored slip (Cizhou) was developed by potters of the _____ dynasty.

31. How did the invasions of Kublai Khan influence the Chinese approach to landscape painting?

 a.

 b.

32. Briefly describe the position of amateur artists during the Ming period.

33. List three glazes that were developed by Ming potters.

 a.

 b.

 c.

34. How does the style of the figure of Guanyin (FIG. 15-31) reflect the iconographic meaning of the Goddess?

 What material was used to create the figure?

35. What artistic style is favored by the People's Republic of China?

36. Name three essential elements of Chinese architecture.

 a.

 b.

 c.

37. From what form did the Chinese pagoda develop?

38. What is *fengshui* and what was its importance for Chinese architecture?

39. What role did color play in Chinese architecture?

40. How does the plan of a Chinese house express Confucian ideals?

41. Where is the Hall of Supreme Harmony located?

 What was its purpose?

 Was the design of the complex revolutionary or conservative?

42. What role did Korea play vis-a-vis the cultural interchange between China and Japan?

43. What is considered to be the golden age of Korean art?

44. What religion dominated Korean art during the Silla and Koryo periods?

45. Give the meaning of the following features of the standing Buddha shown in FIG. 15-44:

ushnisha

mudra (hand gesture)

round face

long ears

dreamy facial expression

Why is the style of this figure considered to be archaic?

46. In what ways does the painted Korean Buddha shown in FIG. 15-45 resemble the Indian Buddha from Sarnath (FIG. 14-13)?

47. What is celadon?

Where and when was it invented?

48. Give the dates for the following Korean periods and note the contemporary Chinese and Japanese periods:

	Dates	Chinese period	Japanese period
Three Kingdoms:			
Great Silla:			
Koryo or Koguryo:			
Yi Dynasty:			

49. What was the significance for the Japanese pottery industry of the Japanese invasion of the Yi Kingdom?

50. What religious and political beliefs are represented by the motif of the sun and moon shown in FIG. 15-49?

51. Locate the following on the map on Study Guide page 160:

China	Korea
Beijing	Hangzhou
Dunhuang	Yungang
Longmen	Shaanxi

DISCUSSION QUESTIONS

1. Compare a bronze guang from the Shang period (FIG. 15-3) with the roughly contemporary Mycenaean *Vaphio Cup* (FIG. 4-26). How does each artist relate the form of the vessel to the form of the animal? Can you think of another period in Western art when animal patterns were closer to those expressed in the Chinese bronze?

2. Compare a Han relief (FIG. 15-7) with a Sumerian seal (FIG. 2-11). In each case consider the type of line used, the relationship of the figures to the space, and the formal conventions used for depicting the figures.

3. Study the portrayal of equine motion and balance in the Chinese bronze horse from the Han dynasty (FIG. 15-8). Then look at the Greek horses from the Parthenon (FIG. 5-54), the Medieval rider from Bamberg (FIG. 13-55), Donatello's *Gattamelata* (FIG. 21-11), Verrocchio's *Colleoni* (FIG. 21-51), and Bonheur's *The Horse Fair* (FIG. 26-48). Which of these Western representations comes closest to the Chinese depiction? What stylistic features do they have in common? How are they different?

4. Select two representations of the Buddha, one Chinese, one Indian. How do they differ in the treatment of the figure and the drapery?

5. Discuss the effects of political and religious changes on Chinese artists of the sixteenth century. Cite specific works to illustrate your discussion.

6. What is the major difference between Chinese and Western attitudes toward nature? How have these attitudes been reflected in art?

7. Compare the warriors from the tomb of Emperor Shi Huangdi (FIG. 15-6) with the Greek warriors from Aegina (FIGS. 5-31 and 5-32) and the Roman soldiers from the Arch of Titus (FIGS. 7-44 and 7-45). What can the placement of the figures tell us about the cultures that produced them?

8. Discuss the influence of the philosophies of Confucianism and Daoism on Chinese painting and house and garden design.

Using the timeline at the beginning of Chapter 15 in the text, enter the appropriate dates for the following periods. Fill in the chart as much as you can from memory; then check your answers against the text and complete the chart.

SUMMARY OF CHINESE ART

Shang Dynasty	_____ B.C. to _____	B.C.
Zhou Dynasty	_____ B.C. to _____	B.C.
Qin Dynasty	_____ B.C. to _____	B.C.
Han Dynasty	_____ B.C. to A.D. _____	
Tang Dynasty	A.D. _____ to _____	
Northern Song Dynasty	A.D. _____ to _____	
Southern Song Dynasty	A.D. _____ to _____	
Yuan Dynasty	A.D. _____ to _____	
Ming Dynasty	A.D. _____ to _____	
Qing Dynasty	A.D. _____ to _____	

	Typical Examples	Stylistic Characteristics	Significant Historical People, Events, and Ideas, etc.
Shang			
Zhou			
Han			

SUMMARY OF CHINESE ART (continued)

	Typical Examples	Stylistic Characterisitics	Significant Historical People, Events, and Ideas, etc
Tang			
Northern Song			
Southern Song			
Yuan			
Ming and Qing			

CHAPTER 16
THE ART OF JAPAN

TEXT PAGES 528–551

1. Define the following terms:

 apsara

 haniwa

 Kabuki

 makimono

 samurai

 Shinto

 tatami

 tokonoma

 torii

 ukiyo-e

 Yamato-e

2. Briefy describe the process of creating lacquer figures.

 What are the advantages of this technique?

3. What was the main art form of the Jomon culture?

4. How do Jomon vessels differ from Neolithic Chinese examples?

5. Name the two cultures that had the strongest influence on the development of Japanese art.

 a. b.

6. Name the largest and most important Shinto shrine in Japan.

 To what century does the style of the main building of that shrine date?

 What Japanese custom assures us that the present building looks pretty much like the first and original one?

7. What happened in the year 552 that was of paramount importance for Japan?

8. Identify the qualities of the statue of *Miroku* (FIG. 16-5) that are Japanese rather than Chinese.

 a.

 b.

9. Which Chinese style most strongly influenced Japanese art of the Late Nara and Early Heian periods?

10. Name two examples of Japanese art of the seventh and eighth centuries that show strong Chinese influence.

 a. b.

11. What culture provided the mold for the Horyu-ji and Todai-ji temple complexes?

12. What material was used for the Kondo?

 When was it built?

 What feature of the building may reflect a third-hand Greek influence?

13. Describe the type of image that was introduced during the Heian period that reflected the influence of Esoteric Buddhism.

14. Who wrote the popular eleventh-century novel *The Tale of Genji*?

What was it about?

15. What is the name given to the type of painting illustrated in the *Shigisan Engi* (FIG. 16-10)?

16. List three characteristics of the Yamato-e style seen in the Genji scrolls.

 a.

 b.

 c.

17. What Chinese compositional device was adopted by Japanese painters at the very end of the Fujiwara period?

18. What is the symbolic meaning of the Phoenix?

19. In contrast with the art supported by the Fujiwaras, the art preferred by the rulers of the Kamakura period emphasized:

 a.

 b.

20. The fifteenth-century Japanese painter who adopted the monochrome landscape style of Chinese masters of the Song period was:

How did his style differ from that of the Song masters?

21. Name the religious sect that influenced the development of the Japanese tea ceremony.

Briefly explain the purpose of the tea ceremony.

22. Compare the ceramics used in the Japanese tea ceremony with contemporary Chinese vessels.

Japanese:

Chinese:

23. List two features that characterize the style of Motonobu and the Kanō school.

a.

b.

24. List three characteristics of the style of painting favored by the Momoyama rulers.

a.

b.

c.

How does the contemporary style of Hasegawa Tōhaku differ from this style?

25. The simplicity and elegance of Japanese teahouses is thought to have influenced the design of the seventeenth-century palace at _____.

Briefly describe the gardens of the palace.

26. What is the purpose of a Zen rock garden?

27. Which Chinese school influenced the Japanese Nanga "southern" painters?

 How did the Nanga painters transform the technique of their Chinese models?

 a.

 b.

 List two representatives of this style:

 a. b.

28. What was the main characteristic of the style of Maruyama Okyo?

29. Who was the first Japanese artist to use woodblock prints to illustrate subjects from everyday life?

30. Name two nineteenth-century Japanese artists who specialized in printmaking.

 a. b.

31. List the major art form used by each of the following artists and the century in which they worked:

	Art Form	Century
Buson		
Hiroshige		
Hokusai		
Jocho		
Kanō Motonobu		
Sesshu		
Torii Busshi		
Utamaro		

32. What structural system was used in Japanese domestic architecture?

 What aspect of Japanese architecture has had the most effect on Western architectural theory?

33. Locate the following on the map on Study Guide page 160:

Kyoto (Heian-kyo)	Japan	Ise
Ashikaga	Nara	Kamakura
Momoyama	Tokyo (Edo)	

DISCUSSION QUESTIONS

1. Compare the architectural style and building technique of the Kondo (Golden Hall) of Hōryū-ji (FIG. 16-8) with those of the Ise Shrine (FIG. 16-3). In what way does the Kondo reflect Chinese prototypes?

2. Compare the treatment of the animals in the Japanese scroll formerly attributed to Toba Sōjō (FIG. 16-11) with the page from Villard de Honnecourt's notebook (FIG. 13-37). What type of drawing style has each artist used? How does each relate to the dominant religion of its time?

3. In what way does the Japanese tea ceremony relate to the style of the painting illustrated in FIG. 16-22?

4. Compare a Harunobu print (FIG. 26-62) with Degas's *Ballet Rehearsal* (FIG. 26-61). In what ways does Degas's composition resemble that of the Japanese print?

5. Discuss briefly the interaction of native traditions and Chinese influence in the art of Japan from the fifth through the fifteenth centuries. What characteristics can be identified as native Japanese? What features can be considered as imported from China?

6. Discuss the evolution of the figure of the Buddha by comparing the Indian Buddha from Gandhara (FIG. 14-11), the Sakyamuni Buddha (FIG. 15-9), the Buddha from Longmen (FIG. 15-10), the Korean standing Buddha (FIG. 15-44), the Buddha from Borobudur (FIG. 14-28), the Chinese Paradise of Amitabha (FIG. 15-15), the Korean Buddha Amitabha (FIG. 15-45) and the Amida Triad (FIG. 16-6). What differences if any, do you see that may be based upon nationality?

7. How do Japanese gardens reflect the attitude of the Japanese toward nature? How do they differ from gardens you have seen?

Using the timeline at the beginning of Chapter 16 in the text, enter the appropriate dates for the following periods. Fill in the chart as much as you can from memory; then check your answers against the text and complete the chart.

SUMMARY OF JAPANESE ART

Period	Dates
Jomon Culture	_____ B.C. to A.D. _____
Archaic Period	A.D. _____ to _____
Asuka and Hakuho Periods	A.D. _____ to _____
Nara Period	A.D. _____ to _____
Early and Late Heian (Fujiwara) Periods	A.D. _____ to _____
Kamakura Period	A.D. _____ to _____
Ashikaga Period	A.D. _____ to _____
Momoyama Period	A.D. _____ to _____
Edo (Tokugawa) Period	A.D. _____ to _____

	Typical Examples	Stylistic Characteristics	Significant Historical People, Events, and Ideas, etc
Jomon/Archaic			
Nara			
Heian/Fujiwara			

SUMMARY OF JAPANESE ART (continued)

	Typical Examples	Stylistic Characteristics	Significant Historical People, Events, and Ideas etc.
Kamakura			
Ashikaga			
Momoyama			
Tokugawa (Edo)			

THE NATIVE ARTS OF THE AMERICAS AND OF OCEANIA

TEXT PAGES 552–595

PRE-COLUMBIAN ART TEXT PAGES 554–578

1. Identify or define the following:

 atlatl

 Chavín

 Coatlicue

 Cortés

 Huitzilopochtli

 Mesoamerica

 Moctezuma

 Pizarro

 pre-Columbian

 Quetzalcóatl

 roof comb

 stele (pl. stelae)

 Teotihuacán

 Tlaloc

2. When do scholars think that human beings originally migrated to North and South America?

 What route did they take?

3. What crop formed the agricultural base of the pre-Columbian economy?

4. Give the generally accepted dates for the following Mesoamerican periods:

Preclassic (Formative)

Classic

Postclassic

5. List the Mesoamerican cultures that were concentrated in the following regions:

Gulf Coast

Yucatán, Honduras, and Guatemala

Southwest Mexico and Oaxaca

Valley of Mexico

6. Which Mesoamerican culture is often referred to as the "mother culture" of the region?

Where was its heartland?

When, approximately, did it flourish?

List two types of sculpture produced by these people.

a.

b.

What type of architectural structure did they create at La Venta and what was its significance?

7. What medium was most favored by the artists of the West Mexican areas of Jalisco, Nayarit, and Colima?

What subjects figured prominently in the art of that region?

What quality is most characteristic of the Colima figures?

8. Where was the ancient city of Teotihuacán located?

At its peak, which was around A.D. _____ , the city had approximately _____ residents, making it the largest city in the world.

What sort of plan was used to lay it out?

What names have been given to the two largest pyramids?

a. b.

What originally stood on top of the pyramids?

9. In what area did the Maya culture flourish?

What form of government ruled the Maya city-states?

When were the foundations of Maya culture laid down?

When did the Maya civilization collapse?

10. Describe the stylistic features that are most characteristic of Maya sculpture.

11. What has helped modern archeologists get a better idea of Maya chronology?

12. What was the main purpose of Maya religion?

What was the importance of blood in Maya ritual?

13. Briefly describe the structure and style of Temple I (Temple of the Giant Jaguar) at Tikal (FIG. 17-8).

14. What does the figure shown in FIG. 17-9 symbolize?

 What formal features help to create the impression that he is an ideal being rather than a specific individual?

15. What is the subject of the Maya lintel from Yaxchilán (FIG. 17-10)?

 What type of relief was used?

16. What is thought to have been the purpose of the numerous figurines found on the island of Jaina?

 Describe their style.

17. What scenes are depicted in the Bonampak murals?

 When were they done?

 What evidence do we have for that date?

 List four words or phrases that characterize the style of the fresco:

 a.

 b.

 c.

 d.

18. List three great cultures that declined sharply at the end of the classic period (700-900):

 a. b. c.

19. List three cultures that flourished during the Postclassic period (900-1521):

 a. b. c.

20. Name the group that succeeded the Zapotecs at Monte Albán.

 At what art form did they excel?

21. What is the *Borgia Codex*?

 Why are there not more extant pre-Columbian codices?

22. Which group strongly influenced the Maya at Chichén Itzá?

23. Describe the form and function of the Caracol at Chichén Itzá.

24. What was the capital city of the Toltecs?

25. What is represented on the four colossal atlantids from Tula?

 List three characteristics of their style:

 a.

 b.

 c.

26. Where did the Aztecs establish their capital and what was it called?

 What was its approximate population when the Spanish conquerors arrived?

 Describe the layout of the city:

27. How did the Aztec practice of human sacrifice differ from that practiced by the Maya?

28. What myth is represented by the dismembered corpse shown in FIG. 17-17?

29. Describe the stylistic attributes of the colossal Aztec sculpture of Coatlicue:

30. What did Cortés vow to place upon the ruins of the great temple of Huitzilopochtli in Tenochtitlán?

31. What sort of carving characterized Chavín sculpture?

 What sort of figures are most typical?

32. The three cultures mentioned in the text that coexisted in coastal Peru from about 500 B.C. to A.D. 600 were:

 a. b. c.

 What are the most characteristic products of these cultures?

 What are the distinctive features that permit us to identify the products as belonging to one of the three cultures?

33. What is the major significance of the tomb excavated on the northwest coast of Peru in 1988?

34. What casting technique was used by the Tairona gold workers of Colombia?

 What did gold symbolize for them?

35. The Inca described gold as the _____ and silver as _____.

36. What explanations have been given for the Nasca Lines?

37. Name the dominant cultures at the arrival of Columbus.

 a. In Mesoamerica:

 b. In the Central Andes:

38. List two important art forms of the Tiahuanaco culture.

 a. b.

39. When did the Inca begin their imperialistic expansion?

40. The southern capital of the Inca empire was:

41. For what characteristics is Inca architecture most famous?

42. How was the Temple of the Sun in Cuzco constructed and decorated?

 What did the Spanish build on its ruins?

43. Locate the following on the map on Study Guide page 192:

La Venta	Jalisco	Nayarit
Colima	Palenque	Bonampak
Tikal	Copán	Chichén-Itzá
Teotihuacán	Mexico City	Cuzco
Chavín de Huántar	Moche	Nasca
Tiahuanaco		

NORTH AMERICAN NATIVE ARTS TEXT PAGES 578–587

1. Identify the following:

petroglyph

pictograph

kiva

kachina

spirit quest

2. List two stylistic characteristics of prehistoric Eskimo art.

a.

b.

3. What was the favorite material of Inuit carvers?

4. What is thought to have been the purpose of most of the Adena and Mississippian art objects that have been found?

5. Name a site in North America where rock paintings or engravings have been found.

6. List three major native North American art forms.

 a. c.

 b.

7. List two characteristics of prehistoric pottery made by the Mimbres people.

 a.

 b.

 What method was used to make this pottery?

8. What is most significant about Pueblo Bonito?

9. Describe a kiva.

10. What is the purpose of Navajo sand painting?

11. In addition to their spiritual uses, art objects created by the Native American inhabitants of the Northwest Coast were often expressions of _____.

12. List some recurrent stylistic characteristics found in objects created by the historic inhabitants of the Northwest Coast.

 a.

 b.

 c.

 d.

13. Describe the changes in design and materials that occurred in the art of the Native American artists of the Great Plains about 1830.

14. What was the False Face Society of the Iroquois?

15. Locate on the map on Study Guide page 192 the areas settled by the following North American tribes/cultures:

Mesa Verde Navajo Tlingit
Arapaho Iroquois

ART OF OCEANIA TEXT PAGES 587–595

1. Name the three cultural areas of Oceania.

 a. b. c.

2. Define the following terms:

 mana

 tapa

 malanggan

 Asmat pole

3. List three characteristics of Polynesian art as seen in the image of Kukailimoku (FIG. 17-47):

 a.

 b.

 c.

4. What stylistic tendency of Polynesian art is represented by tattoo patterns?

5. Describe the characteristics of Polynesian art that are merged in the art of the Maori peoples of New Zealand.

 a.

 b.

6. In what ways does Melanesian art differ from that of Polynesia?

 a.

 b.

 c.

7. What was the purpose of an Asmat pole?

8. What was the purpose of the decorated skull from New Guinea shown in FIG. 17-56?

9. What is the importance of "Dream Time" in the lives of native Australians?

10. Who ware the Djanggawul sisters and brothers?

 List four characteristics of native Australian art as seen in *The Djanggawul Sisters* (FIG. 17-59):

 a.

 b.

 c.

 d.

11. Describe the "X-ray" style of painting from the area of Arnhem Land called Oenpelli.

DISCUSSION QUESTIONS

1. Compare the sculptural style of Central Mexico as seen in the Temple of Quetzalcóatl at Teotihuacán (FIG. 17-5) and the Aztec figure of Coatlicue (FIG. 17-18) with the Maya Maize God (FIG. 17-9). What similarities and what differences do you see?

2. Compare the *Raimondi Stone* from Chavín (FIG. 17-19) with Mesoamerican carving. Is the *Raimondi Stone* closer to the Maya style (FIG. 17-9) or to that of Central Mexico (FIG. 17-5)? In what ways?

3. How do the pyramids of pre-Columbian America compare in structure and function with those of Egypt and the ancient Near East?

4. What similarities can you find between the social structures of pre-Columbian America and those of Egypt and the ancient Near East? In what ways do you think the art forms of the various cultures were influenced by their social structures?

5. Discuss the different building techniques and architectural decoration used by Maya and Peruvian architects. What features would enable you to distinguish between a Maya and a Peruvian building?

6. Compare the style and organization of Navajo sand painting (FIG. 17-37) with that of the animal paintings from Lascaux (FIG. 1-4) and with Mantegna's fresco from the Camera degli Sposi (FIG. 21-61). What type of pictorial organization is used in each? Which type does the sand painting resemble most closely?

Using the timeline at the beginning of Chapter 17 in the text, enter the appropriate dates for the following periods. Fill in the chart as much as you can from memory; then check your answers against the text and complete the chart.

SUMMARY OF PRE-COLUMBIAN ART

Mexico:

Olmec	_____ B.C. to _____ B.C.	
Teotihuacán	A.D. _____ to _____	
Classic Maya	A.D. _____ to _____	
Toltec	A.D. _____ to _____	
Aztec (Tenochtitlán founded)	A.D. _____	

South America:

Chavín	_____ B.C.	
Moche/Nasca	_____ B.C. to A.D. _____	
Tiahuanaco	to A.D. _____	
Inca (beginning expansion)	A.D. _____	

SUMMARY OF PRE-COLUMBIAN ART (continued)

	Typical Examples	Stylistic Characteristics	Significant Historical People, Events, and Ideas, etc.
Olmec			
West Mexico			
Maya			

SUMMARY OF PRE-COLUMBIAN ART (continued)

	Typical Examples	Stylistic Characterisics	Significant Historical People, Events, and Ideas, etc.
Teotihuacán			
Aztec			
Chavín			
Moche			
Nasca			
Tihuanaco			
Inca			

THE AMERICAS

Using the timeline at the beginning of Chapter 17 in the text, enter the appropriate dates for the following periods. Fill in the chart as much as you can from memory; then check your answers against the text and complete the chart.

SUMMARY OF NORTH AMERICAN NATIVE ARTS

	Tribes	Stylistic Characteristics	Cultural Factors
Eskimo			
Southwest Area			
Northwest Coast			
Great Plains			
Eastern Woodlands			

Fill in the chart as much as you can from memory; then check your answers against the text and complete the chart.

SUMMARY OF THE ARTS OF OCEANIA

	Typical Examples	Stylistic Characteristics	Cultural Factors
Polynesia			
Melanesia			
Australia			

CHAPTER 18

THE ARTS OF AFRICA

TEXT PAGES 596–617

1. Identify the following:

 cire perdue

 Gelede

 Ife

 mbari

 Yoruba

2. Is the most common approach of traditional African artists conceptual or perceptual?

 What does that mean?

3. List six African art forms that were traditionally produced by men.

 a. b. c.

 d. e. f.

 List three forms that were traditionally produced by women.

 a. b. c.

 List three that were not gender specific.

 a. b. c.

4. List three African regions where rock art is most plentiful.

 a. b. c.

5. What African culture produced the earliest known sculpture in the round?

 To what period does it date?

 What material was used?

6. What was the major art form of the Ife?

 Describe the style of the Ife King figure (FIG. 18-9).

 From what period does it date?

7. In what area was the terracotta horseman shown in FIG. 18-10 found and when was it created?

 What is this figure thought to represent?

8. List two of the most important medieval empires in West Africa:

 a. b.

9. When was the large stone complex known as Great Zimbabwe built?

 Trade goods found in this complex indicate active trade with:

 a. b. c.

10. When did the Portuguese establish trade relations with the kingdom of Benin?

11. Who were the patrons of the Benin guilds whose members created intricate metal castings and ivory carvings?

12. List two stylistic characteristics of Benin art.

 a.

 b.

13. How did the swords that belonged to the Benin and Akan states acquire their power?

14. What do the leopards symbolize that flank the Benin king in the altar illustrated in FIG. 18-13?

15. What is the meaning of the heads and elephant tusks included in the shrine in FIG. 18-16?

16. Who is the woman in the *Dancing Royal Couple* (FIG. 18-17) thought to portray?

17. Where were most Baule figure sculptures kept?

 What was their purpose?

18. What was the purpose of African ancestral figures like those illustrated in FIGS. 18-19 and 18-23?

19. How did the artist treat the human body in the Dogon carvings illustrated in FIG. 18-20?

20. What was the purpose of the small Asante disc-headed figures shown in FIG. 18-21?

21. What is an Mbari house?

 What is the ritual purpose of its construction?

22. How were power figures like the one shown in FIG. 18-24 consecrated?

23. List two types of beings that masked African dancers most often portray.

 a. b.

 Describe the social function of African masquerades.

24. What female ideals are symbolized by the following features of Mende masks (FIG. 18-30)?

 High, broad forehead:

 Intricately plaited hair:

 Small, closed mouth:

 Downcast eyes:

 How are these masks used?

25. Who are honored and/or placated in Gelede masking spectacles among the Yoruba peoples?

26. List three factors that have added to secularization of the arts in Africa:

 a.

 b.

 c.

27. Locate the homelands of the following groups on the map on Study Guide page 201:

 Yoruba Kongo Dogon
 Benin Asante Dan
 Nok Bangwa

DISCUSSION QUESTIONS

1. Discuss the role of ancestors in the traditional spiritual life of Africa, including the art forms and rituals that are used to evoke them.

2. How do the roles of art and the artist differ in African societies as contrasted with those in European and Asian cultures?

3. Describe briefly the function of masks in the cultures of Africa, Oceania, and among Native Americans in North America.

4. Compare the artistic and political effect and the symbolic meanings of the costumes of the Mandan chief (FIG. 17-44), the Ife king (FIG. 18-9), the French king (FIG. 25-12), the Byzantine emperor (FIG. 9-9), and the Egyptian pharaoh (FIG. 3-36). What does the clothing that leaders wear in our society say about the way they see their role?

Fill in the chart as much as you can from memory; then check your answers against the text and complete the chart.

SUMMARY OF AFRICAN ART

	Typical Examples	Stylistic Characteristics	Cultural Factors
Rock Art			
Nok			
Yoruba			
Bangwa			

SUMMARY OF AFRICAN ART (continued)

	Typical Examples	Stylistic Characteristics	Cultural Factors
Dogon			
Igbo			
Kongo			
Dan			
Akan			
Benin			
Kuba			
Baule			

AFRICA

COMPARATIVE CHRONOLOGY

For each of the periods and cultures listed below, enter the approximate time spans in the appropriate spaces on the following chronological chart.

India: Indus valley civilization; Maurya, Sunga, Andhra, Kushan, and Gupta periods; Muslim invasions

China: Shang, Zhou, and Han dynasties; Three Kingdoms; Tang, Northern and Southern Song, Yuan, and Ming dynasties

Japan: Jomon culture; Asuka, Nara, Fujiwara, Heian, Kamakura, Ashikaga, Momoyama, and Edo (Tokugawa) periods

Pre-Columbian America: Chavín, Olmec, Moche, Nasca, Classic Maya, Teotihuacán, Tiahuanaco, Aztec, Inca, and Mesa Verde cultures

Europe and the Near East: Sumerian, Egyptian Old Kingdom, Egyptian New Kingdom, Assyrian, Greek, Roman, Early Byzantine, Carolingian, Romanesque, Gothic.

	India	China	Japan	Pre-Columbian America	Europe and the Near East
3000 B.C.					
2500 B.C.					
2000 B.C.					
1500 B.C.					
1000 B.C.					
500 B.C.					
B.C. / A.D.					
A.D. 500					
A.D. 1000					
A.D. 1500					
A.D. 2000					

SELF-QUIZ

PART THREE: THE WORLD BEYOND EUROPE

I. Matching. Choose the identification in the right column that best corresponds to the name or term in the left column and enter the appropriate letter in the space provided.

_____ 1. sutra

_____ 2. mandala

_____ 3. stupa

_____ 4. Guanyin

_____ 5. Siddhartha

_____ 6. makimono

_____ 7. bodhisattva

_____ 8. ukiyo-e

_____ 9. ushnisha

_____ 10. Moronobu

_____ 11. Kamakura

_____ 12. roof comb

_____ 13. stele

_____ 14. Chavín

_____ 15. kiva

_____ 16. Yoruba

_____ 17. tapa

_____ 18. malanggan

_____ 19. chaitya

_____ 20. guang

a. Buddhist goddess of compassion

b. an account of a sermon or dialogue involving the Buddha

c. a large mound-shaped Buddhist shrine

d. a person who is a potential Buddha

e. a Japanese horizontal scroll

f. Eskimo ceremonial object

g. a magical, geometric symbol of the cosmos

h. the man who became Buddha Sakyamuni

i. stylized protuberance of the Buddha's forehead symbolizing superhuman consciousness

j. pre-Columbian culture in South America

k. one of the first Japanese artists to use the woodblock technique to illustrate everyday subjects

l. a form of Japanese genre painting ("pictures of the floating world")

m. decoration on Maya temples

n. African language group

o. Buddhist assembly hall

p. intricately carved Melanesian ceremonial masks

q. carved stone slab or pillar, often used as a marker

r. cloth made from hammered bark

s. covered libation vessel from China

t. circular ceremonial center in a pueblo

u. Japanese city and period named after thirteenth- and fourteenth-century rulers

II. Matching. Choose the identification in the right column that best corresponds to the name or term in the left column and enter the appropriate letter in the space provided.

_____ 21. Han

_____ 22. Indus valley civilization

_____ 23. Dan

_____ 24. Maya

_____ 25. Dogon

_____ 26. Gupta

_____ 27. Shang

_____ 28. Inca

_____ 29. Heian

_____ 30. Kushan

_____ 31. Mimbres

_____ 32. Benin

_____ 33. Nok

_____ 34. Olmec

_____ 36. Tang

_____ 37. Aztec

_____ 38. Asante

_____ 39. Nasca

_____ 40. Tokugawa

_____ 41. Song

_____ 42. Jomon

_____ 43. Moche

_____ 44. Maurya

_____ 45. Melanesian

a. India

b. China

c. Japan

d. North America

e. South America

f. Africa

g. Oceania

h. Mexico and Central America

III. Multiple Choice. Circle the most appropriate answer.

46. Ceramic portrait jars with stirrup spouts were the most famous works produced by the a. Aztec b. Hopi c. Moche d. Inca e. Maya

47. Japanese painting of the Nanga School was most strongly influenced by a. Indian miniatures b. Momoyama screens c. ukiyo-e prints d. Chinese "literary" school painting e. a revival of forms from the Jomon period

48. The most striking characteristics of art of the Kamakura period were a. grace and delicacy b. strength and realism c. esoteric symbolism and religious significance d. decorative forms and rich gold work e. primitive power and awkward forms

49. Buddhism entered China in the period known as a. Shang b. Zhou c. Han d. Song e. Ming

50. One of the most important early Buddhist shrines, the Great Stupa, is located in a. Sanchi b. Khajuraho c. Ajanta d. Dunhuang e. Nara

51. The Shang period is most famous for its a. painted scrolls b. bronzes c. representations of the Buddha d. ceramic haniwas e. jade burial suits

52. Important cliff dwellings were found at a. La Venta b. Mesa Verde c. Tlingit d. Teotihuacán e. Colima

53. Mbari ceremonial houses were built in a. Mesa Verde b. Nigeria c. Peru d. Japan e. India

54. An important Maya site was a. Teotihuacán b. Cuzco c. Quito d. Tikal e. Chavín de Huántar

55. During the Heian period a new type of image was brought into Japan that a. was very delicate with graceful folds b. was decorated with complicated interlace patterns c. was heavier with multiple arms d. was markedly realistic e. showed a strong influence of Greco-Roman imagery

56. An important site in the early Indus valley civilization was a. Mohenjo-Daro b. Sanchi c. Borobudur d. Hōryū-ji e. Ajanta

57. Sixth-century Chinese artistic representations created under the influence of the Buddhist Paradise Sects, in contrast to those done for the Esoteric Sects, tended to stress a. more complex symbolism b. greater pomp c. increasing naturalism and grace d. stiffer, more formal compositions e. strange, awkward postures

58. The artistic traditions of Greece and Rome influenced those of Buddhism through contact in the region of a. Karli b. Sanchi c. Gandhara d. Elephanta e. Mohenjo-Daro

59. One of the most important Buddhist monuments of Southeast Asia was erected in the eighth century at a. Borobudur b. Bali c. Sanchi d. Angkor Thom e. Phnom Penh

60. The shrines of Angkor Wat and Angkor Thom are located in a. Thailand b. Cambodia c. Ceylon d. Burma e. Vietnam

61. A triple-headed image of Siva as the incarnation of the forces of creation, preservation, and destruction is an important image of which religious faith? a. Zen Buddhism b. Hinduism c. Islam d. Shinto e. Esoteric Buddhism

62. One of the earliest Buddhist temples in Japan was constructed during the seventh century near Nara and is known as the a. Yunkang b. Ise shrine c. Hōry©-ji d. Toyokuni shrine e. Lomas Rishi

63. The murals at the Ajanta caves best illustrate the characteristics of Gupta art, which are a. grace and delicacy b. exaggerated realism and power c. strong emotion and motion d. clarity, dignity, and serenity e. complicated symbolism and mannerist exaggeration

64. An important artistic form during the Jomon period was the creation of a. clay haniwa figures b. Buddhist images with many arms c. painted makimono d. bronze vessels e. figures of Siva dancing

65. An important fifteenth-century Japanese painter was a. Sessh© b. Hokusai c. Fan Kuan d. Ma Yuan e. Harunobu

66. The pre-Columbian peoples of West Mexico from the areas of Jalisco, Colima, and Nayarit are most famous for their a. stone sculpture b. weaving c. ceramics d. stone pyramids e. earth mounds

67. Which of the following features was least typical of Maya architecture? a. flying facades b. roof combs c. corbeled vaults d. stone construction e. flying buttresses

68. Pre-Columbian art was most highly developed in South America a. in the Central Andes region b. in the Amazon region c. near Tierra del Fuego d. in the jungle region of Brazil e. in what is now Argentina

69. Fine bronze work was done by the group known as a. Dogon b. Benin c. Nok d. Bangwa e. Dan

70. The South American culture located in the northwest corner of Colombia that is noted for exceptional metalwork is a. Tiahuanaco b. Tairona c. Inca d. Nasca e. Moche

71. As opposed to Native Americans of other regions, those of the Northwest Coast of America placed much greater emphasis on art as an expression of a. fertility rituals b. social status c. initiation rituals d. death rituals e. military might

72. In contrast to the style of Polynesian art, that of Melanesia is more a. restrained b. colorful and flamboyant c. simplified d. compact e. solid

73. Which of the following cultures made *least* use of masks? a. Melanesia b. Jomon c. Polynesia d. Northwest Coast of America e. Dan

74. Some of the most realistic representations in African art were done of the kings of a. Nok b. Ife c. Dan d. Tassili e. Kuba

75. Some beautiful Maya murals were found at a. Teotihuacán b. Tenochtitlán c. Bonampak d. Copán e. Veracruz

76. Giant stone heads found in La Venta are thought to have been done by the a. Colima b. Olmec c. Aztec d. Inca e. Moche

77. The capital of the Inca empire was located at a. Tiahuanaco b. Teotihuacán c. Tikal d. Cuzco e. Quito

78. Temple-topped pyramids where human sacrifice took place were important in the religious rituals of the a. Olmec b. Inca c. Aztec d. Tlingit e. Adena

79. Masterful use of the dry-masonry technique was an outstanding feature of the architecture of the a. Aztec b. Moche c. Inca d. Nasca e. Olmec

IV. Identification. Follow the instructions given in each question.

80. Below are two images of warriors. Attribute each of them to a country and a culture or period within that country, and provide each with an approximate date. Give the reasons for your attributions.

A. Country: _____

 Culture or Period: _____

 Date: _____

Reasons:

B. Country _____

 Culture or Period: _____

 Date: _____

81. Compare the two landscapes below, attributing each to a country and period, and providing an approximate date. Give the reasons for your attributions.

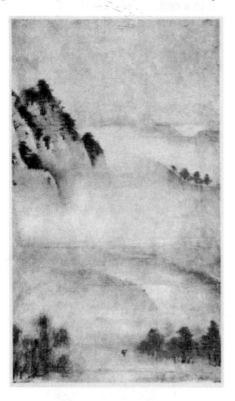

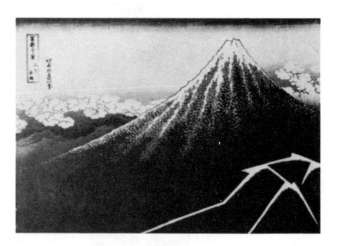

A. Country: _____ B. Country: _____

 Period: _____ Period: _____

 Date: _____ Date: _____

Reasons:

82. Discuss the relief below, attributing it to a country, group, or period, and providing an approximate date. Give the reasons for your attributions. What is the subject? How does it reflect the society that produced it?

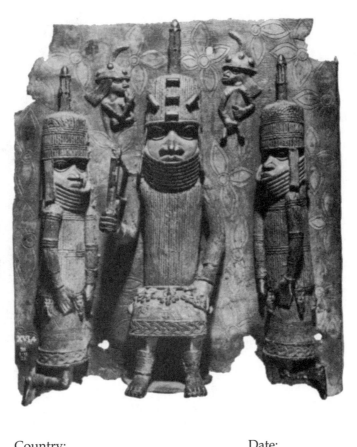

Country: _____ Date: _____

Group or Period: _____

Reasons:

83. Discuss the animal represented below, attributing it to a country, group or period and providing an approximate date. Give the reasons for your attribution.

Country: _____ Date: _____

Group or Period: _____

 Reasons:

84. Compare the two figures of women shown below, attributing each to a country and period, and providing an approximate date. Give the reasons for your attributions.

A. Country: _____

 Period: _____

 Date: _____

B. Country: _____

 Period: _____

 Date: _____

Reasons:

Part Four

The Renaissance and the Baroque and Rococo

CHAPTER 19

LATE GOTHIC ART IN ITALY

TEXT PAGES 624–647

1. Identify:

Cosmati

Dante — *Supreme poet of the age, wrote* <u>Inferno</u>, *which presents a whole theater of sin and suffering, characterizing the actors in sharp, realistic detail. His writings became immensely influential in later centuries.*

Frederick II — *Holy Roman Emporer*

Ghibellines — *the political party of the empire* ⎫
⎬ *who fought for control of the cities*
Guelphs — *the political party of the papacy* ⎭

Humanism – *a civil code of conduct, a theory of education, and a scholarly discipline. The chief concerns were human values and interests as distinct from - but not opposed to - other worldly values*
Petrarch *of religion.*
famous poet, scholar and man of letters. Honored for their achievements as much as the heroes were for their virtue.
Roger Bacon – *English Franciscan experimenter who* <u>stressed experience in acquiring knowledge.</u>

2. Name four Italian city-states that were very successful commercially during the Late Gothic period:

Bankers of Europe

a. *Venice* c. *Lucca*

b. *Milan* d. *Florence*

Papal Rome had most profitable banking transactions.

3. Which city-state claimed to be a self-governing republic based on the model of ancient Rome?

 Florence: a soverign Christian republic that severed all bonds to any feudal, royal, or ecclesiastical authority. To defend its own, + annex additional territory.

4. Name three Italian humanist scholars:

 a. *Petrarch* b. *Boccaccio* c. *Dante*

5. List three tendencies that characterized fourteenth-century religious life:

 a. *Personalizing the religious experience*

 b. *Longing for direct experience of God*

 c. *Revivalist worship*

6. List four elements of Franciscan "radicalism" that influenced the development of fourteenth-century art in Italy.

 a. *the primacy of personal experience*

 b. *the individual's right to know by experiment.*

 c. *the futility of formal philosophy*

 d. *the beauty and value of things in the external world.*

7. Identify two trends shown in the works of Nicola and Giovanni Pisano that later become significant in the development of Renaissance art.

 a.

 b.

8. Which style dominated medieval Italian painting?

 List three of its stylistic characteristics.

 a.

 b.

 c.

 How did Duccio modify this traditional style?

Name three changes made by him.

a.

b.

c.

9. Name the two locations where Giotto's frescoes can be found.

a. Galleria degli Uffizi, Florence, Italy

b. Arena Chapel, Padua, Italy

10. What seem to have been the artistic traditions that influenced Giotto and contributed to the shaping of his style?

Cavalini - + other Roman painters like him
Cimabue - his teacher, most likely
Art of Gothic sculptors of France
Ancient art of Rome
- Nature or the world of visible things

11. List four characteristics of Giotto's style as seen by comparing his *Madonna Enthroned* (FIG. 19-9) with Cimabue's version of the same subject (FIG. 19-8).

a. Sculptural solidity and weight

b. sturdy, queenly mother

c. body is not lost, but asserted, humanly of this world

d. seems to project a shadow, that there is some depth + dimension

12. How did Simone Martini help to form the so-called International Style?

He adapted the insubstantial but luxuriant patterns of French Gothic manner — to Sienese art, and acquainted Northern painters to the Sienese style.

List four characteristics of that style.

a. elegant shapes

b. radiant color

c. flowing, fluttering line

d. weightless figures in spaceless setting

13. Panoramic views of the city of Siena and its surrounding countryside were painted by
Ambrogio Lorenzetti in the Palazzo Pubblico in Siena as part of a fresco known as
Allegory of Good Judgement: The Effects of Good Government in the City and the Country.

What <u>revolutionary</u> aspects are found in this fresco (FIGS. 19-20 and 19-21)? *Combined Giotto's analytical powers with the narrative talen of Duccio.*

The mural elaborates Sienese advances in illusionistic representation spectacularly

Siena's rapidly growing knowledge of perspective is applied.

City & landscape are given particularly careful observation

14. What historical event seems to be the subject of *The Triumph of Death* (FIG. 19-22)?

Buonamico Buffalmacco (active 14th cent.)

Black Death - the great horror of the time

15. Locate the following on the map on Study Guide page 219:

Siena Venice Florence
Pisa Milan

DISCUSSION QUESTIONS

1. Compare the versions of *The Annunciation and the Nativity* by Nicola and Giovanni Pisano (FIGS. 19-2 and 19-3) with the Late Roman *Ludovisi Battle Sarcophagus* (FIG. 7-78). How are the Pisani works similar to this Roman example? How are they different from it and from each other?

2. Compare Giotto's *Death of St. Francis* (FIG. 19-14) with Duccio's *Betrayal of Jesus* (FIG. 19-6); note particularly the use of space, three-dimensional volume, and the sense of drama.

3. Discuss the effects of social and economic changes during the late thirteenth and late fourteenth centuries on Italian art of the period.

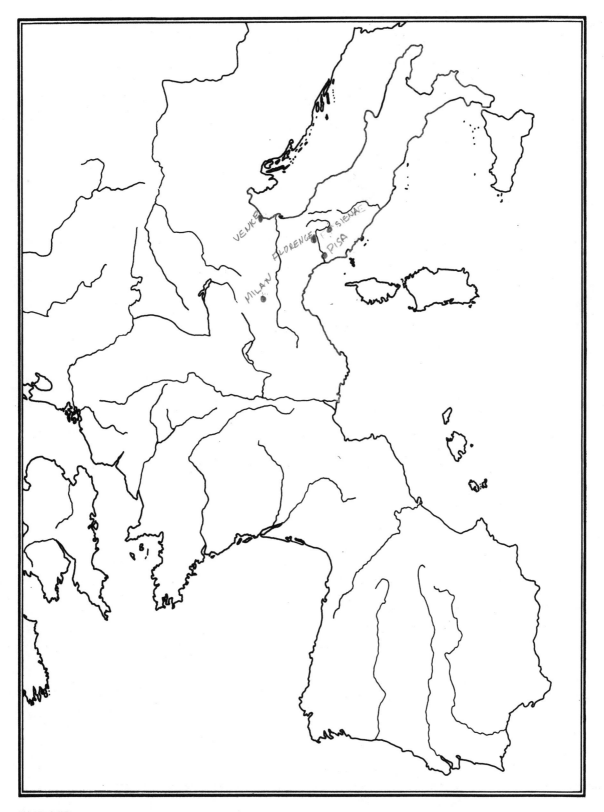

EUROPE

CHAPTER 20

FIFTEENTH-CENTURY ART
IN NORTHERN EUROPE AND SPAIN

TEXT PAGES 648–677

1. Define the following terms:

 alla prima

 engraving

 hatching

 impasto

 intaglio

 polyptych

 retable

 triptych

 woodcut

2. Identify the following:

 Burgundian Netherlands

 Chartreuse de Champmol

 Jacques Coeur

 John of Berry

 Nuremberg Chronicle

 Philip the Bold

3. How does the house of Jacques Coeur (FIG. 20-1) illustrate the new economic conditions of northern Europe in the Late Gothic period?

4. Name the two main sources of wealth in fifteenth-century Bruges.

 a.

 b.

5. Who were the most powerful rulers in northern Europe during the first three-quarters of the fifteenth century?

 Whom did they generally support during the Hundred Years War? Why?

6. Name the two northern dukes who are generally considered to have been the greatest patrons of the arts in northern Europe in the late fourteenth and early fifteenth centuries.

 a. b.

7. List four adjectives or phrases that characterize Claus Sluter's sculptural style.

 In comparison with the figures of Donatello, what seems to be missing from Sluter's conception of the figure?

8. In what ways did the earlier techniques of stained glass and illuminated-manuscript painting influence fifteenth-century panel painting in the north?

 a.

 b.

9. Who was Jean Pucelle?

10. What is a "Book of Hours"?

10. What is a "Book of Hours"?

11. Describe the stylistic characteristics that link the illuminations done by the Limbourg brothers with fourteenth-century Sienese painting.

 a.

 b.

 c.

 d.

12. Describe the role played by the Guild of St. Luke in the life of the northern painter in the fifteenth century and the way in which a young man attained membership in the guild.

 How did most women artists receive their training during the fifteenth and sixteenth centuries?

13. What painting technique was perfected by the fifteenth-century Flemish painters?

 Briefly describe the technique.

 In what respects did it prove to be superior to the tempera technique?

14. Who was the Master of Flémalle?

 List three characteristics of his style:

 a.

 b.

 c.

15. What did the book, candle, sink, and towels symbolize in *The Mérode Altarpiece* (FIG. 20-4)?

16. What is the basis of the controversy regarding Hubert van Eyck?

What part of the original *Ghent Altarpiece* did Lotte Brand Philip attribute to him?

17. What is the general theme of *The Ghent Altarpiece* (FIG. 20-5)?

Write the subjects of the various panels in the corresponding spaces below.

What is symbolized by the following groups on the lower wings?

hermits: judges:

pilgrims: knights:

18. How does Jan van Eyck use perspective in his *Virgin with the Canon van der Paele* (FIG. 20-6)?

 What does this indicate about van Eyck's conception of pictorial space?

19. What is new and significant about the pose of the *Man in a Red Turban* (FIG. 20-7)?

20. How did Nicholas of Cusa's writings provide a justification for the intense realism of fifteenth-century Flemish artists?

21. What was the probable purpose of the painting *Giovanni Arnolfini and His Bride* (FIG. 20-8)?

 List four symbols contained in the painting and give their meanings.

 a. c.

 b. d.

22. Which Flemish artist had the greatest influence on later fifteenth-century northern painting?

23. In contrast to the complex symbolism and optimism of Jan van Eyck, what did Rogier van der Weyden stress in his paintings?

24. List the Flemish characteristics of Rogier's *Portrait of a Lady* (FIG. 20-11) that distinguish it from the work of Italian artists such as Ghirlandaio (FIG. 21-55).

 a.

 b.

 c.

25. Name the two fifteenth-century Flemish painters who demonstrated the greatest interest in the depiction of space and cubic form.

 a. b.

26. Recent studies indicate that _____ was the first northern artist to utilize a single vanishing point for construction of an architectural interior.

27. Describe the distinctive qualities of style that set Hugo van der Goes's paintings apart from those of his contemporaries.

28. Who was Tommaso Portinari?

29. What is the symbolic meaning of the following items in the central panel of *The Portinari Altarpiece* (FIG. 20-15)?

 Iris and columbine:

 Sheaf of wheat:

 Harp of David:

 Where was *The Portinari Altarpiece* displayed?

30. In what sort of subject matter did Memling specialize?

 Briefly describe his style.

31. What are the primary subjects of the panels of Bosch's *Garden of Earthly Delights* (FIGS. 20-17 and 20-18)?

 Left:

 Center:

 Right:

List four of the sources that have been suggested for Bosch's iconography.

a.

b.

c.

d.

32. What is alchemy?

33. How was the style of Jean Fouquet modified by his Italian experiences?

34. The *Avignon Pietà* (FIG. 20-21) seems to be most closely related to the work of which Flemish artist?

What Italian elements are apparent in the painting?

35. List three characteristics of the style of Witz.

a.

b.

c.

36. What subject did Stoss depict in the center of the Kraków altarpiece (FIG. 20-23)?

List three typical Late Gothic characteristics of his style.

a.

b.

c.

37. What mood is most typically expressed in the figures carved by Tilman Riemenschneider?

38. In what country did Gil de Siloé work?

List two influences that are apparent in his style (FIG. 20-25):

a.

b.

39. In what medium did Martin Schongauer work?

Briefly characterize his style:

40. Locate the following on the map on Study Guide page 219:

Burgundy	Dijon	Tournai
Flanders	Paris	Cologne
Bruges	Ghent	

DISCUSSION QUESTIONS

1. Compare Sluter's figure of Moses (FIG. 20-2) with Donatello's *St. Mark* (FIG. 21-4). In what way do these figures typify the concerns of northern and Italian artists?

2. Compare the treatment of the architecture and landscape in the work by the Limbourg brothers (FIG. 20-3) with that in Ambrogio Lorenzetti's *Peaceful Country* (FIG. 19-21). In what ways are they similar? In what ways do they differ?

3. According to Lotte Brand Philip's reconstruction, how was *The Ghent Altarpiece* (FIG. 20-5) displayed originally, and how does that differ from its present state? Does her reconstruction seem reasonable? If not, why?

4. How does Jan van Eyck's approach to portraiture as shown in the portrait of Canon van der Paele (FIG. 20-6) differ from the approach of Italian portraitists?

5. Discuss *The Portinari Altarpiece* (FIGS. 20-14 and 20-15) by Hugo van der Goes; note especially the iconography and the meaning of the disguised symbols. What stylistic influence do you see from Jan van Eyck? How does this altarpiece differ from van Eyck's work?

6. Compare Rogier van der Weyden's *Escorial Deposition* (FIG. 20-10) with the similar subjects portrayed in *The Avignon Pietà* (FIG. 20-21), attributed to Enguerrand Quarton, and Giotto's *Lamentation* (FIG. 19-11). Which moves you the most? Why?

CHAPTER 21

FIFTEENTH-CENTURY ITALIAN ART:
The Early Renaissance

TEXT PAGES 678–727

THE FIRST HALF OF THE FIFTEENTH CENTURY TEXT PAGES 680–705

1. Define the following terms:

 aerial perspective

 cortile

 dressed stone

 horizon

 linear perspective *effect of distance*

 orthogonals

 predella

 rusticated stone

 sacra conversazione

 stringcourse

 vanishing point

2. Identify the following:

 Gattamelata

 Cosimo de' Medici

 Giorgio Vasari

 Jacobus de Voragine

 Leo X

Contrapposto - (counter positioning of the body) - one part of the body is turned opposite the other.

Weight shift - weight of the body tends to be thrown to one foot. Exam., Donatello's St. Mark

Lorenzo de' Medici

Marsilio Ficino

3. Which Italian city played the most important role in the development of Renaissance ideas and art forms in the early fifteenth century?

Florence, Italy

4. Who were the chief competitors for the commission of the east doors of the baptistery of Florence?

a.

b.

When was the competition held? Who won it?

5. In what way do Nanni di Banco's *Quattro Santi Coronati* (FIG. 21-3) differ in relation to their architectural setting from the portal figures of French Gothic churches (FIGS. 13-33 and 13-34)?

6. According to the text, what three elements constitute the art and personality of Donatello?

a. New realism based on the study of humanity + nature

b. An idealism found in the study of classical forms

c. A power of individual expression characteristic of genius

7. In what figure did Donatello first utilize the principle of weight shift?

St. Mark, which closed a millineum of medieval art, and turned a historical corner into a new era.

Describe contrapposto.

(counter positioning of the body)

Weight shift - weight of the body tends to be thrown to one foot. Appearance of motion in the human figure.

8. Describe how Donatello's *Zuccone* (FIG. 21-6) differs strikingly from traditional representations of prophets:

a. Zuccone is bald

b. Zuccone is draped in crumpled garment w/ deeply undercut folds

c. Zuccone's head discloses and appalling personality - full of crude power - even violence

9. The invention of linear perspective is generally attributed to __Brunelleschi__.

10. What is the major significance of Donatello's bronze statue of David (FIG. 21-10)?

David is looking at and † David seems to be conscious for the 1st time of the beauty, vitality & strength of his body. Self-awareness a dominant

Describe the Classical characteristics that are apparent in the figure. *theme in Renaiss. art.*

a. *Donatello re-invented the Classical nude.*

b. *Classical contrapposto*

11. Why did Brunelleschi design the dome of Florence Cathedral with an ogival rather than a semi-circular section?

12. Name two possible sources for the round arches supported by slender columns and framed by pilasters that Brunelleschi used as the major element for his design of the Ospedale degli Innocenti.

 a. b.

 What characteristics of the building create an impression of Classical rationality and logic?

 a.

 b.

 c.

 d.

13. Which of Brunelleschi's buildings most closely approximates the centralized plan?

 When was it begun?

14. The text names only one feature of the church of Santo Spirito (FIGS. 21-15 and 21-16) that uses proportions in a ratio of 1: 2, namely:

 Can you find others in the plan?

15. Who designed the Palazzo Medici-Riccardi?

 The design of the courtyard shows the influence of _____.

16. Although an artistic descendant of ___Giotto___, Masaccio used light to model his bulky figures in an entirely new way. How?

A light that comes from a specific source outside the picture. ~~This light strike the figures~~

17. Three basic characteristics of Masaccio's style seen in the *Tribute Money* (FIG. 21-23) include the following:

 a. chiaroscuro -

 b. individual figures are weighty and solemn

 c. placement of figures - grouped in circular depth

18. What two Renaissance interests are summed up in Masaccio's *Holy Trinity* fresco (FIG. 21-25)?

Realism based on observation
The application of mathematics to pictorial organizatio ~~observation~~ in the new science of perspective

19. List four fifteenth-century Italian painters who were deeply concerned with linear perspective.

 a. c. Masaccio

 b. d. Piero della Francesca

20. Piero della Francesca's great fresco cycle in San Francesco at ___Arezzo___ represents episodes from _True Cross (Legend of the,)_

21. What compositional device that was very popular with Renaissance artists is used effectively by Piero in the *Resurrection* (FIG. 21-30)?

The Golden Legend, by Voragine.

22. List five features of Piero's work that sum up developments in Italian painting in the first half of the fifteenth century.

 a. Realism

 b. Descriptive landscape

 c. Structural human figure

 d. Monumental composition

 e. Perspective

 f. Proportionality

 g. Light + Color

232

23. Fra Angelico combined elements from many styles in his work. Describe three elements he used in his fresco of the *Annunciation* (FIG. 21-32) and name their sources.

1. Simplicity of the statement - ~~Giotto~~ (rainbow-winged Angel)- Giotto

2. Elegant silhouette (sweetly shy Madonna)- Sienese art

3. Flower-carpeted enclosed garden (symbolic of the Virginity of Mary)- International Style Gothic

24. Under the influence of reliefs by Ghiberti and Donatello, Fra Filippo Lippi abandoned a style based on Masaccio's massive forms and developed his mature style, which is characterized by

a linear style that emphasizes the contours of his figures and permits him to suggest movement through flying and swirling draperies.

25. Locate the following on the map on Study Guide page 219:

Urbino Florence

DISCUSSION QUESTIONS

1. Analyze the relative strength of the Classical elements of Ghiberti's style by comparing the nude youth from his *Sacrifice of Isaac* (FIG. 21-2) with the Greek figure of Hermes (FIG. 5-70). Also compare Ghiberti's draped figure of Abraham from the same panel with the Greek figures from the Parthenon (FIG. 5-56) and the Gothic figures from Chartres (FIG. 13-32).

2. What degree of Classical influence is found in the work of Nanni di Banco (FIG. 21-3) in comparison with earlier works by Nicola Pisano (FIG. 19-2) and the figures from Reims Cathedral (FIG. 13-34)? Note particularly the mastery of the contrapposto pose.

3. What major change had taken place in the representation of pictorial space between the time Ghiberti created the panel of the *Sacrifice of Isaac* (FIG. 21-2) and his completion of the "Gates of Paradise" (FIG. 21-8)? How well did Ghiberti utilize the new ideas?

4. How does Donatello's *Gattamelata* (FIG. 21-11) differ from the equestrian portrait of the emperor Marcus Aurelius (FIG. 7-66) and the medieval *Bamberg Rider* (FIG. 13-55)? What was the apparent purpose of the high pedestal used with the *Gattamelata*?

5. Both the Church of the Katholikon (FIGS. 9-20 and 9-21) and the Pazzi Chapel (FIGS. 21-17 and 21-18) are characterized by a centralized plan, yet one is typical of medieval Byzantine structures while the other is often used as the prime example of a Renaissance building. In what ways are the Humanism and rationality of the Renaissance apparent in Brunelleschi's building?

6. What characteristics of style are shared by Gentile da Fabriano's *Adoration of the Magi* (FIG. 21-22) and Uccello's *Battle of San Romano* (FIG. 21-26)? To what style do these characteristics relate? What feature of the Uccello work indicates that it was painted in the fifteenth century?

7. Masaccio's *Holy Trinity* fresco (FIG. 21-25) and Campin's *Mérode Altarpiece* (FIG. 20-4) were done at about the same time. Compare them from the point of view of scale, medium, and treatment of space. Does Campin use linear perspective? Identify the orthogonals in each and locate the vanishing point, if one exists. How do the two works reflect the different concerns of Italian and northern artists?

8. What made perspective so important to Renaissance painters? Discuss Piero della Francesca's use of it in the *Resurrection* (FIG. 21-30).

9. Compare Piero della Francesca's *Flagellation* (FIG. 21-28) with Duccio's related composition (FIG. 19-6). What change has Piero made that lends his figures the air of monumental nobility?

10. In what ways is Fra Angelico's *Annunciation* (FIG. 21-32) related to earlier versions like that by Simone Martini (FIG. 19-18)? What has he learned from his contemporaries?

11. Discuss the use of space and line and the placement of the figures in Fra Filippo Lippi's *Madonna and Child with Angels* (FIG. 21-34) and Giotto's version of the same theme (FIG. 19-9). What is the religious impact of the different figure types and of the landscape background used by Fra Filippo?

THE SECOND HALF OF THE FIFTEENTH CENTURY TEXT PAGES 705–727

1. Name four cultural centers in Italy that became important in the second half of the fifteenth century, and note the leading family of each.

 a. *Urbino – Montefeltri family*

 b. *Mantua – Ganzaga family*

 c. *Milan – Sforza family*

 d. *Naples – Kings of Aragon*

2. What literary and cultural developments mark the second half of the century?

 a. *New interest in the Italian language and literature*

 b. *Beginnings of literary criticism (parallel to the development of theory in art and architecture).*

 c. *Foundation of academics (esp. the Platonic Academy of Philosophy in Florence)*

 d. *Introduction of the printing press.*

3. Describe the effects that the conquest of Constantinople by the Turks in 1453 had on the cultural and economic life of Italy.

 Caused an exodus of Greek scholars, to arrive in Italy bringing with them knowledge of ancient Greece to feed the avid interest in Classical art, literature, + philosophy.

4. What fifteenth-century Renaissance scholar, known primarily for his achievements in architecture, comes closest to realizing the Renaissance ideal of *l'uomo universale*?

 The conquest also closed the Mediterranian to Western shipping, making it necessary to find new routes to the markets of the East. Thus, the age of navigation, discovery, and exploration.

5. Three principles advocated by Leon Battista Alberti in his *De re aedificatoria* were

6. Define the following terms:

 bottega

 di sotto in sù

 engraving

 entablature

 pilaster

 tondo

7. What feature does the Palazzo Rucellai (FIG. 21-35) share with the Roman Colosseum (FIG. 7-39)?

 In what way is it markedly different?

8. Which Romanesque church seems to have influenced Alberti when he designed the facade of Santa Maria Novella?

 How did he modify the Romanesque original to create a highly sophisticated Renaissance design?

9. Which building did Alberti renovate for Sigismondo Pandolfo Malatesta to serve as a neopagan temple?

 The design for the facade was based on that of a Roman _____.

10. The two Roman architectural motifs that Alberti locked together on the facade of Sant'Andrea in Mantua were

 a.

 b.

 How does the plan of the church break with a centuries-old Christian building tradition?

11. Why was the central plan felt to be appropriate for religious architecture during the Renaissance period?

12. The Renaissance ideal of a central-plan church was most nearly realized in the fifteenth century by the church of _____, which was designed by _____.

13. The tomb of Leonardo Bruni in Santa Croce by _____ best expresses the Humanistic concern with _____.

 Name two elements of the tomb's design that are Humanistic and classicizing.

 a.

 b.

14. In what way does Antonio Rossellino's bust of Matteo Palmieri (FIG. 21-47) differ from its Roman prototypes?

15. The fifteenth-century sculptor _____ is best known for his production of glazed terracotta reliefs.

16. One of the most important Italian sculptors of the second half of the fifteenth century, who was also a painter, was _Verrochio_.

 How does his *David* (FIG. 21-50) differ from Donatello's version (FIG. 21-10)?

 a. The narrative is of a brash, confident young man

 b. Open-form — sword pointed elbow stress live tension of still alert David — Donatello's stresses quite classical realism

 c. Anatomy-specific; in Donatello's it is general

 d.

écorché (as without skin)

17. What seems to have been Pollaiuolo's main artistic interest?

 Realistic concern for movement
 Stress + strain of human figure

18. The secularization of sacred themes can be seen in the portraits of Florentine women as represented in the fresco _The Birth of the Virgin_ (FIG. 21-54) by _placing her in a prominent place in the painting (center)_

19. Botticelli's Classical compositions were influenced by the philosophical system known as _Platonism_ ~~The Platonic Academy of Philosophy~~ which attempted to reconcile Classical philosophy with the beliefs of _Christianity_.

20. By what means did Marsilio Ficino believe that the soul could ascend toward union with God?
 By contemplation of beauty, the soul could progress from the love of the material—to the love of the abstract— to the love of the spiritual. The goal of the quest is the vision of God.

21. List three characteristics of Botticelli's style.

 a. _firm, pure outline_

 b. _light shading within contours_

 c. _elegant form_

22. Who was Girolamo Savonarola?

23. The Umbrian painter who exerted considerable influence on Michelangelo was _____.

 What interest did this artist share with Pollaiuolo?

 Another Umbrian painter, Perugino, was more concerned with _____.

24. One of the most brilliant and influential northern Italian artists of the fifteenth century was _____. His style is characterized by:

 a.

 b.

 c.

25. Locate the following on the map on Study Guide page 219:

Mantua Venice

DISCUSSION QUESTIONS

1. Who was Vitruvius? Why was his treatise important to Renaissance architects?

2. Give one example of a Renaissance central-plan church design. What are its advantages and its disadvantages?

3. Discuss the way in which Alberti applied the Classical orders to the facades of the buildings he designed.

4. Compare and contrast the images of *condottiere*, or military leaders, created by Donatello (FIG. 21-11) and Verrocchio (FIG. 21-51).

5. How did the members of Lorenzo de' Medici's Platonic Academy of Philosophy influence the art produced in Florence in the second half of the fifteenth century?

6. Compare the Renaissance portrait of *Matteo Palmieri* (FIG. 21-47) with the *Head of a Patrician* (FIG. 7-5) and head of *Vespasian* (FIG. 7-41). In what ways is the Renaissance example similar to the Roman portraits? In what ways do they differ?

7. How do the authors account for the popularity of the profile portrait in fifteenth-century Italy? What are its advantages and disadvantages?

8. Compare Schongauer's St. Anthony (FIG. 20-27) with Mantegna's representation of St. James (FIG. 21-60) from the points of view of technique, meaning, and emotional impact. What stylistic devices were used to achieve the differing effects?

CHAPTER 22

SIXTEENTH-CENTURY ITALIAN ART:
The High Renaissance and Mannerism

TEXT PAGES 728–787

THE HIGH RENAISSANCE TEXT PAGES 730–762

1. What dates are generally accepted as the span of the High Renaissance?

2. Who were the major art patrons in Rome during the High Renaissance?

3. According to Leonardo, what was the major purpose of his scientific investigations?

4. When did Leonardo move from Florence to Milan?

 Who was his patron in Milan?

 As what did Leonardo advertise himself to his new employer?

5. What two elements did Leonardo consider to be the heart of painting?

 a.

 b.

6. What compositional devices did Leonardo use in the *Virgin of the Rocks* (FIG. 22-1) to knit the figures together?

 a.

 b.

7. Define the following terms:

 atmospheric chiaroscuro

 cartoon (in fine arts usage)

8. What two fifteenth-century trends does Leonardo synthesize in the *Last Supper* (FIG. 22-3)?

 a.

 b

9. Although Leonardo's significance as a scientist may be disputed, his investigations in anatomy originated a tradition that is indispensable to modern science. What is that tradition?

10. Briefly describe four aspects of the sculptural appearance of Bramante's Tempietto.

 a.

 b.

 c.

 d.

11. Who was Julius II?

12. How much of the building of the new St. Peter's was completed during Bramante's lifetime?

 Name two architects other than Bramante who worked on St. Peter's during the sixteenth century.

 a.

 b.

13. List six terms that typify High Renaissance Classical ideals of design.

 a. d.

 b. e.

 c. f.

14. What is the basic structural form of the church of Santa Maria della Consolazione (FIG. 22-9)?

15. The influential Palazzo Caprini was designed by _____.

What feature of the building most clearly distinguishes its facade from those of fifteenth-century Italian palaces?

16. Who designed the Farnese Palace?

Who was his patron?

How does the Farnese Palace differ from the Palazzo Medici-Riccardi (FIG. 21-20)?

17. Raphael was apprenticed to _____ , who had been trained in Verrocchio's shop with Leonardo.

Based on a comparison of FIGS. 22-13 and 21-59, what do you think Raphael learned from his teacher?

In what ways did Raphael improve on his master's work?

18. Raphael worked in Florence from _____ to _____.

19. List three characteristics of Raphael's style as seen in the *Madonna with the Goldfinch* (FIG. 22-14).

a.

b.

c.

20. Name the four general themes Raphael used for his paintings in the Stanza della Segnatura.

a.

b.

c.

d.

21. Who are the two central figures represented in Raphael's *School of Athens* (FIG. 22-15), and what aspects of philosophy does each represent?

22. On the death of Julius II, a son of Lorenzo de' Medici was elected as Pope _____.

23. Who was Baldassare Castiglione?

24. Michelangelo's belief that beauty is a reflection of the divine in the material world derives from what philosophical system?

25. To what extent did Michelangelo utilize the mathematical procedures used by other Renaissance sculptors to achieve harmonious proportion?

26. What is meant by the term *terribilità*?

27. In what two cities did Michelangelo do most of his work?

 a. b.

28. List three figures that Michelangelo is believed to have created for the tomb of Julius II.

 a. b. c.

 What are the two slaves thought to represent?

29. Briefly describe the iconography of the Sistine Chapel ceiling.

30. Characterize Michelangelo's style in painting and sculpture with four adjectives or phrases.

 a.

 b.

 c.

 d.

31. Describe briefly the iconography of the tombs of Lorenzo and Giuliano de' Medici.

 What are the tombs thought to symbolize?

32. List four of the "anti-Classical" features in Michelangelo's design for the vestibule of the Laurentian Library.

 a.

 b.

 c.

 d.

33. With what urban project did Michelangelo enter the field of city planning?

 What limitations did he have to cope with?

34. Describe the changes Michelangelo made in Bramante's original designs for St. Peter's.

 a. In the plan:

 b. In the elevation:

35. Who completed the dome of St. Peter's?

36. Which late work by Michelangelo best reflects the conditions brought on by the Protestant Reformation and the changed religious climate in Italy?

37. List three stylistic characteristics of Andrea del Sarto's *Madonna of the Harpies* (FIG. 22-35) that identify the painting as a High Renaissance work.

 a.

 b.

38. What was Correggio's most enduring contribution to the field of painting?

DISCUSSION QUESTIONS

1. How did the status of the visual artist change in the High Renaissance? What was the reason for this?

2. Compare the compositions of the *Last Supper* by Leonardo (FIG. 22-3) and the work by the same title by Dirk Bouts (FIG. 20-13) from the point of view of style, handling of space and form, and dramatic impact.

3. Compare Leonardo's *Mona Lisa* (FIG. 22-4) with Ghirlandaio's *Giovanna Tornabuoni* (FIG. 21-55); consider the placement of the figures, the definition of form, and the emotional effect achieved by each artist in creating a portrait.

4. Why is Bramante's Tempietto often referred to as the first High Renaissance building? What are the basic qualities that distinguish it from a typical Early Renaissance building?

5. How does the church of Santa Maria della Consolazione (FIG. 22-9) "express the Classical ideals of the High Renaissance"? Do you feel that the building reflects a religious attitude that is different from the medieval one? If so, what is the difference? How is it expressed?

6. How does the iconography of the Stanza della Segnatura relate to the ideals of the High Renaissance?

7. Compare Raphael's *Galatea* (FIG. 22-16) with Botticelli's *Birth of Venus* (FIG. 21-57); note the differences in the handling of space and the representation of the bodies. What are the sources for the two subjects?

8. Compare Michelangelo's *David* (FIG. 22-19) with Polykleitos' *Doryphoros* (FIG. 5-42) from a stylistic point of view. What similarities do you see? What differences? What distinguishes Michelangelo's *David* as a High Renaissance figure?

9. Choose a typical composition by Raphael, one by Leonardo, and one by Michelangelo, and decide in what ways they are stylistically related and in what ways they differ. Do you think the differences relate to the personalities of the artists? Are the similarities helpful in allowing us to make any generalizations about High Renaissance style?

10. Discuss the influence of Neo-Platonism on the art of Michelangelo; cite specific works and explain the Neo-Platonic ideals implicit in each.

MANNERISM AND VENICE TEXT PAGES 762–787

1. When was the Mannerist style most popular?

2. List five of the characteristics of Mannerist painting that can be called "anti-Classical" and that distinguish the Mannerist from the High Renaissance style.

 a. d.

 b. e.

 c.

3. Name three Mannerist painters.

 a. b. c.

4. List three characteristics that Sofonisba Anguissola's *Portrait of the Artist's Sisters and Brother* (FIG. 22-43) shares with other Mannerist portraits like those by Bronzino:

 a.

 b.

 c.

 List one feature that is uniquely hers:

5. Which Italian Mannerist sculptor most strongly influenced the development of French Renaissance art at Fontainebleau?

6. Which Mannerist sculptor developed the compositional device of the spiral?

7. Describe at least four features of the Palazzo del Tè thai are "irregular" from the point of view of Renaissance architectural practice.

 a.

 b.

 c.

 d.

8. The State Library of San Marco in Venice was designed by _____.

 What feature of the building seems to have been modeled after the Roman Colosseum?

 What decorative scheme was used for the second story?

 How did the treatment of the roofline differ from traditional practice?

 In what ways does the library hamonize with the older Doge's Palace opposite it?

9. What was most significant about Palladio's writings?

10. What geometric forms did Palladio use to create the basic structure of the Villa Rotonda (FIG. 22-51)?

11. Describe the device Palladio used for the facade of San Giorgio Maggiore (FIG. 22-53) to integrate the high central nave and low aisles.

12. In what ways does Palladio's architectural style differ from that of Mannerism?

13. What were the major formative influences on Bellini's style of painting?

14. What major High Renaissance characteristics found in Bellini's *San Zaccaria Altarpiece* (FIG. 22-56) distinguish it from his earlier *San Giobbe Altarpiece* (FIG. 22-55)?

15. What concerns distinguish the art of Venice from that of Florence and Rome?

Venice	Florence and Rome
a.	a.
b.	b.
c.	c.

16. Briefly characterize the Venetian approach to landscape painting.

17. Briefly describe three aspects of Giorgione's style.

 a.

 b.

 c.

18. Why is Titian generally considered to be "the father of the modern mode of painting"?

19. Which painting of his teacher, Bellini, did Titian complete?

20. In the allegory *Sacred and Profane Love* (FIG. 22-59), the nude figure symbolizes _____ while the dressed figure symbolizes _____.

21. What characteristics of Titian's *Madonna of the Pesaro Family* (FIG. 22-60) are typical of High Renaissance painting?

 a.

 b.

 What features of the work are not typical of the High Renaissance?

 a.

 b.

22. Which of Titian's paintings established the compositional essentials for the representation of the female nude in much of later Western art?

23. Emperor _____ and his son _____ were among Titian's greatest patrons.

24. Titian's late style, as seen in *Christ Crowned with Thorns* (FIG. 22-63) is characterized by

 a.

 b.

 c.

25. Tintoretto aspired to combine the color of _____ with the drawing of
 _____.

26. What devices does Tintoretto use to identify Christ in his version of the *Last Supper* (FIG. 22-65)?

 How did Leonardo identify him (FIG. 22-3)?

 What style did Tintoretto anticipate?

27. List three characteristics of Tintoretto's painting style that are not Manneristic.

 a.

 b.

 c.

28. Veronese's favorite subjects were

 a. b.

 His architectural settings often reflect the style of _____. To what aspects of his
 paintings did the Holy Office of the Inquisition object?

29. What is the difference in the type of illusion created by Veronese in the *Triumph of Venice* (FIG. 22-67) and
 that created by Correggio for the dome of Parma Cathedral in the *Assumption of the Virgin* (FIG. 22-36)?

DISCUSSION QUESTIONS

1. What was Venice's political and economic situation during the sixteenth century? How do you account
 for the apparent fact that Venice reached the height of its artistic productivity during a period of political
 and economic decline? Can you think of more recent parallels to this phenomenon?

2. In what respects is the Villa Rotonda *not* typical of Palladio's general villa style? How does the building combine functional qualities with esthetic ideals that were important to Renaissance architects?

3. Compare Palladio's San Giorgio Maggiore (FIGS. 22-53 and 22-54) with Sant'Andrea by Alberti (FIGS. 21-40 to 21-42). What differences do you see in the articulation of the facades and the interiors? Note also the degree of plasticity of the surfaces.

4. Compare Titian's *Madonna of the Pesaro Family* (FIG. 22-60) with Bellini's *San Giobbe Altarpiece* (FIG. 22-55). Discuss the organization of space, the compositional devices used, and the treatment of the figures in each painting.

5. Compare Bronzino's *Venus, Cupid, Folly, and Time* (FIG. 22-41) with Giorgione's (and/or Titian's?) *Pastoral Symphony* (FIG. 22-58). Note the poses of the figures, the settings, and the compositions. What do you think were the major concerns of each artist?

6. Discuss the different styles preferred by artists of Venice and those of Florence. What factors do you think might have influenced these preferences?

7. In what ways are the styles of the Early Renaissance in Florence, the High Renaissance in Rome, Mannerism in Florence, and the Late Renaissance in Venice typified in the portraits by Botticelli (FIG. 21-56), Raphael (FIG. 22-17), Bronzino (FIG. 22-42), and Titian (FIG. 22-62)?

8. Compare Andrea del Sarto's *Madonna of the Harpies* (FIG. 22-35) with Bellini's *San Zaccaria Altarpiece* (FIG. 22-56) and Parmigianino's *Madonna with the Long Neck* (FIG. 22-40); consider the handling of space, the logic (or lack of it) of the compositions, and the treatment of the figures, including placement and proportions. What emotional effect does each artist create? Which painting do you like best? Why?

9. Compare the facade designs of Antonio da Sangallo's Farnese Palace (FIG. 22-11), Alberti's Palazzo Rucellai (FIG. 21-35), Michelangelo's Museo Capitolino (FIG. 22-30), and Giulio Romano's Palazzo del Tè (FIG. 22-46). Which building seems to be the most monumental? Why?

SUMMARY OF LATE GOTHIC ART IN ITALY

Fill in this chart as much as possible from memory; then check your answers against the text in Chapter 19.

	Typical Examples	Stylistic Characteristics
Nicola Pisano		
Giovanni Pisano		
Maniera Greca		
Duccio		
Giotto		
Cavallini and Cimabue		
Simone Martini		
The Lorenzetti		

SUMMARY: FOURTEENTH- THROUGH SIXTEENTH-CENTURY ITALIAN ART

Text Pages 624–647, 678–787

Fill in the following charts as much as possible from memory; then check your answers against the text in Chapters 19, 21, and 22 and complete the charts.

HISTORICAL BACKGROUND

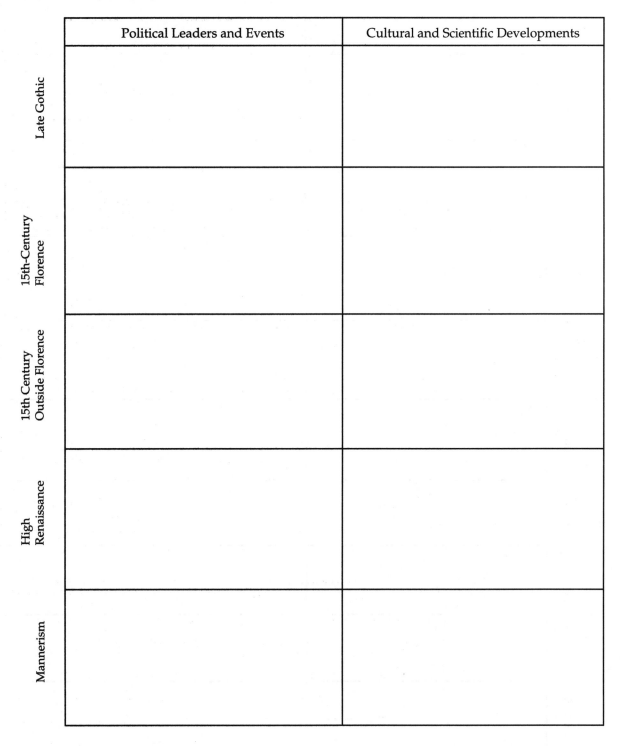

	Political Leaders and Events	Cultural and Scientific Developments
Late Gothic		
15th-Century Florence		
15th Century Outside Florence		
High Renaissance		
Mannerism		

SUMMARY OF FIFTEENTH-CENTURY ITALIAN ART: EARLY RENAISSANCE PAINTING

	Typical Examples	Stylistic Characteristics
Masaccio		
Uccello		
Andrea del Castagno		
Piero della Francesca		
Fra Angelico		
Pollaiuolo (engraving)		
Ghirlandaio		
Botticelli		
Signorelli		
Perugino		
Mantegna		

252

SUMMARY OF SIXTEENTH-CENTURY ITALIAN PAINTING OUTSIDE VENICE

	Typical Examples	Stylisitc Characteristics
Leonardo		
Raphael		
Michelangelo		
Andrea del Sarto		
Correggio		
Pontormo		
Rosso Fiorentino		
Parmigianino		
Bronzino		

SUMMARY OF SIXTEENTH-CENTURY VENETIAN PAINTING

	Typical Examples	Stylistic Characteristics
Bellini		
Girogione		
Titian		
Tintoretto		
Veronese		

SUMMARY OF RENAISSANCE AND MANNERIST SCULPTURE IN ITALY

	Typical Examples	Stylistic Characteristics
Ghiberti		
Donatello		
Antonio Rosselino		
Verrocchio		
Michelangelo		
Cellini		
Giovanni da Bologna		

SUMMARY OF RENAISSANCE AND MANNERIST ARCHITECTURE IN ITALY

	Typical Examples	Stylistic Characteristics
Brunelleschi		
Michelozzo di Bartolommeo		
Alberti		
Bramante		
Antonio da Sangallo		
Michelangelo		
Giulio Romano		
Sansovino		
Palladio		

CHAPTER 23

SIXTEENTH-CENTURY ART IN NORTHERN EUROPE AND SPAIN

TEXT PAGES 788–815

1. Identify the following:

 Charles V

 Erasmus of Rotterdam

 Francis I

 Henry VIII

 Martin Luther

 Philip II

 St. Ignatius of Loyola

2. List three means by which sixteenth-century German artists became aware of the developments in Italian art.

 a.

 b.

 c.

3. To what period of Italian art does the most brilliant period of German sixteenth-century art correspond?

4. What was the Danube style?

 Who was its primary representative?

5. Who is generally credited with having painted the first landscape without human figures in Western art?

6. Who painted *The Isenheim Altarpiece* (FIG. 23-3)?

 How is the altarpiece constructed?

 List three characteristics of the artist's style.

 a.

 b.

 c.

7. What is the subject of the predella of *The Isenheim Altarpiece?*

8. Name an important Italian work that was done about the same time as *The Isenheim Altarpiece.*

 Point out at least two differences between the works.

 a.

 b.

9. Which northern artist is generally considered to have been the first to fully understand the basic aims of the Italian Renaissance?

 Name two Renaissance masters whose works he copied.

 a. b.

 His interest in scientific illustration and artistic theory was similar to that of _____.

10. In what decade did Dürer create the Apocalypse series?

 The woodcut series is based upon the visions of _____ as related in _____.

 List three stylistic characteristics of the woodcut series.

 a.

 b.

 c.

11. The poses of Dürer's *Adam and Eve* are similar to the figures of _____ and
_____.

12. Describe the major difference that you see between Dürer's portrait of *Hieronymus Holzschuher* (FIG. 23-8)
and Raphael's portrait of *Baldassare Castiglione* (FIG. 22-17).

13. Give a brief description of the possible meaning of Dürer's *Melencolia I* (FIG 23-9).

14. In what way does Dürer's *Knight, Death, and the Devil* (FIG. 23-10) symbolize the *vita activa*?

15. Point out those characteristics of Dürer's *Four Apostles* (FIG. 23-11) that it shares with Italian High
Renaissance works.

Which features of the work are essentially "Germanic" and thus set it apart from Italian art?

16. In what type of painting did Holbein specialize?

17. Why is Holbein believed to have left Basel for England?

18. List five characteristics of Holbein's style that are seen in his double portrait of *The French Ambassadors*
(FIG. 23-12).

a.

b.

c.

d.

e.

19. What does *anamorphic* mean?

20. Name two early sixteenth-century artists who tried, with varying degrees of success, to integrate Italian Renaissance characteristics into their native Netherlandish style.

 a. b.

21. List four new types of subject matter that became popular in sixteenth-century Flemish art.

 a. c.

 b. d.

22. The leading artist of the school of Antwerp during the early decades of the sixteenth century was
 _____.

23. What was a Flemish "Romanist"?

24. What name did Jan Gossaert adopt?

 Which features of his *Neptune and Amphitrite* (FIG. 23-14) are Classical?

 Which are not?

25. List three characteristics of Bruegel's landscape paintings

 a.

 b.

 c.

26. What is thought to have been the meaning of Bruegel's *Peasant Dance* (FIG. 23-17)?

27. What contemporary political events do some of Bruegel's paintings seem to reflect?

28. Who painted a famous portrait of Francis I?

29. Name two Italian Mannerists who were instrumental in the formation of the School of Fontainebleau:

 a. b.

30. List three Manneristic characteristics that are seen in the decoration of the Gallery of Francis I at Fontainebleau:

 a.

 b.

 c.

31. List three Italian Renaissance features of the Chateau de Chambord:

 a.

 b.

 c.

 List two French Gothic features:

 a.

 b.

32. Identify those features of the facade of the Louvre courtyard (FIG. 23-21) that are derived from the Italian Renaissance and those that are essentially French.

 Italian:

 a.

 b.

 c.

 French:

 a.

 b.

 c.

33. The architect who designed the Square Court of the Louvre was _____
 and the sculptor who ornamented the facade was _____.

34. Describe the Plateresque style.

35. What features of Bramante's Tempietto (FIG. 22-6) did Machuca use in the palace he designed for Charles V in Granada (FIG. 23-24)?

36. The Escorial was constructed for King _____ of Spain.

 Describe the style of the building.

37. Two seemingly opposing spiritual trends appear to have been expressed in Spanish art during the period of the Counter-Reformation. What are they?

 a.

 b.

38. Describe two elements of El Greco's style that seem to be related to Italian Mannerism.

 a.

 b.

 Describe two elements that point toward the Baroque.

 a.

 b.

 Describe two purely personal stylistic traits that are found in El Greco's work.

 a.

 b.

39. Locate the following on the map on Study Guide page 219:

Nuremberg	Basel	Granada
Toledo	Antwerp	Madrid

DISCUSSION QUESTIONS

1. What different conceptions of the nude and of Classical mythology are apparent in Correggio's *Jupiter and Io* (FIG. 22-37) and Cranach's *Judgment of Paris* (FIG. 23-2)?

2. Make a stylistic comparison of Grünewald's *Resurrection* (FIG. 23-4) with that of Piero della Francesca (FIG. 21-30). Discuss color, form, composition, structure, and dramatic impact. Which do you like better? Why?

3. Compare Grünewald's *Isenheim Altarpiece* (FIGS. 23-3 and 23-4) with the van Eycks' *Ghent Altarpiece* (FIG. 20-5). Discuss the iconography, the handling of light, color, and space, as well as the emotional impact. What kind of landscape setting does each use? How does each treat the human figure?

4. Compare the pose and proportions of the Van Eycks' (FIG. 20-5), Massaccio's (FIG. 21-24) and Dürer's (FIG. 23-6) representations of Adam and Eve. How do these figures relate to Classical proportions and the contrapposto pose?

5. In what ways do you think Dürer and Leonardo were alike? In what ways do you think they were different?

6. Discuss the implications of Dürer's statement: "We regard a form and figure out of nature with more pleasure than any other, though the thing itself is not necessarily altogether better or worse."

7. Compare the Classicism of the Escorial (FIG. 23-25) with that of the Chateau de Chambord (FIG. 23-20). What does each building tell about the life and interests of the kings who commissioned them?

8. What stylistic features does the work by El Greco (FIG. 23-28) share with the following artists: Parmigianino (FIG. 22-40), Rosso and Primaticcio (FIG. 23-19), Cellini (FIG. 22-44), Goujon (FIG. 23-22)? How does his work differ from theirs?

SUMMARY: FIFTEENTH- AND SIXTEENTH-CENTURY ART IN NORTHERN EUROPE AND SPAIN

TEXT PAGES 648–677, 788–815

Fill in the following charts as much as possible from memory; then check your answers against the text in Chapters 20 and 23 and complete the charts.

HISTORICAL BACKGROUND

	Political Leaders and Events	Religious, Cultural, and Scientific Developments
15th-Century Flanders		
16th-Cnetury Flanders		
15th-Century France		
16th-Century France		
15th-Century Germany		
16th-Century Germany		

SUMMARY OF RENAISSANCE PAINTING IN FIFTEENTH-CENTURY FLANDERS

	Typical Examples	Stylistic Characteristics
Limbourg Brothers		
Campin		
Jan van Eyck		
Rogier van der Weyden		
Christus		
Bouts		
Hugo van der Goes		
Memling		
Bosch		

SUMMARY OF RENAISSANCE PAINTING IN SIXTEENTH-CENTURY NETHERLANDS

	Typical Examples	Stylistic Characteristics
Metsys		
Gossaert		
Spranger		
Bruegel		

SUMMARY OF FRENCH RENAISSANCE ART

	Typical Examples	Stylisitic Characterisitics
Fouquet		
Clouet		
Rosso at Fontainebleau		
Goujon		
Lescot		

SUMMARY OF GERMAN RENAISSANCE ART

	Typical Examples	Stylistic Characteristics
Lochner		
Witz		
Riemenschneider		
Pacher		
Schongauer		
Altdorfer		
Cranach		
Grünewald		
Dürer		
Holbein		

CHAPTER 24

BAROQUE ART

TEXT PAGES 816–877

INTRODUCTION TEXT PAGES 818–820

1. Give the approximate dates that embrace the Baroque period.

2. List as many adjectives or phrases that describe the Baroque style as you can think of.

 a. e.

 b. f.

 c. g.

 d. h.

3. What discoveries in the physical sciences fascinated Baroque artists and may be held responsible, at least in part, for the change in style from the Renaissance to the Baroque?

 a.

 b.

 c.

4. Poussin and Rubens were considered as the two poles in the Baroque debate between the forces of passion and reason. Which pole did each artist represent? What characteristics in the work of each artist reflect their attitudes?

 Rubens:

 Poussin:

THE SEVENTEENTH CENTURY IN ITALY AND SPAIN TEXT PAGES 820–848

1. The city that is generally thought to have been the birthplace of Baroque art is _____.

2. With what religious movement is much of the Baroque art in Catholic countries associated?

3. List three ways in which Maderno's early Baroque church of Santa Susanna (FIG. 24-1) resembles the church of Il Gesù (FIG. 22-48):

 a.

 b.

 c.

 List three ways in which they differ:

 a.

 b.

 c.

4. Name four architects who worked on St. Peter's and note the primary contribution of each.

 a.

 b.

 c.

 d.

5. Describe the illusionistic devices that Bernini used to make the Scala Regia (FIG. 24-5) appear longer.

6. What is a *baldacchino?*

7. List four major characteristics of Bernini's sculpture that are typical of Baroque art in general.

 a.

 b.

 c.

 d.

8. In what way did Bernini depict the vision of Saint Theresa?

9. Who developed the sculptural architectural style to its extreme?

 Name two buildings designed by him.

 a. b.

 Both are located in the city of _____.

10. While the circle had been the ideal geometric figure to Renaissance architects, Baroque planners preferred the _____.

 Why?

11. What is the purpose of the lateral, three-part division of Baroque palace facades?

 Upon what human psychological tendency does it seem to be based?

12. In what countries were the architectural styles of Borromini and Guarini particularly influential?

 a.

 b.

 c.

13. What Venetian church may have inspired the centralized plan used by Longhena for the church of Santa Maria della Salute?

 Describe the features of Santa Maria della Salute that look back to the Renaissance.

 Describe the features that can be considered more typically Baroque.

14. The "naturalistic" strain in Baroque art was most pronounced in the countries of
_____ and _____.

15. List three assumptions that were basic to the teaching of art at the Bolognese academy.

 a.

 b.

 c.

 Who founded that academy?

16. What earlier work strongly influenced Annibale Carracci's ceiling frescoes in the gallery of the Farnese Palace in Rome?

 How did Carracci modify the original to achieve heightened illusionism?

17. Define the following terms:

 quadro riportato

 tenebrism

18. The common purpose of Caravaggio's *Conversion of St. Paul* (FIG. 24-24) and Bernini's *Ecstasy of St. Theresa* (FIG. 24-10) was:

19. List three characteristics of Caravaggio's style.

 a.

 b.

 c.

20. Why were some of Caravaggio's works refused by the people who had commissioned them?

21. What was Caravaggio attempting to present in his religious pictures?

 What pictorial devices did he use to achieve his goal?

22. Describe the features of Domenichino's *Last Communion of St. Jerome* (FIG. 24-27) that were adapted from Caravaggio.

 a.

 b.

 Describe the features that reflect the mood of the High Renaissance.

 a.

 b.

23. Which artist most influenced the style of Artemisia Gentileschi?

24. Who were Judith and Holofernes?

25. Who is credited with developing the "Classical" or "ideal" landscape?

 What were its roots?

26. Briefly describe Rosa's landscape style.

27. Name an Italian Baroque artist who specialized in illusionistic ceiling painting.

28. Ribera's style was influenced by the "dark manner" of:

29. What type of lighting did Zurbarán prefer?

30. Velázquez was court painter to King _____.

31. In contrast to the idealized Italian treatment of Classical themes, Velázquez depicted Bacchus and his followers in a style that could be described as:

32. Who suggested to Velázquez that he visit Italy?

 How did this visit affect Velázquez's style?

33. What is the subject of *Las Meninas?*

 How many levels of reality can you find in the picture?

 Briefly describe them.

 What painting technique did Velázquez use in *Las Meninas?*

DISCUSSION QUESTIONS

1. Compare Bernini's *David* (FIG. 24-8) with Michelangelo's version (FIG. 22-19). Discuss the pose of the figures, the closed or open quality of the composition, and the mood that is created by these technical devices.

2. Study the elevations and plans of Giuliano da Sangallo's Church of Santa Maria delle Carceri at Prato (FIGS. 21-43 to 21-45) and Borromini's San Carlo alle Quattro Fontane (FIGS. 24-11 and 24-12). Contrast the basic shapes used in the plans, and describe how these forms relate to the elevations of the buildings.

3. Discuss the different views of the interrelation of realism and of Classical antiquity as illustrated in Titian's *Venus of Urbino* (FIG. 22-61) and Velázquez's *Los Borrachos* (FIG. 24-34).

4. Compare Ribera's *Martyrdom of St. Bartholomew* (FIG. 24-32) with Mantegna's *St. James Led to Martyrdom* (FIG. 21-60). Discuss composition, painting technique, and emotional impact. What major concerns of the Italian Renaissance and the Counter-Reformation in Spain are demonstrated by these works?

5. Bernini's art has been described as "theatrical." If you agree, give examples of its theatricality.

THE SEVENTEENTH CENTURY IN FLANDERS AND HOLLAND TEXT PAGES 848–865

1. Why did the northern provinces of the Low Countries break away from Spain?

 The northern provinces constitute the modern country of _____, while those in the south constitute the country of _____. During the seventeenth century, this southern region was known as _____.

2. The painting style of Rubens synthesizes those of the Renaissance masters _____ and _____ with the styles of the Baroque masters _____ and _____.

3. Rubens's favorite theme was:

 What sort of a mood do his paintings most often reflect?

4. What member of the famous Florentine House of Medici commissioned Rubens to paint a cycle memorializing and glorifying her career and that of her late husband?

5. In what type of paintings did Van Dyck specialize?

 How could his style best be characterized?

 Who was Van Dyck's principal patron?

6. List a few of the political, social, and religious distinctions between seventeenth-century Flanders and seventeenth-century Holland that influenced the art of the two regions.

 a.

 b.

 c.

7. How did the religious and economic conditions in seventeenth-century Holland affect artistic production?

 a.

 b.

 c.

8. Who were the "Caravaggisti"?

 Name one.

9. Frans Hals was the leading painter of the _____ school and specialized in _____.

 What are the main elements of his style that distinguish his works from those of his contemporaries?

10. Briefly describe Rembrandt's use of light and shade.

11. Whose influence is apparent in the lighting effects in such early works by Rembrandt as the *Supper at Emmaus* (FIG. 24-47)?

 How did his interpretation of the same theme (FIG. 24-48) change in his later years?

12. Using the adjectives you listed earlier to describe the Baroque style, to what degree would you classify Rembrandt's *Return of the Prodigal Son* (FIG. 24-49) as Baroque?

 How does this painting relate to the mood of Rembrandt's late portraits?

13. Briefly describe the technique of etching.

 What are its advantages over engraving?

14. What major change did Rembrandt make in the fourth state of the *Three Crosses* (FIG. 24-52) in comparison with the earlier states?

15. Why was Rembrandt's late work not acceptable to his contemporaries?

16. What aspect of Jan van Eyck's art was carried on in seventeenth-century Holland?

17. What was Vermeer's favorite type of subject matter?

18. In what way does Vermeer's use of light differ from Rembrandt's?

19. On what principle does a *camera obscura* work?

20. Describe the mood created by Vermeer's compositions.

21. List three important facts about the optics of color that are illustrated in Vermeer's paintings.

 a.

 b.

 c.

22. Name one seventeenth-century Dutch painter who specialized in landscape painting.

 In what way can his landscape paintings be considered "Protestant"?

23. Locate the following on the map on Study Guide page 219:

 Haarlem Utrecht
 Amsterdam

DISCUSSION QUESTIONS

1. Compare Rubens's *Abduction of the Daughters of Leucippus* (FIG. 24-39) with Giorgione's (and/or Titian's) *Pastoral Symphony* (FIG. 22-58). Compare composition, color, and mood. What is Baroque about the Rubens?

2. In what ways do the works and lives of Rubens and Rembrandt reflect the different social and religious orientations of seventeenth-century Flanders and Holland?

3. Compare Rembrandt's *Self-Portrait* (FIG. 24-50) with Raphael's portrait of *Baldassare Castiglione* (FIG. 22-17), and with Velázquez's portrait of Juan de Pareja (FIG. 24-35). How have the artists depicted the different psychological states of the subjects? How do these works illustrate major differences in the philosophies of the times and/or places where they were painted?

4. Compare Vermeer's *Young Woman with a Water Jug* (FIG. 24-53) with Van Eyck's *Giovanni Arnolfini and His Bride* (FIG. 20-8) and Rubens's portrait of Thomas Howard (FIG. 24-42). Discuss painting surface, composition, and mood. Do you think Vermeer's work is closer to that of Van Eyck or to that of Rubens? Why?

5. What was the effect of the economic and religious climate of seventeenth-century Holland on its artists?

THE SEVENTEENTH CENTURY IN FRANCE AND ENGLAND TEXT PAGES 865–877

1. Which French artist was most influenced by the northern "Caravaggisti"?

 In what ways does his style differ from theirs?

2. The French artist Callot is best known for his works done in the medium of _____.

 His *Miseries* series realistically depicts scenes of _____.

3. Which French artist is credited with having established seventeenth-century Classical painting?

 Where did he spend most of his life?

 What two Italian artists did he most admire?

4. What four characteristics of *Et in Arcadia Ego* (FIG. 24-59) are typical of Poussin's fully developed Classical style?

 a.

 b.

 c.

 d.

5. What type of subjects did Poussin consider to be appropriate for paintings done in the "grand manner"?

 What did he think should be avoided?

6. In what major way does the landscape in Poussin's *Burial of Phocion* (FIG. 24-60) differ from Van Ruisdael's *View of Haarlem* (FIG. 24-55)?

7. What was Claude Lorrain's primary interest in landscape painting?

 In what country did he do most of his painting?

8. Describe the features that create the impression of dignity and sobriety apparent in Mansart's work at Blois (FIG. 24-62).

 a.

 b.

 What feature of the building is typically Baroque?

9. The French Royal Academy of Painting and Sculpture was established in the year _____.

 What was its primary purpose?

10. What three architects collaborated to design the east facade of the Louvre?

 a. b. c.

 What form is used for the central pavilion of the Louvre?

11. Who was the principal director for the building and decoration of the Palace of Versailles?

Name the two architects who were responsible for the design of the garden facade of the Palace of Versailles.

a. b.

12. Who designed the park of Versailles?

13. What is symbolized by the vast complex of Versailles?

14. Which feature of Jules Hardouin-Mansart's Church of the Invalides is most Baroque?

Which is most Classical?

15. Why was the work of the French sculptor Puget not accepted at the French court?

Which sculptor was a court favorite?

16. Which of the visual or plastic arts was most important in seventeenth-century England?

17. Name the Italian architect who had the strongest influence on the buildings of Inigo Jones?

18. Who designed St. Paul's Cathedral in London?

What feature of the building shows the influence of Borromini?

What feature is taken over from the east facade of the Louvre?

DISCUSSION QUESTIONS

1. Discuss the relative balance between Baroque and Renaissance features in the following buildings: the east facade of the Louvre (FIG. 24-63), the Church of the Invalides in Paris (FIG. 24-68), the Banqueting House at Whitehall (FIG. 24-71), and St. Paul's Cathedral in London (FIG. 24-72).

2. In what ways did Louis XIV influence French art of the seventeenth century? How did his utilization of art differ from that of Philip IV in Spain?

3. Could Rubens's *Lion Hunt* (FIG. 24-40) and Van Honthorst's *Supper Party* (FIG. 24-44) serve as illustrations of Poussin's "grand manner"? If not, why not?

4. Who was chiefly responsible for the development of "classical" landscape painting in Italy? How did his approach differ from those of Poussin (FIG. 24-60), Rosa (FIG. 24-30), and Van Ruisdael (FIG. 24-55)?

5. Discuss the influence of Caravaggio on Georges de la Tour (FIG. 24-56) and Louis Le Nain (FIG. 24-57). Which aspects of Caravaggio's style does each adopt and how do their works differ from his and from each other's?

SUMMARY OF SEVENTEENTH-CENTURY PAINTING IN ITALY AND SPAIN

Fill in the following charts as much as possible from memory; then check your answers against the text in Chapter 24 and complete the charts.

	Major Works	Country and Stylistic Characteristics
Annibale Carracci		
Reni		
Il Guercino		
Caravaggio		
Domenichino		
Gentileschi		
Pozzo		
Ribera		
Zurbarán		
Velázquez		

SUMMARY OF SEVENTEENTH-CENTURY PAINTING IN FLANDERS, HOLLAND, AND FRANCE

	Major Works	Country and Stylistic Chararacteristics
Rubens		
Van Dyck		
Van Honthorst		
Hals		
Rembrandt		
Vermeer		
Van Ruisdael		

SUMMARY OF SEVENTEENTH-CENTURY PAINTING IN FLANDERS, HOLLAND, AND FRANCE (continued)

	Major Works	Country and Stylistic Characteristics
Georges De la Tour		
Le Nain		
Poussin		
Claude Lorrain		

CHAPTER 25

THE EIGHTEENTH CENTURY: LATE BAROQUE AND ROCOCO, AND THE RISE OF ROMANTICISM

TEXT PAGES 878–921

INTRODUCTION AND THE EARLY EIGHTEENTH CENTURY TEXT PAGES 880–904

1. Briefly describe how the ideas of each of the following individuals influenced the development of art during the eighteenth century.

 John Locke

 Sir Isaac Newton

 Jean-Jacques Rousseau

 Denis Diderot

 Goethe

2. What is meant by the "Age of Enlightenment" and how did it affect the role of art?

3. Which social class dominated events during the first half of the eighteenth century and provided the major patronage for artists?

4. Where did the Rococo style originate?

 How important was it in England?

5. Blenheim Palace in England was designed by _____ for _____ but even before it was completed it was criticized as being _____.

6. In reaction to Baroque buildings like Blenheim, the restraint of _____ was restated in buildings like Chiswick House, which was designed by _____ and _____.

 List four of its characteristic features.

 a.

 b.

 c.

 d.

7. What is important about the Royal Crescent at Bath (FIG. 25-3)?

8. In what way does Juvara's Superga, near Turin (FIG. 25-4), differ from the Baroque palaces of his predecessor Guarini (FIG. 24-16)?

9. Name two architects who most influenced the Rococo architecture of southern Germany and Austria.

 a. b.

10. The church of Vierzehnheiligen was designed by _____.

11. Theatrical illusionism is an important characteristic of the work of the German Baroque sculptor _____.

12. Which eighteenth-century Italian painter is best known for his elegant illusionistic ceiling paintings?

13. List four adjectives that describe the type of art created for the eighteenth-century French aristocracy.

 a.

 b.

 c.

 d.

14. Compare the photographs of the Salon de la Princesse of the Hôtel de Soubise (FIG. 25-9) and the Galerie des Glaces of Versailles (FIG. 24-66). List three adjectives or phrases that describe each.

Salon de la Princesse Galerie des Glaces

a. a.

b. b.

c. c.

15. One of the best examples of French Rococo architecture, known as the _____, was built near Munich, Germany. It was designed by _____.

In sharp contrast to the restraint of Chiswick House, the Rococo features of this small building can be described as:

a.

b.

c.

16. What two seventeenth-century artists inspired the debate in eighteenth-century France between the advocates of color as the most important element in painting and those of form?

Color: Form:

Which element did Watteau consider to be the most important?

17. List four characteristics of Watteau's *Return from Cythera* (FIG. 25-14) that are typical of Rococo art in general.

a.

b.

c.

d.

18. List three Baroque devices used by Boucher in *Cupid a Captive* (FIG. 25-15).

a.

b.

c.

19. Name a sculptor who worked in the Rococo style:

List three characteristics of his work:

a.

b.

c.

20. In what type of subject matter did Quentin de la Tour specialize?

What was his favorite medium?

21. Who was Voltaire?

How does Houdon's portrait of him (FIG. 25-19) differ from a typical Rococo or Baroque portrait?

22. Describe the type of lighting that was often used by Joseph Wright of Derby.

23. What was the significance of the Coalbrookdale bridge?

24. How does Copley's portrait of Paul Revere (FIG. 25-23) differ from contemporary British and continental portraits?

25. Although Gainsborough preferred to paint landscapes, he is best known for his _____.
Briefly characterize his style:

26. The French painter Élisabeth Louise Vigée-Lebrun specialized in _____.
 In contrast to Rococo artificiality, the style of her self-portrait can be described as:

27. What is a veduta painting?

 Name an artist who was famous for painting them.

28. From what social class did the majority of Chardin's patrons come?

 Why did his work appeal to them?

29. What stylistic feature did Hogarth borrow from continental Rococo artists?

 What type of subject matter did he portray?

30. Sir Joshua Reynolds is most famous for his _____ of contemporaries.

31. Sentimentality and moralizing are obvious traits of the work of the French painter _____.

32. Name an American painter who was influential in the Anglo-American school of history painting.

DISCUSSION QUESTIONS

1. Discuss the influence of Palladian Classicism on eighteenth-century architecture.

2. How are social attitudes reflected by Versailles (FIGS. 24-64 to 24-67), the Amalienburg (FIGS. 25-10 and 25-11), Blenheim Palace (FIG. 25-1), and Chiswick House (FIG. 25-2)?

3. Compare the ceiling paintings of Mantegna (FIG. 21-61), Veronese (FIG. 22-67), Carracci (FIG. 24-21), Guercino (FIG. 24-23), and Pozzo (FIG. 24-31) with that of Tiepolo (FIG. 25-8). Which is closest to his work, and what features do they share?

4. Among the other works you have studied, which do you feel are closest in spirit to Neumann's pilgrimage church of Vierzehnheiligen (FIGS. 25-5 and 25-6) and Asam's *Assumption of the Virgin* (FIG. 25-7)? Why?

5. Compare Benjamin West's *Death of General Wolfe* (FIG. 25-31) with El Greco's *Burial of Count Orgaz* (FIG. 23-27).

6. Compare Fragonard's *The Swing* (FIG. 25-16) with Bronzino's *Venus, Cupid, Folly and Time* (FIG. 22-41). Although both works have strong erotic overtones, they are very different in their emotional effects. What makes one Rococo and the other Mannerist?

THE RISE OF ROMANTICISM TEXT PAGES 904–921

1. The shift from reason to feeling, from objective nature to subjective emotion, is characteristic of the attitude of mind known as _____.

 List three values that were stressed during the so-called Age of Sensibility.

 a.

 b.

 c.

2. What feelings were thought to be evoked by the "sublime" in nature and art?

3. What was meant by the term *Gothick* in the eighteenth century?

4. What style did Walpole revive at Strawberry Hill (FIG. 25-32)?

5. How does Piranesi's *Carceri 14* (FIG. 25-34) illustrate eighteenth-century "Gothick" taste?

 In what medium did he work?

6. What type of painting did George Stubbs invent?

7. What type of subject matter was preferred by his contemporary Henry Fuseli?

8. Who was William Blake?

 Briefly characterize his style:

9. What feature of Chinese gardens was adopted by the English?

10. The building erected by Sanderson Miller in Hagley Park (FIG. 25-33) was in the _____ style.

11. Who was Johann Winckelmann, and why was he important for the development of art?

12. What provided the inspiration for Soufflot's design for the church of Ste.-Geneviève (now the Panthéon) in Paris (FIG. 25-40)?

13. Neoclassicism was stimulated by the excavation of the Roman cities of _____ and _____ in the mid _____.

14. What was the significance of the work of Robert Adam?

15. Name two buildings that apparently influenced Jefferson's designs for Monticello.

 a. b.

16. Why did Jefferson believe that the Neoclassic style was appropriate for the architecture of the new American republic?

17. Describe Flaxman's style:

18. In what style did Angelica Kauffmann paint?

19. What was the importance of the subject matter in the *Oath of the Horatii* (FIG. 25-46)?

 List at least two Neoclassical stylistic features that are found in that work.

 a.

 b.

SUMMARY: SEVENTEENTH- AND EIGHTEENTH-CENTURY ART TEXT PAGES 816–921

Fill in the following charts as much as possible from memory; then check your answers against the text in Chapters 24 and 25 and complete the charts.

HISTORICAL BACKGROUND

	Political Leaders and Events	Religious Orientation	Cultural and Scientific Developments
Italy			
Spain			
Flanders			
Holland			
France			
England			
Germany			

SUMMARY OF EIGHTEENTH-CENTURY PAINTING

	Major Works	Country and Stylistic Characteristics
Tiepolo		
Rigaud		
Watteau		
Boucher		
Fragonard		
Quentin De la Tour		
Joseph Wright of Derby		
Gainsborough		
Vigée-Lebrun		
Canaletto		

SUMMARY OF EIGHTEENTH-CENTURY PAINTING (continued)

	Major Works	Country and Stylistic Characteristics
Chardin		
Hogarth		
Greuze		
Reynolds		
West		
Piranesi		
Fuseli		
Blake		
Kauffmann		
David		

SUMMARY OF SEVENTEENTH- AND EIGHTEENTH-CENTURY ARCHITECTURE

	Major Works (Give dates of buildings	Country and Stylistic Characterisitics
Maderno		
Bernini		
Borromini		
Guarini		
Jones	Louvre:	
	Versailles:	
Wren		
Boyle and Kent		
Vanbrugh		
Juvara		

SUMMARY OF SEVENTEENTH- AND EIGHTEENTH-CENTURY ARCHITECTURE (continued)

	Major Works (Give dates of buildings)	Country and Stylistic Characteristics
Neumann		
Boffrand		
Cuvilliés		
Walpole		
Soufflot		
Jefferson		

SUMMARY OF SEVENTEENTH- AND EIGHTEENTH-CENTURY SCULPTURE

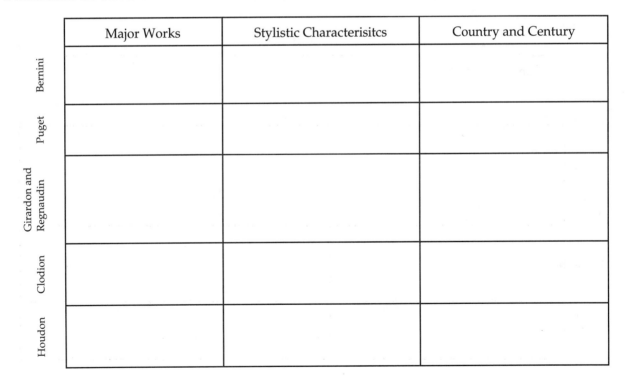

	Major Works	Stylistic Characterisitcs	Country and Century
Bernini			
Puget			
Girardon and Regnaudin			
Clodion			
Houdon			

SUMMARY: THE RENAISSANCE AND THE BAROQUE AND ROCOCO TEXT PAGES 624–921

ICONOGRAPHIC STUDY

While stylistic analysis tells us how a thing is represented, iconographic analysis helps us understand what is represented. Images of saints are usually identified by certain attributes that are associated with their particular story. Look at the representations of the following religious figures in Chapters 19 through 25 and briefly describe the way you would identify them in terms of their iconography.

St. Anthony

St. Catherine

David

St. Francis

St. George

Judith (with Holofernes)

Mary Magdalene

Moses

St. John the Baptist

St. Peter

St. Paul

St. James

St. Stephen

St. Theresa

SELF-QUIZ

PART FOUR: THE RENAISSANCE AND THE BAROQUE AND ROCOCO

I. **Matching.** Choose the identification in the right column that best corresponds to the term or name in the left column and enter the appropriate letter in the space provided.

_____ 1. Franciscans

_____ 2. tondo

_____ 3. baldacchino

_____ 4. Lorenzo de' Medici

_____ 5. Giulio Romano

_____ 6. chiaroscuro

_____ 7. Girolamo Savonarola

_____ 8. Julius II

_____ 9. St. Ignatius of Loyola

_____ 10. Ludovico Sforza

_____ 11. sfumato

_____ 12. tenebrism

_____ 13. triptych

_____ 14. Martin Luther

_____ 15. predella

_____ 16. genre

_____ 17. Louis XIV

_____ 18. Francis I

_____ 19. Voltaire

_____ 20. polyptych

_____ 21. alla prima

_____ 22. Baldassare Castiglione

_____ 23. orthogonal

a. soft, smoky modeling

b. "weight-shift" pose

c. monastic preaching order

d. extreme contrasts of light and dark

e. Florentine political leader and Humanist

f. High Renaissance pope

g. a canopy with columns, often over an altar

h. gradations of light and dark to produce the effect of modeling

i. Mannerist architect

j. multi-paneled altarpiece

k. Florentine monastic reformer

l. painting technique using no underpainting

m. German religious reformer

n. a circular painting or relief sculpture

o. three-paneled altarpiece

p. founder of Jesuit order

q. French writer of the Enlightenment

r. sixteenth-century French king

s. a narrow panel at the bottom of an altarpiece

t. northern painters using extreme light-dark contrasts of Caravaggio

u. Duke of Milan

v. scenes of everyday life

w. seventeenth-century French king

x. a perspective line perpendicular to the picture

y. Italian author of High Renaissance period

II. Matching. Choose the architect in the right column that corresponds to the building in the left column and enter the appropriate letter in the space provided.

_____ 24. Villa Rotonda near Venice

_____ 25. Campidoglio, Rome

_____ 26. Sant'Andrea, Mantua

_____ 27. Palazzo Rucellai, Florence

_____ 28. Dome of Florence Cathedral

_____ 29. Palazzo del Tè, Mantua

_____ 30. Tempietto, Rome

_____ 31. Square Court of the Louvre, Paris

_____ 32. Scala Regia, Vatican

_____ 33. East facade of the Louvre, Paris

_____ 34. San Carlo alle Quattro Fontane, Rome

_____ 35. Church of Vierzehnheiligen, near Bamberg

_____ 36. Pazzi Chapel, Florence

_____ 37. Palazzo Carignano, Turin

_____ 38. St. Ivo, Rome

_____ 39. Banqueting House, Whitehall

a. Michelangelo

b. Jones

c. Alberti

d. Brunelleschi

e. Neumann

f. Wren

g. Perrault, Le Vau, and Le Brun

h. Le Vau and Mansart

i. Palladio

j. Giulio Romano

k. Bernini

l. Lescot

m. Borromini

n. Guarini

o. Vanbrugh

p. Michelozzo

q. Giuliano da Sangallo

r. Giacomo della Porta and Vignola

s. Bramante

t. Maderno

II. Matching. Choose the artist in the right column that corresponds to the art work in the left column and enter the appropriate letter in the space provided.

_____ 40. *Lamentation* (Arena Chapel)

_____ 41. *The Isenheim Altarpiece*

_____ 42. *The School of Athens*

_____ 43. *The Ghent Altarpeice*

_____ 44. *The Garden of Earthly Delights*

_____ 45. Sistine Ceiling

_____ 46. *Las Meninas*

_____ 47. *The Ecstasy of St. Theresa*

_____ 48. "Gates of Paradise"

a. Bernini

b. Michelangelo

c. Leonardo

d Rogier van der Weyden

e. Raphael

f. Dürer

g. Ghiberti

h Masaccio

i. Grünewald

j. Velázquez

k. Ribera

l. Bosch

m. Bruegel

n. Giotto

o. Donatello

p. Jan van Eyck

q. Rubens

IV. Multiple Choice. Circle the most appropriate answer.

49. Which of the following architects best exemplifies the principles of High Renaissance style? a. Guarini b. Bramante c. Brunelleschi d. Borromini e. Michelozzo

50. Which one of the following Dutch artists specialized in landscape? a. Hals b. Van Honthorst c. Van Ruisdael d. Heda e. Vermeer

51. Melodramatic moralism is most often found in the work of a. Watteau b. Greuze c. Boucher d. Velázquez e. Bernini

52. The combination of Germanic and Italian characteristics is most apparent in the work of a. Leonardo b. Cranach c. Bosch d. Dürer e. Grünewald

53. The counter-positioning of a figure about its central axis, with the weight of the body on one leg and with the other leg relaxed is called a. chiaroscuro b. contrapposto c. condottiere d. orthogonal e. sfumato

54. Rococo artists most valued a. disproportion and disturbed balance b. magnificence and order c. pyramidal composition and chiaroscuro d. pleasure and delicacy e. symmetry and balance

55. A painting using much gold, flat patterns, a high horizon line, elegant figure style, many details from nature, and curvilinear line would most likely be a. High Renaissance b. Early Renaissance c. Rococo d. International Gothic e. Baroque

56. The paintings of Vermeer most often convey a feeling of a. agitation b. ostentation c. serenity d. pomposity e. fury

57. Which of the following artists best exemplifies French Classical Baroque style? a. Boucher b. Poussin c. Rigaud d. Rubens e. Watteau

58. In which of the following cities did Borromini build the majority of his buildings? a. Rome b. Florence c. Paris d. Venice e. Milan

59. The supreme master of the group portrait was a. Hals b. Rembrandt c. Gainsborough d. Anguissola e. West

60. Seventeenth-century Dutch paintings were characteristically a. commissioned by the aristocracy b. commissioned by the church c. painted to glorify military leaders d. sold on the open market e. scarce and hard to find

61. Which of the following is *least* characteristic of Baroque art? a. dramatic use of light b. emphasis on diagonal lines c. calm, Classical figures d. a reflection of the ideals of the Counter-Reformation e. energy and complexity of design

62. Which is *least* characteristic of Baroque architecture? a. three-part division of the facade b. compact, centralized plan c. emphasis on a grand central entrance d. greater variation in the depth of wall surface e. preference for rectangular and circular mofifs

63. Which of the following is a court style developed as a reaction against the formality of Louis XIV and characterized by a light and delicate treatment of sensual subjects? a. Mannerism b. Rococo c. Classical Baroque d. High Baroque e. High Renaissance

64. Which building is located in Paris? a. Palazzo Vecchio b. Campidoglio c. Louvre d. Farnese Palace e. St. Ivo

65. Oil painting was first used by the a. fifteenth-century Flemish b. fifteenth-century Florentines c. sixteenth-century Venetians d. fifteenth-century Germans e. sixteenth-century Germans

66. Two versions of *The Virgin of the Rocks* were painted by a. Botticelli b. Leonardo c. Raphael d. Andrea del Sarto e. Bellini

67. The frescoes in the Arena chapel were painted by a. Masaccio b. Michelangelo c. Giotto d. Duccio e. Raphael

68. Which artist was commissioned to design a tomb for Julius II? a. Donatello b. Verrocchio c. Michelangelo d. Giovanni da Bologna e. Bernini

69. A concern for realism, psychological portraiture, and emotional expression best describes the style of the a. Italian "proto-Renaissance" b. International Gothic c. Italian High Renaissance d. German Renaissance e. Mannerism

70. Which of the following *least* characterizes the International Gothic style? a. intricate ornamentation b. rational perspective c. splendid processions d. uptilted ground plane e. brilliant color and costuming

71. An important characteristic of much fifteenth-century Flemish art was the use of a. linear perspective b. disguised symbolism c. contrapposto d. sfumato e. painterly brush strokes

72. The use of sfumato, full figures, psychological interpretation, and anatomical accuracy most correctly describes the work of a. the Lorenzetti b. El Greco c. Leonardo d. Duccio e. Botticelli

73. Which of the following is *not* characteristic of High Renaissance figure painting? a. slow, rhythmic movement b. rational control c. restrained gravity d. balance and order e. elongation and distortion

74. Which artist created paintings protesting the brutality of an occupying force in his country? a. Jan van Eyck b. Holbein c. Cranach d. Bruegel e. Campin

75. The Limbourg brothers are known for their a. frescoes b. engravings c. panel paintings d. manuscript illuminations e. woodcuts

76. Giotto's work is best classified as a. Italian High Renaissance b. fifteenth-century Flemish c. International Gothic d. Italian Late Gothic e. Mannerist

77. An important Mannerist painter was a. Botticelli b. Ghirlandaio c. Andrea del Sarto d. Parmigianino e. Correggio

78. Which of the following Baroque painters did *not* do frescoed ceilings? a. Pozzo b. Guercino c. Caravaggio d. Reni e. Annibale Carracci

79. The major part of El Greco's work was done in a. Greece b. Italy c. Netherlands d. France e. Spain

80. Which of the following architects did not take part in the building of St. Peter's or its piazza? a. Bramante b. Michelangelo c. Maderno d. Bernini e. Borromini

V. Chronological Chart. Fill in the names of the major architects, painters, and sculptors in the following charts by country of origin and the century in which they did the major part of their work.

	13th–14th Centuries	15th Century	16th Century
Italy	_____ _____ _____ _____ _____ _____ _____ _____ _____ _____ _____	_____ _____ _____ _____ _____ _____ _____ _____ _____ _____ _____ _____ _____	_____ _____ _____ _____ _____ _____ _____ _____ _____ _____ _____ _____ _____
Flanders (Netherlands)	_____	_____ _____ _____	_____ _____
Germany		_____ _____ _____	_____ _____ _____

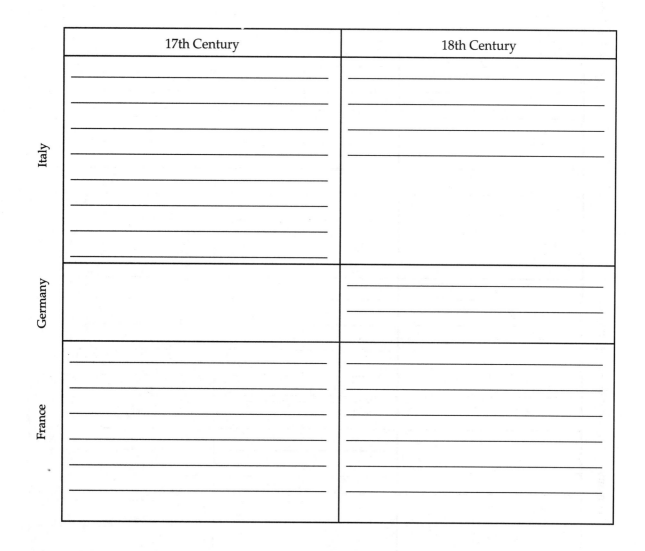

13th–14th Centuries	15th Century	16th Century
France		

17th Century	18th Century
Italy	
Germany	
France	

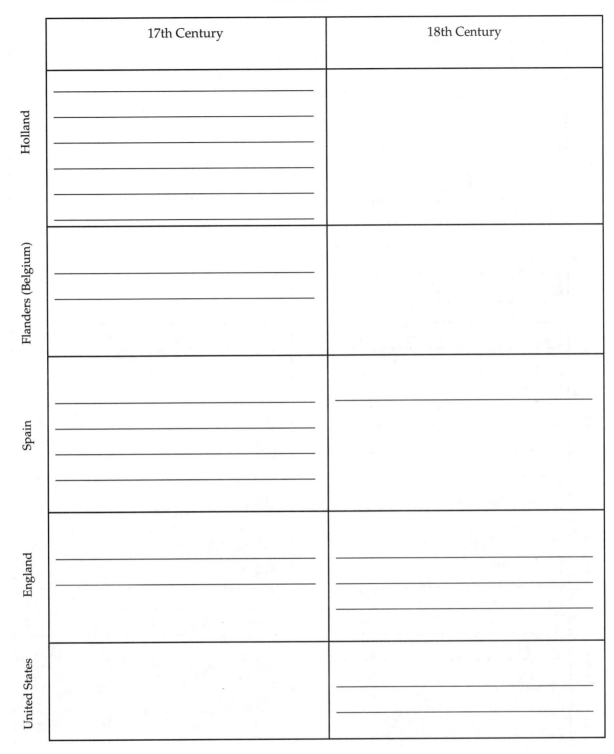

	17th Century	18th Century
Holland	_____ _____ _____ _____ _____ _____	
Flanders (Belgium)	_____ _____	
Spain	_____ _____ _____ _____	_____
England	_____ _____	_____ _____ _____
United States		_____ _____

VI. Identification.

81. Compare the two pictures of the Virgin Madonna below, attributing each to an artist, country, century, and style. Give the reasons for your attributions.

Artist: _____

Country: _____

Century: _____

Style: _____

Artist: _____ Country: _____

Century: _____ Style: _____

Reasons:

82. Compare the plan and photograph of a building below, attributing it to an artist, country, century, and style. Give the reasons for your attributions.

Artist: _____

Century: _____

Country: _____

Style: _____

Reasons:

83. These two very different interpretations of the sky were painted in the same century but in different countries. Attribute these paintings to a century and assign a country to each. Describe the artistic concerns that link these paintings to the same period as well as the differences between them. How might these differences have been affected by the patrons for whom the artists worked?

Century: _____

A. Country: _____

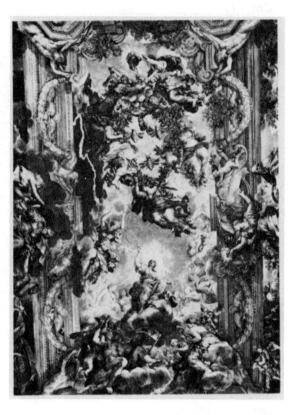

B. Country: _____

84. Compare the two paintings below, attributing each to an artist, country, and century. How do these paintings illustrate the different approaches to the use of light that characterize the works of these two artists?

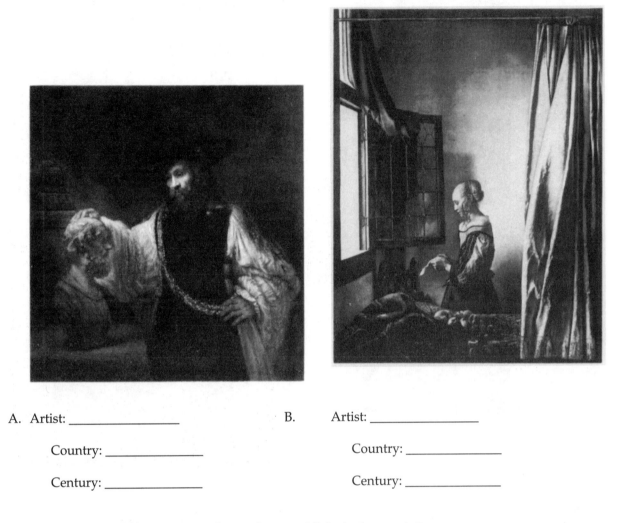

A. Artist: _____

 Country: _____

 Century: _____

B. Artist: _____

 Country: _____

 Century: _____

Describe below the different approaches to the use of light in these paintings.

85. Compare the two sculptures below, attributing each to an artist, country, century, and style. Give the reasons for your attributions.

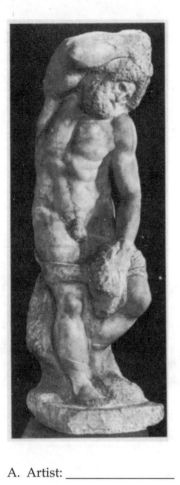

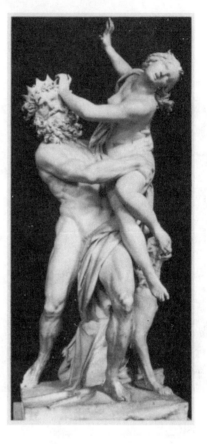

A. Artist: _____

Country: _____

Century: _____

Style: _____

B. Artist: _____

Country: _____

Century: _____

Style: _____

Reasons:

Part Five

THE MODERN WORLD

CHAPTER 26

THE NINETEENTH CENTURY: PLURALISM OF STYLE

TEXT PAGES 926–1017

INTRODUCTION TEXT PAGES 928–931

1. What was the "doctrine of progress"?

2. Who were the major patrons of artists in the nineteenth century?

3. What two general directions can be identified within the welter of nineteenth-century styles?

 a.

 b.

4. List three nineteenth-century innovations that drastically affected the artist as a producer of unique pictures.

 a. c.

 b.

THE EARLY NINETEENTH CENTURY: THE ROLE OF ROMANTICISM TEXT PAGES 931–957

1. List four of the social attitudes inherent in the Romantic view of life.

 a.

 b.

 c.

 d.

2. List four sources of subject matter that were favored by Romantic artists.

a.

b.

c.

d.

3. What was the original purpose of La Madeleine (FIG. 26-1)?

What are its primary stylistic features?

4. Which aspect of Canova's portrait of Pauline Borghese (FIG. 26-2) comes from the earlier Rococo style?

Which aspect is realistic?

Which features are Neoclassical?

5. What style did Greenough use for his portrait of George Washington?

Why did many consider the work to be a failure?

6. Name two of David's pupils:

a. b.

7. In breaking with David, Ingres adopted a manner that he felt was based on true and pure Greek style. Two characteristics of this style were:

a.

b.

8. Who said "Drawing is the probity of art," and what meaning was the speaker trying to convey by that statement?

9. Name two Renaissance artists whose influence is apparent in Ingres's *Grande Odalisque* (FIG. 26-5).

 a. b.

10. What did Ingres use as the model for the composition of his *Apotheosis of Homer?*

11. Goya's work cannot be confined to a single stylistic classification. Briefly summarize his varied concerns as expressed in the following works:

 The Family of Charles IV (FIG. 26-9)

 The Third of May, 1808 (FIG. 26-10)

 Saturn Devouring His Children (FIG. 26-11)

12. In what respects does Gros's *Pest House at Jaffa* (FIG. 26-12) differ stylistically from David's *Oath of the Horatii* (FlG. 25-46)?

 a.

 b.

 c.

13. Name three artists whose influence can be seen in Gericault's *Raft of the Medusa* (FIG. 26-13).

 a. b. c.

14. For Gericault, suffering and death, frenzy and madness are characteristic of _____.

15. List three qualities of mind that Delacroix admired.

 a.

 b.

 c.

16. List four characteristics of Delacroix's style that are seen in *The Death of Sardanapalus*:

 a.

 b.

 c.

 d.

17. Describe the compositional technique known as a "vignette."

18. Who did Delacroix consider to be "nature's noblemen"?

19. Write down one of Delacroix's observations on the way to apply color to the canvas.

20. What was the significance of landscape painting for Philipp Otto Runge?

21. What did Caspar David Friedrich believe that the artist should paint?

22. What features of Turner's work were most influential in liberating painting from the Tradition?

23. To what school of art did Thomas Cole belong?

24. Describe Constable's approach to landscape painting.

25. Which aspect of Corot's work points toward Impressionism?

26. What style did Barry and Pugin use for the rebuilding of the Houses of Parliament in London (FIG. 26-27)?

27. What style did Nash use for the Royal Pavilion in Brighton (FIG. 26-28)?

28. List three features that the Paris Opera house (FIG. 26-29) shares with the east facade of the Louvre (FIG. 24-63).

 a.

 b.

 c.

DISCUSSION QUESTIONS

1. Compare Ingres's *Grande Odalisque* (FIG. 26-5) with Titian's *Venus of Urbino* (FIG. 22-61). How do they differ in composition, body type, distortion, and degree of idealization?

2. How do Ingres's and Delacroix's portraits of Paganini (FIGS. 26-8 and 26-15) typify each artist's approach to his subject?

3. Do you think there are remnants of Romanticism alive today in our society? If so, can you identify them? How are they reflected in the arts? What film that you have seen recently best embodies the ideas of Romanticism? Can you think of an artist working today whom you would consider to be a Romantic?

4. Discuss the difference in approach to the depiction of the landscape in works by Turner (FIG. 26-21), Constable (FIG. 26-23), Cole (FIG. 26-22), Runge (FIG. 26-19), and Friedrich (FIG. 26-20).

MID-CENTURY REALISM AND THE LATER NINETEENTH CENTURY TEXT PAGES 957–1017

1. Who was Eugène Durieu and why is he important for the history of painting?

2. What is the difference between the *camera obscura* and the *camera lucida?*

3. When did Daguerre present his new photographic process in Paris?

Briefly describe the daguerreotype process.

In general, how did artists react to Daguerre's invention?

4. Who developed the calotype? When?

 What is it?

5. For what type of work was Nadar most famous?

6. Name two photographers who documented the Civil War:

 a. b.

7. Briefly describe the new type of history painting that developed in the nineteenth century.

 Name two artists who specialized in this new type of history painting.

 a. b.

8. What was the Barbizon school?

 Name one artist who belonged to it and one artist who painted in close association with its members.

 a. b.

9. Although Daumier did many fine paintings, he is primarily known for his work in the medium of
 _____.

10. Name two artists who were concerned principally with realistic portrayals of the members of the working classes.

 a. b.

11. Although hailed as the father of Realism, Courbet did not like to be called a Realist. What can we gather from his statements were his goals as a painter?

 What formal qualities distinguish his work?

12. How did the American public receive Thomas Eakins's *Gross Clinic* (FIG. 26-41)?

13. For what is Eadweard Muybridge most famous?

14. List artists from each of the following countries who adhered to the Realists' credo of depicting modern scenes in a realistic manner.

 United States

 France

 England

 Germany

 Russia

15. What earlier style seems to have influenced Rosa Bonheur's *Horse Fair* (FIG. 26-48)?

16. List two concerns that were shared by the artists who formed the Pre-Raphaelite Brotherhood.

 a.

 b.

17. List three adjectives or phrases that describe the style of Burne-Jones.

 a.

 b.

 c.

18. In what way do the Classical figures painted by Bouguereau (FIG. 26-52) differ from those painted by Puvis de Chavannes (FIG. 26-80)?

19. Name one photographer who worked in the Pictorial style.

20. *Le Déjeuner sur l'herbe* (FIG. 26-55), the painting that caused such a scandal at the Salon des Refusés of 1863, was painted by _____.

 Which aspects of the picture shocked the public?

 What was the artist's major concern when he painted the work?

21. What stylistic features does Berthe Morisot share with the Impressionists?

22. What was Degas most interested in depicting?

 In what ways does his work show the influence of photography and of Japanese prints?

 a.

 b.

 c.

 What feature of his work leads many critics to question Degas's identification as an Impressionist?

23. List four characteristics of Impressionism.

 a.

 b.

 c.

 d.

24. Name four Impressionist painters

 a. c.

 b. d.

 During which two decades did they exhibit together?

25. What were Mary Cassatt's favorite subjects?

26. Which Impressionist called color his "day-long obsession, joy and torment"?

27. What qualities in photographs like Jouvin's *The Pont Neuf, Paris* (FIG. 26-68) were admired by the Impressionists?

28. What types of subjects did Renoir prefer to paint?

29. Why did Whistler call his paintings "arrangements" and "nocturnes"?

30. Name four major Post-lmpressionist painters.

 a. c.

 b. d.

 What aspects of Impressionism did they criticize?

How were these criticisms reflected in the work of each of the artists you named?

31. Name two features that Seurat adapted from Renaissance formalists like Uccello and Piero della Francesca.

 a.

 b.

32. Who said, "I want to make of Impressionism something solid and lasting like the art in the museums"?

33. What two roles does color play in Cézanne's paintings?

 a.

 b.

34. For Van Gogh, the primary purpose of color in his paintings was:

 How did Van Gogh apply paint to his canvas, and what type of effect did his application produce?

35. How did Gauguin's use of color differ from Van Gogh's?

36. Where did Gauguin spend the last ten years of his life?

37. List three influences seen in Toulouse-Lautrec's *At the Moulin Rouge* (FIG. 26-79) and describe the features that reflect each influence.

 a.

 b.

 c.

38. By the end of the nineteenth century, what major change had occurred in the artist's vision of reality?

39. In what year did the literary manifesto of Symbolism appear?

 In what city?

40. What did the Symbolist artists consider to be their primary task?

41. List three stylistic characteristics of the work of Gustave Moreau.

 a.

 b.

 c.

42. According to Redon, his originality consisted of:

43. Name two late nineteenth-century painters who used harsh colors and distorted forms to express moral criticism of the modern world.

 a. b.

44. Describe the type of painting done by Albert Pinkham Ryder.

45. What stylistic influences are most evident in the sculpture of Jean-Baptiste Carpeaux?

46. What style did Augustus Saint-Gaudens utilize for his monument to Mrs. Henry Adams?

47. Name two earlier sculptors whose work influenced Rodin's style.

 a. b.

 In what major ways did his work differ from theirs?

48. Describe the effect of the use of iron on nineteenth-century architectural structures.

49. What was the significance of the techniques used by Paxton to construct the Crystal Palace (FIG. 26-94)?

50. When did Eiffel construct his tower in Paris (FIG. 26-95)?

 For what event?

51. What was the importance of the Marshall Field wholesale store?

DISCUSSION QUESTIONS

1. Compare Daumier's *Rue Transnonain* (FIG. 26-38) with Goya's *The Third of May, 1808* (FIG. 26-10), David's *Oath of the Horatii* (FIG. 25-46), and Delacroix's *Liberty Leading the People* (FIG. 26-17). What is the style and the social message of each? Which do you feel is most effective? Why?

2. Compare Manet's *Le Déjeuner sur l'herbe* (FIG. 26-55) with Giorgione/Titian's *Pastoral Symphony* (FIG. 22-58). In what ways are they similar, and in what ways do they differ?

3. What characteristics does Courbet share with the Impressionists and in what ways does his work differ significantly from theirs? Should the Impressionists be considered Realists?

4. Compare Eakins's *Gross Clinic* (FIG. 26-41) with Hawes and Southworth's *Early Operation under Ether* (FIG. 26-32). What medium has each used, and how does the medium influence the art work?

5. Compare Cézanne's *Still Life* (FIG. 26-73) with Heda's (FIG. 24-54); note differences in composition, the treatment of color, painting technique, and distortion of form.

6. Compare Seurat's *Sunday Afternoon on the Island of La Grande Jatte* (FIG. 26-71) with Renoir's *Le Moulin de la Galette* (FIG. 26-69) and Piero della Francesca's *Flagellation of Christ* (FIG. 21-28). What characteristics does Seurat's painting share with each?

7. Discuss the main contribution made by each of the major Post-Impressionists. In what ways are their works a continuation of historical artistic traditions?

8. In what sense is the slogan "form follows function" accurate or inaccurate as a summary description of the majority of today's architecture? For examples in answering this question, consider buildings in your own community.

SUMMARY: THE NINETEENTH CENTURY TEXT PAGES 926–1017

Fill in the following charts as much as possible from memory; then check your answers against the text and complete the charts.

STYLISTIC SUMMARY OF NINETEENTH-CENTURY ART

	Painters	Photographers and Sculptors	Characterisitics of the Style	Influential Historical and Cultural Factors
Romanticism				
Neoclassicism				
Realism				
Impressionism				
Post-Impressionism				
Symbolism				

SUMMARY OF NINETEENTH-CENTURY PAINTING

	Major Works	Country and Stylistic Characteristics
Goya		
Gros		
Géricault		
Delacroix		
Ingres		
Turner		
Constable		
Cole		
Friedrich		
Corot		
Daumier		

SUMMARY OF NINETEENTH-CENTURY PAINTING (continued)

	Major Works	Country and Stylistic Characteristics
Courbet		
Manet		
Eakins		
Repin		
Homer		
Millais		
Puvis de Chavannes		
Bouguereau		
Bonheur		
Monet		
Pissarro		
Renoir		

SUMMARY OF NINETEENTH-CENTURY PAINTING (continued)

	Major Works	Country and Stylistic Characteristics
Degas		
Cassatt		
Seurat		
Cézanne		
Van Gogh		
Gauguin		
Toulouse-Lautrec		
Ensor		
Munch		
Morisot		

SUMMARY OF NINETEENTH-CENTURY ARCHITECTURE

Building	Architect(s)	Country and Date	Style	Description
La Madeleine, Paris				
Houses of Parliament, London				
Royal Pavillion, Brighton				
The Opéra, Paris				
Carson, Pirie, Scott Building, Chicago				
Reading Room, Bibliothèque, Ste.-Geneviève, Paris				
Crystal Palace, London				
Marshall Field Wholesale Store, Chicago				
Guaranty (Prudential) Building, Buffalo				

SUMMARY OF NINETEENTH-CENTURY SCULPTURE

	Major Works	Country and Stylistic Characterisitics
Canova		
Greenough		
Rude		
Barye		
Saint-Gaudens		
Carpeaux		
Rodin		

SUMMARY OF NINETEENTH-CENTURY PHOTOGRAPHY

	Major Works	Country and Stylistic Characterisitics
Muybridge		
Daguerre		
Nadar		
Hawes and Southworth		
Gardner		
Käsebier		

CHAPTER 27

THE EARLY TWENTIETH CENTURY: THE ESTABLISHMENT OF MODERNIST ART

TEXT PAGES 1018–1089

1. List three facts that undercut the nineteenth-century belief in progress and the Enlightenment belief that reason and knowledge would lead to the moral improvement of humanity.

 a.

 b.

 c.

2. What do the authors believe is the core idea of Modernism?

3. How have the discoveries of modern science affected our view of reality?

4. List four goals of the Modernist avant-garde:

 a.

 b.

 c.

 d.

5. When did the "Secessionist" exhibitions introduce Art Nouveau to the public?

 What sort of forms were preferred by Art Nouveau artists?

List four sources from which Art Nouveau artists drew inspiration:

a.

b.

c.

d.

6. Briefly describe Gaudi's architectural style.

7. How was Frank Lloyd Wright's concern for "organic" form reflected in his buildings?

List two houses he designed:

a. b.

8. Who designed the Schröder House (FIG. 27-6)?

What style does it reflect?

9. List four stylistic characteristics of the Art Deco style:

a.

b.

c.

d.

Name one building that illustrates the style:

10. What was the Bauhaus?

Who founded it?

Name three artists who taught there.

a. b. c.

11. What did Moholy-Nagy mean by "vision in motion"?

12. Who defined a house as a "machine for living"?

13. How does Le Corbusier's Villa Savoye (FIG. 27-11) differ from Wright's houses (FIGS. 27-3 to 27-5)?

14. List three characteristics of Mies van der Rohe's architectural style that are found in International Style architecture.

a.

b.

c.

15. In what year was the exhibition held in which the name "Fauve" was coined?

What did it mean?

Name two Fauve painters.

a. b.

List three types of non-European art that inspired Fauve artists.

a.

b.

c.

Describe the characteristics that Fauve paintings have in common.

16. What sort of subjects did Georges Rouault prefer?

17. Where did Gustav Klimt work?

What features did his work share with the works of nineteenth-century Symbolist painters? (See Chapter 26)

18. Name two artists who belonged to *Die Brücke* (the Bridge).

a.

b.

Why did they select the name *Die Brücke*? What did it signify?

Name three sources for their art.

a.

b.

c.

19. What beliefs were shared by members of the Blue Rider (*Der Blaue Reiter*) group?

Name two artists who belonged to this group.

a. b.

20. In what medium did Käthe Kollwitz do most of her work?

What social class did she most often depict?

21. What was the purpose of Neue Sachlichkeit art?

22. Name one German artist whose work alludes to his flight from Nazi Germany.

23. List two German Expressionist sculptors.

 a. b.

24. What idea did the Cubists adopt from Cézanne?

 Describe one way in which they expanded upon his idea.

25. Who was Apollinaire?

26. Identify three probable sources of the dislocation of form seen in Picasso's *Demoiselles d'Avignon* (FIG. 27-29).

 a.

 b.

 c.

27. Name two Cubist painters.

 a. b.

28. What is the basis of Cubist pictorial space, and how does it differ from Renaissance perspective?

29. What is Orphism and who was its founder?

30. How does Synthetic Cubism differ from Analytic Cubism?

31. What is a collage?

32. Name two American artists who were influenced by Cubism.

 a. b.

33. How did Fernand Léger modify Cubist practices?

34. What were the Futurists trying to express in their art?

 Name two Futurist painters:

 a. b.

 Name one Futurist sculptor:

35. Name two sculptors whose abstracted forms derive from the experiments of the Cubists:

 a. b.

36. What new material and technique did Julio González contribute to modern sculpture?

37. What artistic tradition profoundly influenced Modigliani?

38. Explain the difference between *abstract* and *non-objective*.

39. What did Malevich believe to be the supreme reality?

40. In what country did Constructivism develop?

 An outstanding representative of the Constructivist movement was:

 Why did he call himself a "Constructivist"?

41. List three new materials used by Naum Gabo.

 a.

 b.

 c.

42. What basic colors and forms characterize Mondrian's mature work?

 What did they symbolize for him?

43. Where and when did Vladimir Tatlin work?

 What did he believe was the purpose of art?

44. What is a mobile?

 Who invented them?

45. What type of form did Brancusi believe was "the most real"?

46. What does the sculpture of Hans Arp have in common with the sculpture of Barbara Hepworth?

47. List three characteristics of the sculpture of Henry Moore.

 a.

 b.

 c.

 What was the most recurrent theme in his work?

 What apparently originally inspired it?

48. In contrast to Mondrian's geometric severity, O'Keeffe's approach to abstraction can be characterized as:

49. When did the Dada movement develop?

 Where?

 Name two artists connected with the Dada movement.

 a.

 b.

50. What was the original purpose of the Dada movement?

 Although short-lived, Dadaism had important consequences for later art. What were they?

51. What is a ready-made?

 Who developed them?

52. What was "automatism" and how did artists like Jean Arp use it?

53. Describe a "photomontage."

 Who developed the technique?

54. What did Schwitters mean by the term *merz?*

55. In what way did the work of Man Ray express the ideas of Dada?

56. Who was the major practitioner of the style known as *pittura metafisica?*

57. According to André Breton, what was the purpose of the Surrealist movement?

58. List two techniques used by Surrealist artists to free their creative processes.

 a.

 b.

59. Name three painters connected with the Surrealist movement.

 a. b. c.

 How does their work differ?

60. What type of subject matter did Frida Kahlo prefer?

61. List three styles that Marc Chagall synthesized in his work.

a. b. c.

What type of subject matter did he draw upon?

62. Who said "Art does not reproduce the visible; rather it makes visible. . . ."?

What did this artist mean by that statement?

63. What did the Surrealists admire in the work of Atget (FIG. 27-71)?

64. Who was the founder of the Photo-Secession group and Gallery 291?

What type of photography did he practice?

65. The American woman photographer whose work brought the nation's attention to the plight of the rural poor was:

66. How do Sheeler's photographs differ from those of Dorothea Lange?

67. What is the dominant mood of Hopper's *Nighthawks* (FIG. 27-76)?

68. Why would the work of Ben Shahn be considered as Social Realism?

69. What was the favorite subject of Jacob Lawrence?

70. What was the theme of much of Orozco's work?

In what medium did he do most of his work?

71. What event inspired Picasso's *Guernica* (FIG. 27-80)?

What symbols did Picasso use to refer to the event, and how did he emphasize its horror?

DISCUSSION QUESTIONS

1. Compare the use of mass, space, and decorative detail in the Villa Rotonda (FIG. 22-51), Chiswick House (FIG. 25-2), the Villa Savoye (FIG. 27-11), and the Kaufmann House (FIG. 27-5). Which do you like best? Why?

2. Relate Maurice Denis's statement that "a picture before being a war horse, a nude woman or some anecdote, is essentially a plane surface covered with colors assembled in a certain order" to the early twentieth-century paintings you have studied. How does his view differ from the traditional one regarding the meaning and purpose of a painting? Which artists do you think would agree with Maurice Denis? Why?

3. Compare Klimt's *Death and Life* (FIG. 27-16) with El Greco's *Burial of Count Orgaz* (FIG. 23-27); note the differences in composition, handling of surface, space, color, and the distortion of form. What world view is represented by each composition?

4. In what ways does the work of Rouault, Kollwitz, Barlach, and Beckmann relate to that of Grünewald and Dürer?

5. How does the Cubist conception of space differ from that held during the Renaissance?

6. Compare Boccioni's *Unique Forms of Continuity in Space* (FIG. 27-42) with the *Nike of Samothrace* (FIG. 5-93) and describe the basic differences between the two works as well as the similarities.

7. Compare Brancusi's *Bird in Space* (FIG. 27-53) with Gabo's *Column* (FIG. 27-49). In what ways are the forms similar, and in what ways are they different? How does each artist explain the techniques and goals of his art?

8. Discuss the role of chance in both the Dada and Surrealist movements. What connection do you see between the Dada movement and art movements today?

9. In what way does the work of twentieth-century African-American artist Jacob Lawrence (FIG. 27-78) differ from that of nineteenth-century African-American artist Henry Ossawa Tanner (FIG. 26-46)? Discuss both style and subject matter for each artist.

CHAPTER 28

THE LATER TWENTIETH CENTURY

TEXT PAGES 1090–1153

1. What is the prevailing attitude of Postmodern critics toward "fine art"?

2. For what reason do Postmodernist critics denounce formalist critics like Clement Greenberg?

3. What is the attitude of Existentialists toward human existence?

 List three artists whose work reflects these ideas:

 a. b. c.

4. What is Art Brut?

5. What major artistic style developed in the United States after the influx of refugee artists from Europe?

 In what city did it begin?

6. Describe the way Jackson Pollock created his "gestural" Abstract Expressionist pieces.

7. Name three New York Abstract Expressionists.

 a. b. c.

8. What is Color-Field painting?

9. Describe the function of Barnett Newman's "zips."

10. What feelings did Mark Rothko hope to evoke with his large, luminous canvases?

11. Why was Ellsworth Kelly's work known as "Hard-Edge Abstraction"?

12. Describe Frankenthaler's soak-stain technique.

What effect did she want to achieve with it?

Name one other artist who utilized the soak-stain technique:

13. Two artists who created complex ordered patterns dealing with three-dimensional illusion were:

a. b.

14. What inspired the work of Jean Tinguely and what sort of materials did he use?

15. What is Assemblage?

16. What type of art did Louise Nevelson create?

17. How does the work of Louise Bourgeois (FIG. 28-19) relate to that of Barbara Hepworth (FIG. 27-55)?

18. In what way did David Smith's sculpture relate to Abstract Expressionism?

19. Name two Minimalist sculptors:

 a. b.

20. In what way are the principles of Post-Painterly Abstraction related to Minimalist sculpture?

21. What beliefs about art did Donald Judd assert in works like the cubes illustrated in FIG. 28-22?

22. How does Eva Hesse's Post-Minimalist work differ from the work of Judd and other artists of the Minimalist school?

23. Name two artists who specialize in what is called Earth, Environmental, or Site Art.

 a. b.

 Briefly describe their techniques.

24. What subject matter was characteristic of Pop Art of the 1960s?

25. Name two artists who worked in the Pop mode in England.

 a. b.

26. In what way does Jasper Johns's *Target with Four Faces* (FIG. 28-28) cause us to wrestle with the relationship between an art object and what it represents?

27. What are "combine" paintings?

 Who developed them?

28. Name the artist who creates designs for gigantic monuments depicting ordinary objects:

29. How did Andy Warhol utilize his background as a commercial artist in creating "fine art" works?

30. Briefly describe the style used by Edward Ruscha:

31. How do the authors distinguish between Modernist and Postmodernist attitudes?

32. What type of art does Duane Hanson create?

33. Name two Superrealist painters:

 a. b.

34. What is a "Happening"?

 Name one artist who specialized in Happenings.

35. Briefly state the artistic philosophy of Joseph Beuys.

36. What is meant by "Conceptual Art"?

37. In what way is Sylvia Mangold involved with conceptual issues and paradoxes regarding the relation between illusion and reality?

38. Name two British Conceptual artists who assert that they are "living sculpture."

 a. b.

39. Name four artists who consider themselves to be feminist artists.

 a. c.

 b. d.

40. Who designed *The Dinner Party* (FIG. 28-42)?

 What techniques were used to create it?

41. To what issues does Barbara Kruger want her art to draw attention?

42. What medium does Magdalena Abakanowicz use for her expressive sculptures?

43. Who said "History for me is like the burning of coal, it is like a material. History is a warehouse of energy"?

44. Briefly characterize the style of Julian Schnabel:

45. Describe the technique used by the sculptor Martin Puryear and the sources from which he drew his inspiration:

46. What do the authors mean by "Pictorialism" as it relates to Postmodernist art?

47. In what way does digital imaging (computer manipulation of images) contribute to the "dissolution of reality"?

48. How does Tansey's *Innocent Eye Test* illustrate the ambiguities and paradoxes of Postmodernist Pictorialism?

49. Name two artists who utilize computers in their work.

 a. b.

50. What interests does video technology allow Nam June Paik to combine?

51. Briefly describe the Vietnam Memorial in Washington, D.C.:

52. What form did Frank Lloyd Wright use as the basis for his design for the Guggenheim Museum (FIGS. 28-60 and 28-61)?

53. What forms provided the inspiration for Le Corbusier's Notre Dame du Haut (FIGS. 28-62 and 28-63)?

 In what way does Notre Dame du Haut differ from Le Corbusier's earlier works?

54. Who designed the Opera House in Sydney, Australia?

55. What architectural style is represented by the Seagram Building in New York (FIG. 28-65)?

56. How did Philip Johnson's style change in his AT&T Tower in New York (FIG. 28-66)?

57. What aspects of Graves's Portland Building (FIG. 28-67) can be considered Postmodernist?

58. What is the official name for the "Beaubourg"?

Where is it located?

What is significant about its structure?

59. Who designed the East Building that was added to the National Gallery in Washington in the late 1970s?

What geometric shape was the basis for the design?

60. What tradition did Kahn follow in his design for the Kimbell Art Museum?

61. Give two examples of the application of Postmodernism to architecture.

62. What historical styles are cited by Charles Moore in his *Piazza d'Italia?*

63. What is meant by Deconstructionism?

DISCUSSION QUESTIONS

1. What European political events and artistic movements influenced the development of American Abstract Expressionism? How?

2. Discuss the use of industrial processes in the work of David Smith, Julio González, and Donald Judd. Which processes did each use and how were the processes related to the artist's esthetic concerns?

3. Compare Hamilton's *Just What Is It That Makes Today's Homes So Different, So Appealing?* (FIG. 28-26) with Campin's *Mérode Altarpiece* (FIG. 20-4). Discuss the compositional structure and the symbolism of both works, along with their cultural meanings.

4. What distinguishes the works of Robert Rauschenberg from those of early Dada artists?

5. Can you relate Judd's untitled work (FIG. 28-22) and Tinguely's *Homage to New York* (FIG. 28-16) to the earlier traditions of Classic and Romantic art? How?

6. Compare the self-portraits of Chuck Close (FIG. 28-37), Quentin de la Tour (FIG. 25-18), Vigée-Lebrun (FIG. 25-25), and Rembrandt (FIG. 24-50). Discuss the techniques used by each artist as well as the view of the self that each presents.

7. Compare Francis Bacon's *Painting* (FIG. 28-2) with Dürer's *Four Horsemen* from the *Apocalypse* series (FIG. 23-5) and Fuseli's *The Nightmare* (FIG. 25-36). What attitudes toward society does each represent and how is each reflective of its time?

8. Compare the following landscapes: Fan Kuan's *Travelers Among Mountains and Streams* (FIG. 15-19), and van Ruisdael's *View of Haarlem* (FIG. 24-55), Van Gogh's *Starry Night* (FIG. 26-76) and Richard Estes's *Nedick's* (FIG. 28-38). Compare the formal techniques each artist used and discuss what each implies about the society that produced it.

9. What changes in social and religious attitudes are represented by the comparison of *Christ Enthroned in Majesty* from the apse of Santa Pudenziana (FIG. 8-14), *Virgin with the Dead Christ* (FIG. 13-56), Puvis's *The Sacred Grove* (FIG. 26-80), and Anselm Kiefer's *Vater, Sohn, Heiliger Geist* (Father, Son, Holy Ghost [FIG. 28-48]).

10. Recently, the International Style, which has dominated the architecture of the past fifty years, seems to have fallen into disfavor. What criticisms have been leveled against it? In your opinion, are they justified? Describe some of the alternatives that have been tried.

11. One reason for the stylistic similarity of International Style buildings, whether erected in Brasilia, Tokyo, Paris, or New York, is the architects' dependence upon intricate machinery to control the interior climates of their buildings. Do you feel that increasing reliance on complex technology is still justified in view of dwindling energy sources and the threat of accompanying economic and social upheavals throughout the world? What practical alternatives, if any, do you see?

SUMMARY: THE TWENTIETH CENTURY TEXT PAGES 1018–1153

Fill in the following charts as much as possible from memory; then check your answers against the text of Chapters 27 and 28 and complete the charts.

SUMMARY OF TWENTIETH-CENTURY ART MOVEMENTS

	Painters and Photographers	Sculptors	Characterisics of the Style	Influential Historical and Cutural Factors
Art Nouveau				
Fauvism				
Expressionism				
Cubism				
Purism				
Futurism				
De Stijl				

SUMMARY OF TWENTIETH-CENTURY ART MOVEMENTS (continued)

	Painters and Photographers	Sculptors	Characteristics of the Style	Influential Historical and Cultural Factors
Suprematism				
Dada				
Surrealism				
Constructivism				
Pittura Metafisica				
Social Realism				
Abstract Expressionism				

SUMMARY OF TWENTIETH-CENTURY ART MOVEMENTS (continued)

	Painters and Photographers	Sculptors	Stylistic Characteristics	Influential Historical and Cultural Factors
Activist and Feminist Art				
Abstract Formalism (Minimal Art, Color-Field, etc.)				
Earth and Site Art				
Kinetic and Technological Art				
Pop Art				
Conceptual Art				
Postmodernism and Deconstructivism				

TWENTIETH-CENTURY ARCHITECTURE

	Style and Country	Major Buildings and Dates	Characteristics
Horta			
Gaudí			
Wright			
Le Corbusier			
Rietveld			
Gropius			
Mies van der Rohe			
Graves			
Rogers and Piano			
Site Inc.			
Moore			

THE LATER TWENTIETH CENTURY

TWENTIETH-CENTURY ARCHITECTURE (continued)

	Style and Country	Major Buildings and Dates	Characteristics
Kahn			
Pei			
Johnson			
Venturi			

355

SELF-QUIZ

PART FIVE: THE MODERN WORLD

I. **Matching.** Choose the architect in the right column that best corresponds to the building in the left column and enter the appropriate letter in the space provided.

_____ 1. Notre Dame du Haut, Ronchamp

_____ 2. Guggenheim Museum, New York

_____ 3. Casa Milá, Barcelona

_____ 4. Pompidou Center, Paris

_____ 5. Panthéon, Paris

_____ 6. Kimball Art Museum, Fort Worth

_____ 7. Seagram Building, New York

_____ 8. Schröder House, Utrecht

_____ 9. Kaufmann House, Bear Run, Pennsylvania

_____ 10. Bauhaus, Dessau

_____ 11. Crystal Palace, London

_____ 12. Marshall Field wholesale store, Chicago

_____ 13. Portland Building, Portland

_____ 14. Piazza d'Italia, New Orleans

_____ 15. National Gallery addition, Washington, D.C.

a. Richardson

b. Labroust

c. Sullivan

d. Wright

e. Walpole

f. Mies van der Rohe and Johnson

g. Portman

h. Gaudí

i. Paxton

j. Gropius

k. Le Corbusier

l. Kahn

m. Graves

n. Soufflot

o. Rogers and Piano

p. Rietveld

q. Barry and Pugin

r. Pei

s. Moore

t. Venturi

II. **Matching.** Choose the art style/movement in the right column that corresponds to the artist in the left column and enter the appropriate letter in the space provided.

_____ 16. Mondrian	a. Romanticism
_____ 17. Ingres	b. Neoclassicism
_____ 18. Malevich	c. Realism
_____ 19. Cézanne	d. Impressionism
_____ 20. Oldenburg	e. Post-Impressionism
_____ 21. Picasso	f. Symbolism
_____ 22. Delacroix	g. Art Nouveau
_____ 23. Duchamp	h. The Fauves
_____ 24. Matisse	i. Expressionism
_____ 25. Monet	j. Cubism
_____ 26. Boccioni	k. Futurism
_____ 27. Pissarro	l. Neoplasticism
_____ 28. Gros	m. Surrealism
_____ 29. Newman	n. Dada
_____ 30. Klimt	o. Suprematism
_____ 31. Kelly	p. Constructivism
_____ 32. Courbet	q. Pittura metafisica
_____ 33. Seurat	r. Abstract Expressionism
_____ 34. Judy Chicago	s. Abstract Formalism
_____ 35. De Chirico	t. Feminist Art
_____ 36. Dali	u. Pop Art
_____ 37. Braque	v. Conceptual, Performance, and Happenings
_____ 38. Kaprow	w. Color-Field
_____ 39. Daumier	
_____ 40. Géricault	
_____ 41. Gabo	
_____ 42. Van Gogh	
_____ 43. Judy Pfaff	
_____ 44. Eakins	
_____ 45. Kline	

IV. Multiple Choice. Circle the most appropriate answer.

46. The most important Realist painter of the mid-nineteenth century was a. Degas b. Ingres c. Courbet d. Delacroix e. Géricault

47. The first Impressionist exhibition was held in the year a. 1855 b. 1863 c. 1874 d. 1886 e. 1895

48. The short-lived student at David's studio who soon broke with David's use of style was a. Delacroix b. Courbet c. Ingres d. Girodet-Trioson e. Géricault

49. A group portrait of the family of Charles IV was painted by a. Ingres b. Goya c. Courbet d. Géricault e. David

50. The twentieth-century architect whose work is distinguished by attention to volume and light and whose designs include the Kimbell Art Museum is a. Graves b. Moore c. Gehry d. Kahn e. Shinohara

51. The photographer who introduced avant-garde art to the American public at his 291 Gallery in New York was a. Gardner b. Close c. Stieglitz d. Sheeler e. Sherman

52. The artist who developed "combine paintings" was a. Oldenburg b. Rauschenberg c. Kelly d. Hamilton e. Kruger

53. Movement is an important element in much of the art of a. Calder b. Smith c. Kline d. Puryear e. Maillol

54. The artist who created Happenings was a. Chagall b. Klee c. Duchamp d. Kaprow e. Schwitters

55. An architect who worked primarily in the Postmodern style was a. Garnier b. Gaudi c. Venturi d. Sullivan e. Wright

56. The famous *Horse Fair* was painted by a. Ingres b. Bonheur c. Gros d. Marc e. Goya

57. An important sculptor who worked primarily in the Neoclassical style was a. Rodin b. Saint-Gaudens c. Canova d. Barye e. Lehmbruck

58. A sculptor whose work was most closely associated with Cubism was a. Lipchitz b. Rodin c. Tinguely d. Giacometti e. Moore

59. The architect who was associated with the Art Nouveau movement was a. Wright b. Gaudí c. Willaim van Alen d. Mies van der Rohe e. Gropius

60. Strong Expressionist tendencies are seen in the work of a. Mondrian b. Munch c. Seurat d. Cézanne e. Matisse

61. The artist who believed that "the art of painting can consist only in the representation of objects visible and tangible to the painter" was a. Ingres b. Delacroix c. Goya d. Courbet e. Dali

62. The concern with images deriving directly from the subconscious is most apparent in the work of the a. Expressionists b. Impressionists c. Cubists d. Surrealists e. Post-Painterly Abstractionists

63. The mural entitled *Guernica* was painted by a. Braque b. Picasso c. Kollwitz d. Kandinsky e. Beckmann

64. The first exhibition of the Fauves took place in a. 1874 b. 1890 c. 1905 d. 1915 e. 1925

65. *Monument to the Third International* was designed by a. Gabo b. Malevich c. Tatlin d. Kandinsky e. Arp

66. Line is stressed over color in the works of a. Ingres b. Delacroix c. Turner d. Monet e. Pissarro

67. Which artist uses a formal approach to painting that is closest to that of Mondrian? a. Rubens b. Vermeer c. Delacroix d. Fragonard e. Turner

68. Which of the following artists has the least Romantic or Expressionist approach to landscape painting? a. Friedrich b. Van Ruisdael c. Turner d. Cézanne e. Van Gogh

69. An important Abstract Expressionist was a. Pollock b. Dali c. Malevich d. Johns e. Brancusi

70. The artist most representative of the Impressionist style was a. Van Gogh b. Renoir c. Manet d. Toulouse-Lautrec e. Munch

71. The Spanish painter who most effectively combined realism and fantasy was a. Velázquez b. Zurburán c. Goya d. Miró e. Ribera

72. The sculptor who effectively combined aspects of Impressionism, Romanticism, and Expressionism in his work was a. Canova b. Calder c. Rodin d. Maillol e. Lehmbruck

73. The Post-Impressionist who based his work on the color theories of Delacroix and the scientists Helmholtz and Chevreul was a. Van Gogh b. Gauguin c. Cézanne d. Seurat e. Toulouse-Lautrec

74. The artist who did many self-portraits in a Surrealist style was a. Géricault b. Kahlo c. Man Ray d. Ernst e. Chicago

75. The harsh, flat lighting and the juxtaposition of a nude woman with two men dressed in contemporary clothes shocked the public when Manet first exhibited his famous work entitled a. *Le Dejeuner sur l 'herbe* b. *Le Moulin de la Galette* c. *Sunday Afternoon on the Island of La Grande Jatte* d. *The Spirit of the Dead Watching* e. *The Night Café*

76. The American artist who was famous for his precise photographs and paintings was a. Gardner b. Sheeler c. Hopper d. Estes e. Muybridge

77. An important video artist is a. Paik b. Bell c. Beuys d. Christo e. Shapiro

78. The landscape painter who influenced Delacroix and anticipated both the attitude and technique of Impressionism was a. Turner b. Constable c. Friedrich d. Van Ruisdael e. Courbet

79. The *Raft of the Medusa* was painted by a. Delacroix b. Goya c. Gérome d. Géricault e. Gros

80. A large construction of Earth Art, called *Spiral Jetty,* was designed by a. Smith b. Hesse c. Hockney d. Smithson e. Caro

IV. Identification.

81. Compare the two sculptures below, attributing each to an artist, country, and decade. Give the reasons for your attributions.

A. Artist: _____

 Country: _____

 Decade: _____

B. Artist: _____

 Country: _____

 Decade: _____

Reasons:

82. Compare the two sculptural groups below, attributing each to an artist, country, approximate date, and style. Give the reasons for your attributions.

A. Artist: _____

 Country: _____

 Date: _____

 Style: _____

B. Artist: _____

 Country: _____

 Date: _____

 Style: _____

Reasons:

83. Compare the two abstractions below, attributing each to an artist and approximate date. Give the reasons for your attributions.

A. Artist: _____

Date: _____

B. Artist: _____

Date: _____

Reasons:

84. Compare the two landscapes below, attributing each to an artist and approximate date. Give the reasons for your attributions.

A. Artist: _____

 Date: _____

B. Artist: _____

 Date: _____

Reasons:

85. The two paintings reproduced here reflect very different ways of depicting a still life. Attribute each to an artist, a style or stylistic grouping, and a decade. Give the reasons for your attributions. What do you think were the major concerns of each artist.

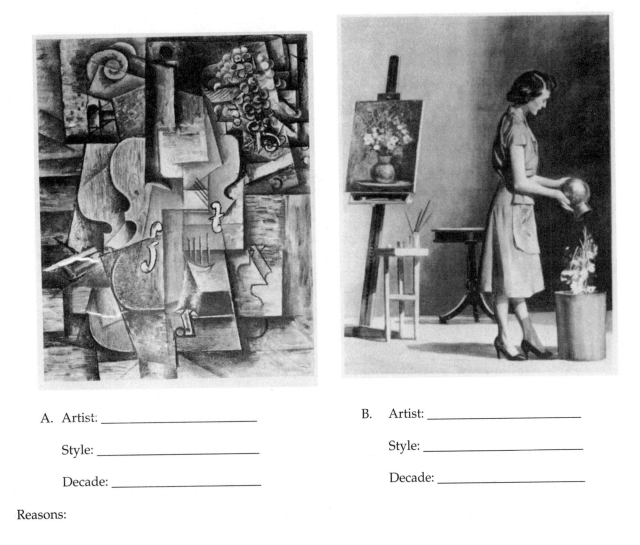

A. Artist: _____

 Style: _____

 Decade: _____

B. Artist: _____

 Style: _____

 Decade: _____

Reasons:

86. You see the two twentieth-century buildings illustrated below on a visit to San Diego, California, and you want to explain them to a companion. What would you say? (You may use your textbook to look up the varying architectural traditions that they embody.)

ANSWERS FOR SELF-QUIZZES

PART ONE: THE ANCIENT WORLD

I. 1. h 2. r 3. s 4. a 5. i 6. k 7. l 8. o 9. r 10. n 11. b 12. e 13. r 14. e 15. f 16. c 17. q 18. o 19. f 20. q 21. l 22. e 23. d 24. r 25. p 26. p 27. h 28. m 29. j 30. k **II.** 31. n 32. h 33. a 34. l 35. f 36. i 37. m 38. o 39. k 40. q 41. e 42. g 43. j 44. b 45. v 46. w 47. x 48. t 49. s 50. c 51. p 52. d 53. u 54. y 55. r **III.** 56. e 57. b 58. c 59. e 60. b 61. a 62. b 63. b 64. e 65. d 66. a 67. e 68. b 69. d 70. c 71. c 72. b 73. c 74. a 75. c 76. d 87. a 78. c 79. b 80. a **IV.** 81. E 82. BB 83. H, J, N, Q, AA, OO 84. A, B, F, G, M, O, DD, LL, ZZ 85. W 86. D, X, MM, SS, WW 87. S, T, Z, MM, PP, TT, UU, YY 88. U, EE, QQ 89. K, P, Y, KK, RR, VV 90. C, I, R, V, JJ, NN 91. XX 92. L, FF, GG, HH, II 93. CC

V. 94. A. Greek, fifth century B.C. (Detail from the Parthenon frieze, *c.* 440–423 B.C. British Museum, London.)

　　 B. Assyrian, ninth to seventh centuries B.C. (*Banquet Relief of King Ashurbanipal*, Nineveh, 668–627 B.C. British Museum, London.)

As you compare these two reliefs, which illustrate the differences between the Assyrian and Classical Greek handling of relief sculptures, you might have made the following observations. The Greek relief shows the same characteristics that were noted in the other reliefs from the Parthenon: the balance between the "ideal" and the "real," between the tactile and optical approaches to form. The texture of the drapery folds contrasts with the smooth, monumental forms of the bodies. The human figures are the dominant element in the relief; a plain background and a few props give only a summary indication of the setting. The greater three-dimensionality of the Greek relief contrasts with the lower bas-relief technique used by the Assyrians. In contrast to the relaxed and idealized Greek figures, which seem to be engaging in easy and familiar conversation, the conventionalized Assyrian figures seem stiff and tense. While the Classical Greek figures are fully understood anatomically and move freely and naturally in space, the Assyrian figures are rendered in an age-old combination of front and side views. The short, stocky, heavily muscled figures are characteristic of the reliefs of both Ashurnasirpal II and Ashurbanipal, as are the tight curls of hair and beard. The stylized details of the plant forms and the furniture are combined to reinforce a rather stiff formality similar to that of the Assyrian reliefs illustrated in the text (FIGS. 2-20 and 2-21).

95. Roman, Republican period, second century B.C. to first century A.D. (Maison Carrée, Nîmes, France, beginning of first century B.C.)

Although this temple bears a close resemblance to a Greek peripteral temple, it is obviously Roman for several reasons: like the Temple of "Fortuna Virilis" in Rome (FIG. 7-1), it is set on a high podium and is approached by stairs only from the front. Greek temples, by contrast, which were ordinarily set on the tiered stylobate and stereobate, were much more easily approached from all sides. The cella of this temple, like that of the Roman Temple of "Fortuna Virilis," extends the full width of the podium, with the result that the columns around the cella are attached to its walls as engaged columns, and only those of the porch are free-standing. This type of construction is known as "pseudoperipteral" and was very popular with Roman architects. Another typically Roman feature is the use of the Corinthian order, which was used by Roman architects more often than were the Greek Doric and Ionic orders.

96. A. Roman, second century B.C. to first century A.D. (*Roman Head*, Republican period, first century B.C. Glyptothek, Munich.)

　　 B. Greek, fifth to fourth centuries B.C. (Praxiteles, *Head of Hermes*, detail of *Hermes and Dionysos*, *c.* 340 B.C. Museum, Olympia.)

*In each of the answers to the identification questions, the first date given is the range within which you should have dated the work, and the second, in parentheses, is the actual date accepted by scholars.

These two heads illustrate the contrast between Greek idealism and Roman realism. As you identified them, you probably noted the difference between the youthful beauty of the Greek head and the mature dignity of the Roman head. The Greek head has the rounded face, the slightly pouting lips, small eyes, and straight nose and brow line that are characteristic of heads from the Classical period. The locks of the hair are loosely rendered, and shadows that slightly soften the formal perfection of the features are apparent around the eyes, a softening that is seen in the style of Praxiteles. In contrast to the smooth perfection and generalization of the features of the Greek face, the Roman face is deeply lined and strongly particularized. The wrinkles seem to be his and his alone, etched by profound experiences of life. With painstaking care the artist has indicated every change in the contour of the face, an approach to portraiture that was particularly popular during the years of the Roman Republic and that has been called "veristic."

97. Egyptian, New Kingdom, Amarna period, fourteenth century B.C. (*Relief of Akhenaton and his family,* Tell el-Amarna, Eighteenth Dynasty, *c.* 1360 B.C. Ägyptisches Museum, Berlin.)

The hieroglyphics and the unique shape of the tall crowns identify the work as Egyptian. The relief can be precisely placed in the Amarna period, for it clearly demonstrates the new sense of life and movement introduced by the artists who worked for Akhenaton. Although the Egyptian figural conventions of head and legs shown in profile with shoulders seen from the front is still observed, the bodies seem to be much more relaxed and lively than those found in traditional figural representations. In this relief one also sees the predilection for fluid curved lines and attenuated bodies that was typical of the Amarna style, as well as the strange combination of naturalism and stylization favored by artists of the period. All the members of the family, even the tiny children, show the wide hips, sinuous bodies, long graceful necks, and elongated heads that were seen in representations of Akhenaton himself. The intimacy and the informality of the family grouping, in which the children gesticulate freely and fondle their royal parents, is similar to the informality seen in the Amarna relief of King Smenkhkare and his wife Meritaten (FIG. 3-39).

98. A. Early Christian or Early Byzantine, sixth century A.D. (Detail of *Procession of Female Saints,* mosaic from Sant'Apollinare Nuovo, Ravenna, Italy)
 B. Roman, second century B.C. to second century A.D. (*Judgment of Paris,* fresco from Pompeii, first century B.C. National Museum, Naples)

These two works illustrate the change from Roman illusionism (as seen at Pompeii) to the more abstract and symbolic style that was to develop through Early Christian art into the Early Byzantine style. Even from the black-and-white reproductions, you should be able to distinguish between the media of the two works; the fresco technique, which was so commonly used by the Romans for wall decorations, and the glistening mosaic preferred by the Christian artists of the sixth century working at Ravenna. Although the media contributed to a certain degree to the style seen in the two works—the quick, painterly brush strokes adding to the illusionism of the Roman example and the glass chips of the mosaic emphasizing the flat, otherworldly quality of the frieze—the artists manipulated the media to produce the effects favored by their respective cultures. To achieve the illusion of the world in which we live is of obvious interest to the Roman artist; his figures are placed to emphasize their existence in three-dimensional space and modeled in the round with rapid, painterly strokes to heighten a sense of their reality. The Early Christian/Byzantine artist, on the other hand, uses formal means to minimize real space and to set his figures in a transcendental world. Instead of overlapping his figures as the Roman artist had done, he places them in a line, separating them from each other by date palms, and thus creates a rhythmically repeated pattern. The heads and feet all extend to the same level, and the ground on which they stand seems to be tilted upward. As in other sixth-century mosaics, like the *Miracle of the Loaves and Fishes* in Sant'Apollinare Nuovo, the artist tells his story in terms of an array of symbols, lined up side by side. The details of costume and trees create a rich tapestry design, although the figures retain hints of the three-dimensional modeling that characterized the Roman style and which would be lost in many subsequent Byzantine works. However, the flat background keeps us from confusing our world with theirs; they abide solely on another plane of reality.

PART TWO: THE MIDDLE AGES

I. 1. m 2. j 3. a 4. b 5. d 6. e 7. i 8. c 9. a 10. b 11. c 12. i 13. j 14. i 15. b 16. j 17. l 18. l 19. l 20. j 21. n 22. f 23. i 24. f 25. b 26. a 27. h 28. l 29. k 30. h **II.** 31. f 32. p 33. b 34. d 35. j 36. k 37. n 38. u 39. i 40. g 41. a 42. m 43. o 44. q 45. e 46. c 47. h 48. r 49. t 50. x **III.** 51. b 52. c 53. a 54. b 55. a 56. c 57. e 58. b 59. d 60. c 61. e 62. c 63. c 64. e 65. d 66. c 67. b 68. c 69. a 70. e 71. b 72. b 73. a 74. c 75. c 76. c 77. e 78. e 79. d 80. c **IV.** 81. A, D, F, G, J, T, X, GG 82. B, O, P, Z 83. C, M, U, W 84. E, K, S, CC, FF 85. H, N, I, L, R, BB, DD, EE, HH, II, KK, LL 86. Q, V, AA 87. Y, JJ

V. 88. A. Hiberno-Saxon, sixth to ninth centuries A.D. (*Mathew the Evangelist*, from *Book of Darrow*, seventh century A.D. Trinity College, Dublin.)

 B. Carolingian, eighth to ninth centuries A.D. (*John the Evangelist*, from the *Gospel Book of Archbishop Ebbo of Reims, c.* 816–835. Bibliothèque Nationale, Paris.)

These two evangelist pages illustrate two very different approaches to form that were used by artists working in the Early Middle Ages. Illustration A is typical of the fusion of Germanic and Celtic styles found in Hiberno-Saxon manuscripts. The artist was not in the least concerned with illusionism, but instead created a style that was abstract, decorative, and (except for the figure's feet) bilaterally symmetrical. The flat form of the body with its complex inlay patterns is closely related to the jewelry forms created by Germanic craftsmen, while the spirals around the frame reflect the complicated interlace so popular with Celtic artists. The entire page decoration is flat and linear, and there is no interest whatsoever in three-dimensional form. The artist who created the Evangelist from the *Ebbo Gospels*, however, was very much interested in creating the illusion of three-dimensional form and undoubtedly based the drawing on prototypes that were derived from the illusionistic, Late Antique style, a practice encouraged by the emperor Charlemagne. The strange perspective of the writing desk and stool indicate that the Carolingian artist did not fully understand the spatial illusionism of the model. Yet the overall linear technique of this northern artist has given a new vitality to the old models. The nervous, spontaneous line of the tense energetic figure is closely related to the other illuminations produced by artists of the Reims School in the first half of the ninth century.

 89. A. Romanesque, twelfth century (*Prophet Isaiah*, from the portal of the church of Souillac, Lot, France, *c.* 1130–1140.)

 B. Gothic, thirteenth to fourteenth centuries (*Virgin*, from the north transept, Notre-Dame, Paris, second half of the thirteenth century.)

These two figures demonstrate some of the changes that took place in French monumental sculpture between the Romanesque and Gothic periods. The elegant prophet with his elongated body and decorative drapery resembles many Romanesque figures from southern France. The incised linear detail, the swinging drapery folds, and the cross-legged, almost dancing pose show a close relationship to the Jeremiah carved on the trumeau of St.-Pierre at Moissac (FIG. 12-28). In both cases, the artist seems to be using the forms of the body and drapery to express the mystic inner state of his figures rather than to describe their physical presence. The low relief of the Romanesque figures has given way in the Gothic statue to a body carved much more fully in the round, and the trancelike ecstasy of the Romanesque prophet has been transformed into the fully ripened corporality of the Gothic style. Like the figures from the Reims portal (FIG. 13-34), the drapery of the Virgin is heavy, falling in massive folds quite different from the delicate arabesques of the Romanesque drapery. The Virgin demonstrates the Gothic concern for natural appearances, as is apparent in the more naturalistic rendering of the drapery and the more natural proportions of the body; however, this naturalism is blended with a kind of Classical calm and monumentality seen in many High Gothic figures. The graceful swing of the drapery shows hints of the mannered elegance that began with Reims and continued in fourteenth-century Gothic figures like *The Virgin of Paris* (FIG. 13-39), as does the upward tilt of the hips, which gives the figure a typical Gothic **S**-curve.

90. Romanesque, Cluniac-Burgundian, principally twelfth century (Santiago de Compostela, Spain, 1077–1211.)

Both the plan and elevation of this Romanesque church bear a strong resemblance to the church ofSt.-Sernin at Toulouse (FIGS. 12-3, 12-4, 12-5) and this is one of the churches that were built along the pilgrimage road in southern France and northwestern Spain. This particular church marked the site that was the goal of the pilgrimage. Many of the churches along this road were built in the Cluniac-Burgundian style, a style characterized by semicircular stone vaults, a square crossing, extreme regularity and precision, and an ambulatory with radiating chapels. As in the church of St.-Sernin, the square crossing of this church is used as a module for the rest of the building, with each nave bay measuring exactly one-half and each aisle square measuring exactly one-fourth of the crossing square. The floor plan is carried up the walls by the attached columns that mark the edges of each bay and then over the vault by the transverse arches. The wall elevation, like that of St.-Sernin, is marked by aisle arcades surmounted by tribunes. The heavy masonry vaults in both cases preclude the creation of a clerestory, thus creating dark interiors. The aisles are covered by groin vaults, but while St.-Sernin has a double row of aisles, this church has only one. It does, however, have the same type of ambulatory with radiating chapels, a feature that was particularly popular in the pilgrimage churches, since it permitted the pilgrims to view the relics without disrupting the monastic services.

While this building shares the clear articulation and segmentation of space that characterize Gothic churches, the round arches, the lack of rib vaulting as well as the lack of a clerestory, and the use of a gallery rather than a triforium mark it as Romanesque.

91. Notre-Dame, Paris, late twelfth to mid-thirteenth century (1163–1250), Early and High Gothic styles. Check the accuracy of your identification of the various parts of the building using the diagrams below.

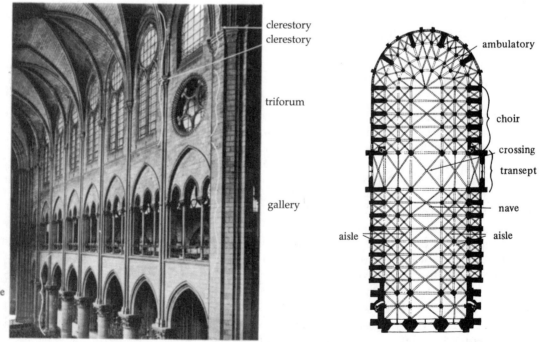

The illustration shows clearly the transition from Early to High Gothic architecture, as described in the text. Most significant is the change in the nave-wall elevation from a quadripartite elevation to a tripartite elevation. The four parts of an Early Gothic elevation—nave arcade, gallery, triforium, and clerestory—seen

in the right bay were changed in the other bays of the nave to a tripartite elevation by merging the two upper windows to allow more light to penetrate the nave. The retention of the gallery in the tripartite elevation shows this to be a modification of Early Gothic rather than a true High Gothic elevation, which typically consists of a nave arcade, triforium, and clerestory. The six-part vault system used in the nave is typical of Early Gothic buildings, but the alternate-support system used in Early Gothic churches has been abandoned.

The architect of this building was strongly influenced by the Early Byzantine church of Hagia Sophia that was built in Constantinople in the sixth century. Like Hagia Sophia this building is dominated by a large central dome, which is buttressed by supporting half domes and a series of smaller domes. The four minarets mark the building as Islamic rather than Christian. This building could have been constructed in Turkey in the sixteenth century for it strongly suggests the style of the Ottoman architect Sinan the Great. It closely resembles the Selimiye Cami that he erected in Eridne, Turkey, in the early sixteenth century, demonstrating the same combination of a domed centralized structure with flanking minarets.

PART THREE: THE WORLD BEYOND EUROPE

I. 1. b 2. g 3. c 4. a 5. h 6. e 7. d 8. l 9. i 10. k 11. u 12. m 13. q 14. j 15. t 16. n 17. r 18. p 19. o 20. s
II. 21. b 22. a 23. f 24. h 25. f 26. a 27. b 28. e 29. c 30. a 31. d 32. f 33. f 34. h 35. c 36. b 37. h 38. f 39. e 40. c 41. b 42. c 43. e 44. a 45. g **III.** 46. c 47. d 48. b 49. c 50. a 51. b 52. b 53. b 54. d 55. c 56. a 57. c 58. c 59. a 60. b 61. b 62. c 63. d 64. a 65. d 66. c 67. e 68. a 69. b 70. b 71. b 72. b 73. b 74. b 75. c 76. b 77. d 78. c 79. c

IV. 80. A. Japan, Jomon, first to sixth centuries (*Haniwa* figure of a warrior, Tumulus period, fifth century.)
 B. China, Qin dynasty, third century B.C. (*Charioteer*, Lintong, Shaanxi Province, China, 221–206 B.C.)

Figure A is an example of the haniwa figures that were produced in Japan during the Jomon period. It is molded in tubular form, with the legs and torso echoing the cylindrical shape of the base. The slit eyes, the necklace, and the swelling legs are very similar to those of the haniwa figure illustrated in the text (FIG. 16-2), although this one is more complete and is represented wearing his helmet and padded armor. The forward motion of the arms seems to indicate that he is in the act of drawing his sword. As in other haniwa figures, the simple, direct forms of this warrior seem to express a type of energy and creativity that is specifically Japanese.

The Chinese warrior—stiff and formal, rigidly frontal, done with simple volumes and sharp, realistic detail—shows all the stylistic characteristics of the warriors discovered in the tomb mound in Shaanxi, China. With his detailed armor, he represents one member of the vast army who made up the imperial bodyguard (see FIG. 15-6) Since his hands are stretched out in front, he was probably a charioteer. The realistic style seems to be much more sophisticated than that of the energetic Japanese haniwa figure.

81. A. Japan, Ashikaga period, fifteenth to sixteenth centuries (Attributed to Soami, detail of a six-fold screen, 1525. Metropolitan Museum of Art, New York.)
 B. Japan, Edo or Tokugawa period, nineteenth century (Hokusai, *Fuji Above the Storm, c.* 1823. Woodblock print.)

If you guessed Chinese for the misty landscape, don't feel bad, because although it is Japanese, it comes from a period when Japanese art was strongly influenced by that of China, particularly the delicate misty landscapes of the Song period. Here the Japanese artist has used the Song device of dividing the landscape into foreground, middle ground, and far distance, with a cliff in the middle distance and pale mountain peaks suggested in the far distance. The three areas are similarly held together by a field of mist. The painting also used some of the bolder brushwork that was introduced by Zen Buddhist masters of the Yuan period. You should have no trouble, however, in identifying the specifically Japanese qualities of the representation of Mt. Fuji, for the boldness and strength of this woodblock print is unlike anything produced in China. The bold lines and patterns of this woodblock resemble closely those of the Hokusai woodblock print reproduced in the text (FIG. 16-31), and one finds the same asymmetrical composition. Both reflect Hokusai's grand and monumental view of nature.

82. Benin, fifteenth to eighteenth centuries (*The King with Two Chiefs,* sixteenth to seventeenth centuries. Bronze. The British Museum, London.)

The bronze panel showing the king flanked by two chiefs is very closely related to the Benin altar illustrated in the text (FIG. 18-13). The figures are depicted with the same simplified, somewhat rigid naturalism; the helmeted heads, the decorated necks, and the bodies are all part of the same cylindrical form to which small arms and legs are attached. The patterns of armor, helmets, and necklaces further emphasize the rigidity of the forms and the hieratic dignity of the king. As in the Benin altar, the background is covered with engraved decoration; no surfaces except faces, hands, and feet are free from it. Like many Benin bronzes, this one glorifies the power of the divine king.

83. China, Shang, sixteenth to eleventh centuries B.C. (Wine vessel in the shape of a bird. Bronze. The Art Institute of Chicago, Lucy Maud Buckingham Collection.)

This bronze vessel is a typical example of the most outstanding type of art produced during the Shang period in China. It possesses the dynamic sculptural shape and rich surface decoration that is typical of such pieces. Although of a different shape and design, it bears a strong stylistic resemblance to the twelfth-century B.C. bronze *guang* illustrated in the text (FIG. 15-3). Both pieces are a masterly blend of naturalistic and abstract forms; the strange zoomorphic creatures both sport horns that would belong neither to the feline creature represented in the text nor to the bird that forms the basis of this vessel. The silhouettes of both vessels are dynamic and broken, and in both cases the decoration seems to be an integral part of the sculptural whole rather than mere surface embellishment. The decoration of both vessels, and undoubtedly the shapes themselves, carried a symbolic meaning that was important to the ritual purpose of Shang bronzes.

84. A. India, Andhra period, first century B.C. to fourth century A.D. (Aspara, from the Kandarya Mahadeva Temple, Khajuraho, India.)
 B. China, Tang, seventh to tenth centuries (Terracotta funerary statuette, 618–906. Museum Rietberg, Zurich.)

These two very different representations of women are typical of those found respectively in traditional Indian and traditional Chinese art. The sensuous and undulating curves of the Indian figure are reminiscent of those of the woman carved on the facade of the chaitya hall at Karli (FIG 14-10) and of the voluptuous yakshis, or nature spirits, carved at Sanchi (FIG. 14-7). The exaggeration of the sexual characteristics, the rich jewelry, and flimsy veil all emphasize the eroticism that played a much greater role in Indian art than it did in the Chinese tradition. The dainty Chinese lady represents an entirely different spirit. This delicate little figure, which was created by Tang potters, was placed in a tomb and was intended to provide entertainment for the deceased in the world beyond. The figure shown here is a sleeve dancer. Her body is completely covered by a long flowing garment, very different from the revealing garments of the Indian figure, which were intended to emphasize rather than conceal bodily charms.

PART FOUR: THE RENAISSANCE AND THE BAROQUE AND ROCOCO

I. 1. c 2. n 3. g 4. e 5. i 6. h 7. k 8. f 9. p 10. u 11. a 12. d 13. o 14. m 15. s 16. v 17. w 18. r 19. q 20. j 21. l 22. y 23. x **II.** 24. i 25. a 26. c 27. c 28. d 29. j 30. s 31. l 32. k 33. g 34. m 35. e 36. d 37. n 38. m 39. b **III.** 40. n 41. i 42. e 43. p 44. l 45 b 46. j 47. a 48. g **IV.** 49. b 50. c 51. b 52. d 53. b 54. d 55. d 56. c 57. b 58. a 59. b 60. d 61. c 62. e 63. b 64. c 65. a 66. b 67. c 68. c 69. d 70. b 71. b 72. c 73. e 74. d 75. d 76. d 77. d 78. c 79. e 80. e

V. Answers for Chronological Chart: (More artists could be listed than the number of spaces provided.)
Italy: 13th–14th centuries: Nicola Pisano, Giovanni Pisano, Andrea Pisano, Berlinghieri, Duccio, Cimabue, Cavallini, Giotto, Simone Martini, Gaddi, Pietro Lorenzetti, Ambrogio Lorenzetti, Traini

Italy: 15th century: Ghiberti, Nanni di Banco, Donatello, Brunelleschi, Michelozzo di Bartolommeo, Masaccio, Uccello, Andrea del Castagno, Piero della Francesca, Fra Angelico, Fra Filippo Lippi, Alberti, Giuliano da Sangallo, Rossellino, Desiderio da Settignano, Andrea del Verrocchio, Pollaiuolo, Ghirlandaio, Botticelli, Signorelli, Perugino, Mantegna

Italy: 16th century: Leonardo, Bramante, Antonio da Sangallo, Raphael, Michelangelo, Andrea del Sarto, Correggio, Jacopo da Pontormo, Rosso Fiorentino, Parmigianino, Cellini, Giovanni da Bologna, Giulio Romano, Palladio, Bellini, Giorgione, Titian, Tintoretto, Veronese

Netherlands: 13th–14th centuries: Sluter

Netherlands: 15th century: Limbourg Brothers, Campin, Jan van Eyck, Rogier van der Weyden, Christus, Bouts, Hugo van der Goes, Memling, Bosch

Netherlands: 16th century: Gossaert, Bruegel, Metsys, Spranger

Germany: 15th century: Riemenschneider, Lochner, Witz, Schongauer, Stoss

Germany: 16th century: Altdorfer, Cranach, Grünewald, Dürer, Holbein

France: 15th century: Fouquet

France: 16th century: Clouet, Goujon, Lescot

Italy: 17th century: Giacomo da Vignola, Giacomo della Porta, Maderno, Bernini, Borromini, Guarini, Annibale Carracci, Reni, Guercino, Caravaggio, Domenichino, Pozzo, Gentileschi

Italy: 18th century: Tiepolo, Juvara, Piranesi, Canaletto

Germany: 18th century: Neumann, Asam, Cuvilliés

France: 17th century: Georges de la Tour, Le Nain, Poussin, Claude Lorrain, Mansart, Perrault, Le Vau, Le Brun, Puget, Girardon

France: 18th century: Watteau, Boucher, Fragonard, Chardin, Clodion, Greuze, Houdon, Vigée-Lebrun, Soufflot, David

Holland: 17th century: Van Honthorst, Hals, Rembrandt, Vermeer, Heda, Van Ruisdael

Flanders (Belgium): 17th century: Rubens, Van Dyck

Spain: 17th century: El Greco, Ribera, Zurbarán, Velázquez

Spain: 18th century: Goya

England: 17th century: Jones, Wren

England: 18th century: Vanbrugh, Hogarth, Gainsborough, Reynolds, Kauffmann, West, Fuseli, Blake, Adam, Wood, Stubbs, Boyle, Kent, Wright of Derby

United States: 18th century: West, Copley, Jefferson, Latrobe

VI. 81. A. Jan van Eyck, Flanders, fifteenth century, Northern Renaissance (*The Annunciation, c.* 1435. National Gallery, Washington, D.C.)

B. Raphael, Italy, sixteenth century, High Renaissance (*La Belle Jardiniére*, 1507–1508. Louvre, Paris.)

The precision and absolute clarity of the rendition of every form in this Annunciation scene indicate its fifteenth-century northern origin. The emphasis is on the specific, as shown in the rich brocaded robe, and the sparkling jewels point to Van Eyck as the artist. Similar details are seen in his painting of *The Virgin with the Canon van der Paele* (FIG. 20-6). The slightly awkward position of the Virgin of this panel is very similar to that of the Virgin on the exterior of his *Ghent Altarpiece* (FIG. 20-5). The slight upward tilt of the floor indicates that single-point linear perspective was not used to construct the architectural setting, as most likely would have been done by an Italian painter of the same period. Rich surface, precise detail, and symbolism are more important than unified space. As in other fifteenth-century Netherlandish works, disguised symbolism plays an important role in this painting, with such things as the scenes depicted on the capitals of the columns and the tiles of the floor adding to the devotional meaning of the altarpiece.

The Madonna with the Christ Child and St. John is an excellent example of Raphael's High Renaissance style, for it demonstrates the tightly organized pyramidal composition that was favored by High Renaissance artists, as well as the subtle chiaroscuro Raphael used to model the idealized faces. Like the *Madonna with the Goldfinch* (FIG. 22-14), this work demonstrates Raphael's striving to combine grace, dignity, and idealism with simplicity and logic. The beauty and calm dignity of these figures and their monumental form illustrate Raphael's great achievement in merging Christian devotion with pagan beauty.

82. Bernini, seventeenth century, Italy, Baroque (Sant'Andrea al Quirinale, Rome, 1658–1670).

The building illustrated here very clearly demonstrates the approach to form favored by Baroque architects. Variations on the oval were much more popular with Baroque architects than variations on the square and circle, which were the ideal forms for Renaissance architects. That preference is apparent in the plan of the Baroque church shown here. The facade also demonstrates the distinctive approach of Baroque architects. While the typical Renaissance facade is composed of discrete geometric units, carefully proportioned and coordinated, the facade of Sant'Andrea is composed of forms molded deeply in space, with curve playing against curve, creating a rich plastic surface. Many of the stylistic characteristics of this church, which was designed by Bernini, are apparent in other Baroque buildings as well, for example Borromini's church of San Carlo alle Quattro Fontane (FIGS. 24-11 and 24-12), Guarini's Palazzo Carignano (FIG. 24-16), and the piazza of St. Peter's (FIG. 24-3), which was also designed by Bernini. All share with this building the Baroque delight in dynamic forms that reach out and embrace space, plastic handling of surfaces, contrast of concave and convex forms, and preference for oval plans rather than the more static forms of circle and square preferred by Renaissance architects.

83. A. Holland, seventeenth century (Philips Koninck, *Landscape with a Hawking Party,* National Gallery, London.)
 B. Italy, seventeenth century (Pietro da Cortona, *Triumph of Barberini,* 1633–39. Ceiling fresco. Gran Salone, Palazzo Barberini, Rome.)

These Baroque paintings share the seventeenth-century's expansiveness and dynamism. Like Baroque scientists, the artists of these works see physical nature as matter in motion through space and time. However, while the Dutch artist paints the motion of clouds through a realistic landscape, dappled with a constantly changing light, the Italian artist gives an intense physical reality to his personifications of abstract ideas and then sets his massive figures into dynamic motion.

The differences between the paintings can be attributed in part to the desires and expectations of the patrons. The Italian artist was commissioned to paint an allegorical painting in praise of his powerful ecclesiastical patron and used a form similar to that used by Pozzo in his *Glorification of St. Ignatius* (FIG. 24-31), painted on the ceiling of one of the huge new Roman churches. The Dutch artist, on the other hand, was working for the open market, attempting to paint something that would be appreciated and purchased by a prosperous Dutch burgher to decorate his residence. These patrons were not interested in allegory, but rather in something real, such as portrayals of the changing moods of their beloved skies. The Dutch Protestant preferred to worship God reflected in his works, rather than under the majestic painted ceilings so popular in Catholic Rome.

84. A. Rembrandt, Holland, seventeenth century (*Aristotle with the Bust of Homer,* 1653. Metropolitan Museum of Art, New York.)
 B. Vermeer, Holland, seventeenth century (*Girl Reading a Letter,* c. 1655–1660. Staatliche Kunstsammlungen, Dresden.)

Rembrandt and Vermeer shared with other seventeenth-century Dutch artists an intense interest in the optics of light. However, their handling of it was quite different. Vermeer was primarily concerned with the creation of pictorial illusion and with extremely subtle optical effects. His attention to the effects of a warm and sunny light entering a quiet room, its reflections on the glass, and the varying textures it illuminates is very clearly seen in this painting.

Rembrandt, on the other hand, used subtle modulations of light and dark to indicate spiritual or psychic states, to explore nuances of character and mood. The man represented here shares with many of the others portrayed by Rembrandt a sense of inwardness, of quiet contemplation. Only a portion of his face emerges out of the darkness, while the bust, on which he rests his hand, seems to glow with light. Rembrandt makes us wonder about the relationship between the man and the bust, even if we do not know that they represent Aristotle, the famous philosopher, contemplating a bust of the blind poet Homer. Is he recognizing the superiority of Homer's intuitive wisdom over his own more worldly knowledge and success, symbolized by the golden chain? (Even if you didn't write anything about the subject Rembrandt was representing, I hope that you wrote something about the mysterious effects he created.)

85. A. Michelangelo, Italy, seventeenth century, High Renaissance (*The Bearded Giant*, 1530–1533. Galleria dell' Accademia, Florence.)
 B. Bernini, Italy, seventeenth century, Baroque (*Rape of Proserpine*, 1621–1622. Borghese Gallery, Rome.)

These two works are typical of the sculptural styles of Michelangelo and Bernini. While some of Michelangelo's works shared the qualities found in the work of other High Renaissance artists, this work demonstrates the quality of "terribilita" so characteristic of his personal style. Pent-up passion and power are represented here rather than calm and ideal beauty. This figure has an even more massive physique than the two slaves illustrated in the text (FIGS. 22-21 and 22-22), but like them, it seems to represent the human soul struggling to free itself from matter. The same straining of the huge limbs in contrary directions is seen in the unfinished figure of Day from the tomb of Giuliano de' Medici (FIG. 22-27). While the action of Michelangelo's figure can be understood from a single view—as is typical of most Renaissance sculpture—one must walk around the Bernini group in order to fully appreciate the complex composition, a characteristic of much Baroque sculpture. As he did in his rendition of David (FIG. 24-8), Bernini captures the split-second action of the most dramatic moment. The two struggling bodies pull against each other with great energy, and Bernini contrasts the strong musculature of the male figure with the softer quality of female flesh. Virtuoso treatment of surface textures, combined with great energy and movement, is typical of Bernini, as is the work's expansive quality as it reaches out into space and refuses to be confined to the block from which it is carved.

PART FIVE: THE MODERN WORLDS

I. 1. k 2. d 3. h 4. o 5. n 6. l 7. f 8. p 9. d 10. j 11. i 12. a 13. m 14. s 15. r **II.** 16. l 17. b 18. o 19. e 20. u 21. j 22. a 23. n 24. h 25. d 26. k 27. d 28. a 29. s 30. g 31. s or w 32. c 33. e 34. t 35. q 36. m 37. j 38. v 39. c 40. a 41. p 42. e 43. v 44. c 45. r **III.** 46. c 47. c 48. c 49. b 50. d 51. c 52. b 53. a 54. d 55. c 56. b 57. c 58. a 59. b 60. b 61. d 62. d 63. b 64. c 65. c 66. a 67. b 68. d 69. a 70. b 71. c 72. c 73. d 74. b 75. a 76. b 77. a 78. b 79. d 80. d

IV. 81. A. David Smith, United States, 1960s (*Cubi XXVII*, 1965, Guggenheim Museum, New York.)
 B. Claes Oldenburg, United States, 1960s (*Model Ghost Typewriter*, 1963. Sidney Janis Gallery, New York.)

Both of these pieces of sculpture were created by American artists in the 1960s, and they represent two very different approaches to art. Smith is representative of the Formalist/Structuralist approach, which aims to eliminate the human element in art in favor of formal machinelike perfection. Like the steel sculpture by Smith illustrated in the text (FIG. 28-20), this one shows his interest in arranging "solid, geometric masses in remarkable equilibriums of strength and buoyancy." Notice particularly the precarious balance of the columnar form on the upper right part of the sculpture. The beautifully machined surfaces of the forms demonstrate Smith's interest in contemporary machines and his professed desire to turn his studio into a factory.

Oldenburg's approach is almost diametrically opposed, for one of his goals was to humanize the machine, which he does with a kind of sly humor by means of his "soft" sculptures. The various mechanisms of the soft typewriter sag and assume a strangely grotesque organic quality, which completely denies its function as a machine. Oldenburg's fantasy seems to be a combination of Dada mockery of society and the interest of American Pop artists in the forms of the commercial world around them.

82. A. Rodin, France, late nineteenth to early twentieth century (Three Fates from *The Gate of Hell*, 1880–1917. Musée Rodin, Paris.)
 B. Canova, Italy or France, early nineteenth century, Neoclassicism (*Three Graces*, 1814. Ny Carlsburg Glyptych, Copenhagen.)

These two sculptured groups demonstrate the difference between Canova's cool and formal Neoclassicism and Rodin's much more emotional style, which combines elements from Romanticism,

Impressionism, and an expressive Realism (FlGS. 26-91 and 26-92). Rodin's figures are cast in bronze from clay models, and his use of soft clay enabled him to create subtle variations and shifts of the planes under the play of light and thus to achieve effects that were impossible to an artist like Canova, who carved directly into marble. Rodin's fluid modeling is analogous to the deft Impressionist brush stroke, but the exaggerations of the forms and the striking gestures of the three figures as they point downward echo the dramatic intensity of Romantic and Expressionist works. The impression of work in-progress created by the figures seems to derive from the unfinished works of Michelangelo, which influenced Rodin deeply. Rodin's concern with dramatic statement and with expressive bodily pose and gesture shows clearly the influence of Michelangelo.

Canova's graceful female figures derive from very different sources. There is a lingering Rococo charm, but the precise technique used to create the idealized figures, which combine careful detailing and generalized forms, is clearly in the Classical tradition. These three figures are closely related to Canova's representation of *Pauline Borghese as Venus* (FIG. 26-2), for they demonstrate the same type of femininity: ideal and seemingly distant, yet human and accessible at the same time.

83. A. Mondrian, second-quarter twentieth century (*Broadway Boogie Woogie*, 1942–1943. Museum of Modern Art, New York.)
 B. Kandinsky, first-quarter twentieth century (*Picture with a White Edge*, 1913. Guggenheim Museum, New York.)

These two compositions illustrate the range of experimentation that was found in the development of abstract art in the early twentieth century. They could be said to represent the Romantic or Baroque approach as opposed to the Classical approach. Mondrian's composition, like the one illustrated in the text (FIG. 27-50), is composed exclusively of straight lines that form squares and rectangles of various sizes, arranged very carefully on a two-dimensional surface to create a subtle asymmetrical balance. He was interested in the idea of an absolute artistic order, but he did not want mechanical uniformity. This composition illustrates his belief that "true reality is attained through dynamic movement in equilibrium," for while there is a sense of balance in the composition, there is no symmetry, and the shapes of the rectangles are infinitely varied. Yet, he is not unlike the Neoclassical artists, since his approach, like theirs, can best be described as "deliberate and studious."

Although the words used to describe the Romantic artist as "impetuous, improvisational, and instinctive" are out of place in describing Mondrian's work, they do seem to describe exactly the approach used by Kandinsky in the works illustrated here and in the text (FIG. 27-21). The painting demonstrates the point at which Kandinsky's exploration of the emotional and psychological properties of color, line, and shape have dispensed with the depiction of subject matter and have moved into the realm of pure abstraction. The title, which he used for many of the pictures of this time, including *Improvisation 28* in the text, aptly describes his approach and is very different from the deliberate, intellectual one of Mondrian. Where Mondrian's lines are vertical or horizontal, lines and masses of color move across Kandinsky's canvas in all directions, movements and arrangements that seem to burst directly from his subconscious. Kandinsky's own writing stresses the importance of allowing the instinctual world of the subconscious to emerge and to control directly the artistic expression of the artist. In this work we see the results of that technique.

84. A. Van Gogh, late nineteenth century (*Stairway at Auvers*, 1890. City Art Museum, St. Louis.)
 B. Cézanne, late nineteenth century (*The Gulf of Marseilles Seen from L'Estaque*, 1884–1886. Metropolitan Museum of Art, New York.)

These two paintings, done in late nineteenth-century France by two Post-Impressionists, show the same contrast in approach that we saw in the twentieth century between Mondrian and Kandinsky. Van Gogh's approach to the painting is instinctive and emotional, while Cézanne's is deliberate and intellectual. The Van Gogh landscape shows the same type of swirling, impulsive brush strokes that he used in *Starry Night* (FIG. 26-76). There are no stable forms; rather everything seems to be in motion. Unfortunately, the black-and white reproduction does not show the intense color that Van Gogh loved and made such an important part of his painterly expression.

Color was important to Cézanne too, but he used it to build up form and pictorial structure and not to express emotional states as did Van Gogh. The carefully interlocked planes he developed in his painting of Mont. Sainte-Victoire with Viaduct (FIG. 26-72) are also used here and interlock forcibly on the two-dimensional surface of the canvas. As in his other landscapes, he has immobilized the shifting colors of Impressionism and has created a series of clearly defined planes. How much more stable this landscape looks than the one created by Van Gogh! Like Mondrian, Cézanne has achieved this stability by emphasizing vertical and horizontal lines in his composition, while Van Gogh, like Delacroix and Kandinsky, has created an emotional and constantly changing effect in his by using diagonal lines that undulate.

85. A. Picasso or Braque, Analytic Cubism, 1910s (Picasso, *Violin and Grapes*, 1912. Museum of Modern Art, New York.)
 B. Mark Tansey, Postmodernist, 1980s (*Still Life*, 1982. Metropolitan Museum of Art, New York.)

The subject of painting A, which seems to be some sort of stringed instrument and a fruit resembling grapes, is not depicted according to our usual view, but rather is dissected, spread out across the picture plane, and compressed into a very shallow space. Shortly before 1910, Picasso and Braque began experimenting with ways to present the total reality of three-dimensional objects on a two-dimensional plane. They utilized multiple angles of vision and simultaneous presentations of discontinuous planes to represent various aspects of their subjects. Color was kept to a minimum in these works, and the surface was broken up as forms were subjected to careful analysis. All of these characteristics are seen in the painting reproduced here, although the color range is impossible to detect in this black-and-white reproduction.

Painting B shows us a traditional still life, but it is a painting within a painting. The style is a kind of careful realism like that used by a number of artists during the 1930s, but the pun is in the spirit of the work done by Mark Tansey in the 1980s. It is a kind of modern *memento mori*, not only for the flowers, which die while their painted representation lives on, but also for the painting style of so many artists of an earlier era. Although Tansey painted many of his images in the tones of grey of a news photograph in order to create an additional level of reality, this black-and-white reproduction does not allow us to detect the colors used in this still-life painting. Both Picasso and Tansey set problems for the viewer to solve: Picasso's is the analysis of pictorial space, while Tansey's concern is with a wry dissection and analysis of the conventions of art and of the art world itself.

86. The two buildings shown here are both influenced by buildings of the past. The one on the left is related to the eclecticism and revival traditions of the late nineteenth and early twentieth centuries. It seems to be a revival of the Baroque style of Bernini and Borromini with their curving lines and richly plastic surfaces with the addition of the Spanish decorative style as seen in the portal of San Gregorio at Valladolid. The painting on the right shows the influence of Postmodern architecture, which refers to earlier architectural forms without reproducing them. The architect of this building has looked back to the classic tradition of the Italian Renaissance with its simple clear geometric forms, forms that were repeatedly used by architects in the Palladian tradition. The stark black-and-white contrasts are seen in Italian churches like Santa Maria Novella and Santa Maria delle Carceri. However, here the forms are used to create a backdrop for a shopping center rather than to create a building that has its own interior meaning.

(The building on the left was built as part of the World's Fair Exposition in Balboa Park in the early years of the twentieth century, while the building on the right is part of Horton Plaza, a redevelopment project on the waterfront in San Diego.)

PICTURE CREDITS

page

86 top	Detail from Parthenon frieze. c. 440–423 B.C. British Museum, London, Photo: Hirmer Fotoarchiv, Munich
86 bottom	*Banquet Relief of King Ashurbanipal.* Nineveh. 668–627 B.C. British Museum, London. Photo: Hirmer Fotoarchiv, Munich
88 left	*Roman Head.* 1st century B.C. Staatliche Antikensammlung und Glyptothek, Munich. Photo: Christa Koppermann
88 right	Head of Hermes. Detail of *Hermes and Dionysos.* 340 B.C. Marble. Archeological Museum, Olympia. Photo: Hirmer Fotoarchiv, Munich
89	*Akhenaton and his Family* relief. Tellel–Amarna. Eighteenth dynasty, c. 1360 B.C. Agyptisches Museum, Berlin. Photo: Bildarchiv Preussischer Kulturbesitz, Berlin
90 left	*Procession of Female Saints.* Mosaic from Sant' Apollinare Nuovo, Ravenna, Italy. c. 561 A.D. Photo: Alinari/Art Resource
90 right	*Judgment of Paris.* Fresco from Pompeii, National Museum, Naples. 1st century B.C. Photo: Anderson/Giraudon/Art Resource
146 left	Symbol of Matthew the Evangelist. *Book of Darrow.* 7th century A.D. Trinity College, Dublin; by permission of the Board
146 right	*John the Evangelist* from the *Ebbo Gospels* (the *Gospel Book of Archibishop Ebbo of Reims*), Hautvilliers (near Reims), France. c. 816–835. Approx. 10" x 8". Bibliotheque Nationale, Paris. Photo: Giraudon/Art Resource
147 left	*Prophet Isaiah.* Portal of the Church of Soulillac, Lot, France. c. 1130–1140. Photo: Bulloz
147 right	*Virgin.* North Transept. Notre Dame, Paris. 13th century. Photo: Alinari/Art Resource
148 left	Nave of Santiago de Compostela, Spain. 1077–1211. Photo: Ampliaciones y Reproducciones MAS, Barcelona
149 left	Nave arcade of Notre Dame, Paris. Photo: Giraudon/Art Resource
209 left	*Haniwa* figure of a warrior. Tumulus period, fifth century. The Art Institute of Chicago. Photo: © 1990 The Art Institute of Chicago. All rights reserved
209 right	*Charioteer.* Lintong, Shensi Province, China. 221-206 B.C. Courtesy of the Cultural Relics Bureau, Beijing, and The Metropolitan Museum of Art, New York
210 left	Detail of a six-fold Japanese screen. Attributed to Soami, 1525. The Metropolitan Museum of Art, New York (gift of John D. Rockefeller, Jr., 1941)
210 right	Katsushika Hokusai. *Fuji Above the Storm.* c. 1823. Woodblock print. From *Japanese Prints: Hokusai and Hiroshige in the Collection of Louis V. Ledoux.* Copyright 1951 © 1979 by Princeton University Press
211	Benin. *The King with Two Chiefs.* 16–17th century. Bronze. British Museum, London. Reproduced by courtesy of the Trustees of the British Museum.
212	Chinese wine vessel in the shape of a bird. Bronze. Photo: © 1990 The Art Institute of Chicago (Lucy Maud Buckingham Collection). All rights reserved

Picture Credits (continued)

213 left	Indian *Aspara* figure. From the Kandarya Mahadeva Temple, Khajuraho, India. 1st century B.C.–4th century A.D. Photo: Raghubir Singh/Woodfin Camp and Associates
213 right	T'ang China Terracotta funerary statuette. Sui Dynasty, 7th century, 618–906. Museum Rietberg, Zurich. Photo: © Museum Reitberg, Zurich
306 left	Jan van Eyck. *The Annunciation.* c. 1435. National Gallery of Art, Washington (Andrew W. Mellon Collection)
306 right	Raphael. *La Belle Jardiniere.* 1507–08. Louvre, Paris. Photo: Reunion des Musees Nationaux, Paris
307 right	Gianlorenzo Bernini. Sant' Andrea al Quirinale, Rome. 1658–70. Photo: Seala/Art Resource
308 left	Philips Koninck. *Landscape with a Hawking Party.* 17th century. National Gallery, London
308 right	Pietro da Cortona. *Triumph of Barberini.* 1633–39. Ceiling fresco, Gran Salone, Palazzo Barberini, Rome. Photo: Alinari/Art Resource
309 left	Rembrandt. *Aristotle with the Bust of Homer.* 1653. The Metropolitan Museum of Art, New York
309 right	Jan Vermeer. *Girl Reading a Letter.* c. 1655–60. Staatliche Kunstsammlungen, Dredsen. Photo: Alinari/Art Resource
310 left	Michelangelo. *The Bearded Giant.* 1530–33. Galleria dell'Accademia, Florence. Photo: Scala/Art Resource
310 right	Gianlorenzo Bernini. *Rape of Prosepine.* 1621–22. Borghese Gallery, Rome. Photo: Alinari/Art Resource
359 left	David Smith. *Cubi XXVII.* 1965. The Solomon R. Guggenheim Museum, New York. © 1996 Estate of David Smith/Liscensed by VAGA, New York, NY. Photo: Robert E. Mates
359 right	Claes Oldenburg. *Soft Typewriter—Ghost Version.* 1963. Oldenburg Studio, New York. Museum fur Moderne Kunst, Frankfurt. Photo: Sidney Janis Gallery, New York
360 left	Auguste Rodin. *Three Fates* from *The Gates of Hell.* 1880–1917. Musee Rodin, Paris. Photo: Bruno Jarret, Musee Rodin, Paris. © 1996 Artists Rights Society (ARS), New York/ADAGP, Paris
360 right	Antonio Canova. *Three Graces.* 1914. Ny Carlsberg Glyptotek, Copenhagen. Photo: Alinari/Art Resource
361 left	Piet Mondrian. *Broadway Boogie Woogie.* 1942–43. Oil on canvas, 50 x 50" (127 x 127 cm). The Museum of Modern Art, New York (given anonymously). Photo: © 1996 The Museum of Modern Art, New York
361 right	Wassily Kandinsky. *Picture with a White Edge.* 1913. The Solomon R. Guggenheim Museum, New York. © 1996 Artists Rights Society (ARS), New York/ADAGP, Paris
362 top	Vincent van Gogh. *Stairway at Auvers.* 1890. St. Louis Art Museum
362 bottom	Paul Cezanne. *The Gulf of Marseilles Seen From L'Estague.* 1884–86. The Metropolitan Museum of Art, New York (bequest of Mrs. H. O. Havemeyer, 1929. The H.O. Havemeyer Collection)
363 left	Pablo Picasso. *Violin and Grapes* Ceret and Sorques. Spring–summer 1912. Oil on canvas, 20 x 24" (50.6 x 61 cm.). The Museum of Modern Art, New York (bequest of Mrs. David M. Levy). Art: © 1996 Artists Rights Society (ARS), New York/SPADEM, Paris. Photo: © 1996 The Museum of Modern Art, New York
363 right	Mark Tansey. *Still Life.* 1982. Oil on canvas, 62 x 46". Collection of The Metropolitan Museum of Art, New York (purchase, Louise and Bessie Adler Foundation, Inc. gift). Courtesy Curt Marcus gallery, New York.
370 left	Nave arcade of Notre dame, Paris. Photo: Giraudon/Art Resource